THIS ADVENTURE BELONGS TO

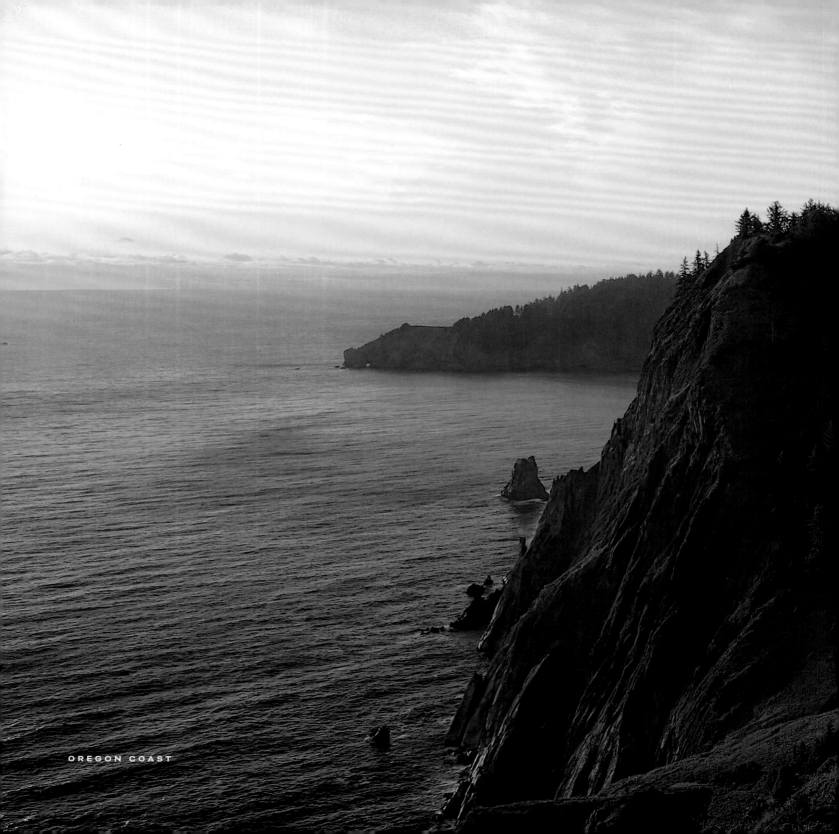

OREGON COAST

WILD WONDER

WHAT NATURE TEACHES US ABOUT SLOWING DOWN AND LIVING WELL

STEPHEN PROCTOR

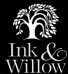

Ink &
Willow

GIFFORD PINCHOT NATIONAL FOREST, WASHINGTON

In memory of my mother, Irene Alice Nix Proctor,
whose prayers helped bring this book to fruition.

I love you, Mama.
Thank you for showing me the Way of Grace.

CONTENTS

FOREWORD

MAKOTO FUJIMURA

ARTIST AND AUTHOR OF *ART+FAITH: A THEOLOGY OF MAKING* (YALE UNIVERSITY PRESS)

ART BEYOND THE SEA

As an artist of the "slow art movement," I offer a paradox. Stephen's photographs, though they were taken using the nimble and fast-moving technology of an aerial drone, help us in the development of "slow art." How could something that buzzes around in the air with an attached camera processing millions of bits per second create slowness? That, precisely, is the question that draws all of us to Stephen's imagery.

These frames are also part of Stephen's effort to capture the mysteries of Creation and vast, untouched stretches of nature. Such an exploration through the in-between fragments of the matrix of digital technology is now incarnated into this book. These images do not reproduce the immersive experience that the original footage possesses in themselves; rather, they are translations, and perhaps transfigurations, into a different form. I use the word *transfiguration* intentionally to connote a type of spiritual transcendence as applied to these images.

They are portals into a vista beyond, thus inherently foreign and alien to our normative experiences. Unless we are willing to, and able to, suspend our normative way of perceiving the world, we will not be able to fully appreciate these works. In that sense, we need to not only slow down ourselves to appreciate these images, but there also needs to be another mechanism, or cultural language, to enter into these images, to open our exploring of their philosophical and theological depths.

I am a founder of the Culture Care movement, a metaphorical inversion to reconnect culture to nature and to see culture as an ecosystem to steward, rather than a battleground of Culture Wars atroc-

ity. In such a movement, true artists are border-stalkers, navigating the in-between gaps between warring tribal realms. A typical border-stalker is marked by identities that do not fit nicely into categorical terms. Categories such as "photographs" or, worse yet, "drone photos" may be only arbitrary distinctions, distinctions that disappear the more the viewer lingers to take in the layers of Stephen's works. Stephen's "photographs" are taken from being suspended in the air, not grounded by a tripod. They can be printed and framed or be part of an immersive projection collaboration, such as the one in New York City I had Stephen participate in as a collaboration with renowned percussionist/visionary Susie Ibarra and me, live-painting during the *Re-Sonance* exhibit. Our works defy binary separations of contemporary versus traditional, photograph versus painting, and create immersive expressions.

So why print a "photography" book? For one, Stephen's photos are worthy as "photography" on their own. And, as I know very well as a visual artist, any attempt to reproduce an image is always a work of translation. What works on the page, integrated into paper and design, is a separate incarnation. And, I am sure Stephen will attest, these videos, however immersive, are at best a simulation of reality, a reality of awe and even suspension of disbelief that such beauty is allowed to be experienced.

These images do not "exist" but remain only in bits on the memory card of a drone. The uniqueness of these images also amplifies the gap between Reality and Art, and even for the "photographer," these images could not be experienced directly but only after downloading them. So, again, no tripod image of Ansel Adams standing on a cliff to take

a photo of Yosemite, then spending hours in a darkroom to develop it into silvery details. These images are dependent on, and integrative of, technology, but photos now hold their own, liberated materially from dependency with technology. How they are to be liberated is the art of the gap, one that Stephen can lead us into to experience.

Today, one can make a documentary film with an iPhone, write a novel on a subway on a mobile device (as a friend of mine has done), and create multidimensional stories that get posted on Instagram. So the question to ask is no longer, "Is this a photograph?" but, "What is the New in this expression?" and then even dare to ask, "What is a photograph today?"

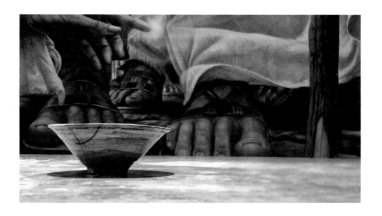

TEA CEREMONY IN MAGDALA

Sen no Rikyū, the renowned tea master of sixteenth-century Japan, refined the art of tea, flowing out of China and Korea into Japan, and then refined the aesthetic of Japan to what we know today. Rikyū's art, life, and even his death (by Seppuku suicide) indicates a life marked by feudal wars and a generative force that brought the impossibility of creating the art of peace in the midst of strife. My work as an artist and the work of Culture Care set the path of Rikyū in contemporary art language, and in this book's images, Stephen successfully incarnates these values into his works.

Stephen came with me to travel through Israel. Accompanying us was Keiko Yanaka, a tea master apprentice who has been collaborating with me to present the Japanese art of Rikyū's school of tea in unusual settings. Stephen helped by creating an immersive projection in an underground cavern, turning a sanctuary at Magdala into a contemporary art space.

Magdala is a historic site and the home of Mary Magdalene, a local patron who supported Jesus's ministry. It has survived the years of contested turmoil of the area, and they have recently discovered the original first-century synagogue, a site where Rabbi Jesus must have opened the scrolls. At the entry of Magdala is a stone table for such an occasion.

When we served tea, we recalled the centuries of Japanese history after severe persecution of Christians began in the seventeenth cen-

tury, as recounted by Shūsaku Endō's novel (and Martin Scorsese's film) *Silence*. Japanese tea was a way for hidden Christians to practice Eucharist. Zen priests protected them, in some cases, and evidence of such an extraordinary partnership is seen in Daitokuji temple, the Mecca of Zen, where the most important tea master of Japanese history, Sen no Rikyū, is venerated.

Art, as well as Stephen's work, also contains hidden elements. These images (including ones from Magdala) are like maps of underground railroad signatures to direct the escaped slaves where to go. Rather than a visual symbolism of quilts specifically made as a hidden map, these images liberate us to see beyond the current crisis in environmental stewardship, beyond the divisiveness of culture, and toward a vista of hope. A drone view, after all, is a macro view, or a view from above, from the heavenly. And it is where the border-stalkers meander into.

As we were serving tea, a sudden storm came up, a tempest of the Sea of Galilee, pouring buckets of rain on a dry ground. As we came out of the chapel, immersed in the pungent aroma, the local guide told us that it had not rained so heavily in the month of June for the seventeen years he has been a guide, and, "Rain," he said, "is a sign of blessing."

These works mark the rare storm of keen insight and technology. They capture the New in the "eye" of the storm, calming the raging wind around us. There is silence in these works, a feast to share in our storms of life. The images slow us down to hear what angels may dare tell us about what they see above the world.

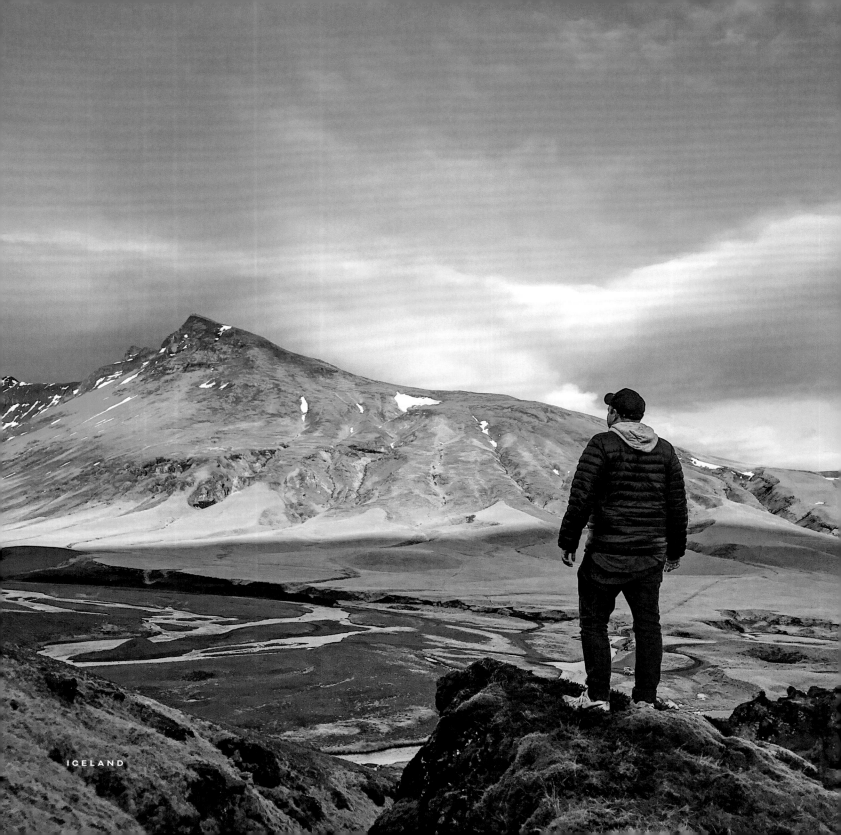

ICELAND

THE ADVENTURE BEGINS

I'm going on an adventure!

~ THE HOBBIT: AN UNEXPECTED JOURNEY

Is there anything quite like going off on an adventure? Taking the scenic route instead of the main highway, driving down a winding road deep in the forest, hiking on a new trail and wondering what scenery awaits around the corner, or taking a flight to some distant land and exploring its hidden landscapes—any kind of adventure, however long or short, is a chance to recalibrate our souls and reconnect to the child within.

I grew up in a small, rural town in northeast Arkansas. Hunting, fishing, hiking, and four-wheeler riding were constants in my outdoor life. I loved exploring the woods with my dad and my friends. We'd discover hidden gems in the woods like ponds, fallen trees, and rock quarries and give them names such as "The Resting Log," "The Secret Lake," and "The Frontier." I'd even sketch out maps as though my surroundings were Narnia or Middle-earth. Nature was one big playground for my imagination, and so I spent as much time as I could outside. (Well, that and playing *Super Mario Bros.*, of course.)

When it came to nature, I was taught that all of Creation was fashioned by a loving Creator and that the Earth, along with the whole universe, declared the creativity and glory of God. This majestic and divinely inspired aspect of nature made sense to me because, though I didn't realize it at the time, being out in nature was where I felt most alive and connected to my imagination. And even more significantly, nature would eventually become the place where I would experience the most profound of spiritual awakenings. It's where I would discover a passionate love for the Creator of the cosmos and where I would nurture a deep communion with Christ. Because, to paraphrase Eric Liddell in *Chariots of Fire*, when I'm outside, *I feel God's pleasure.*

Of course, that realization wouldn't come until later.

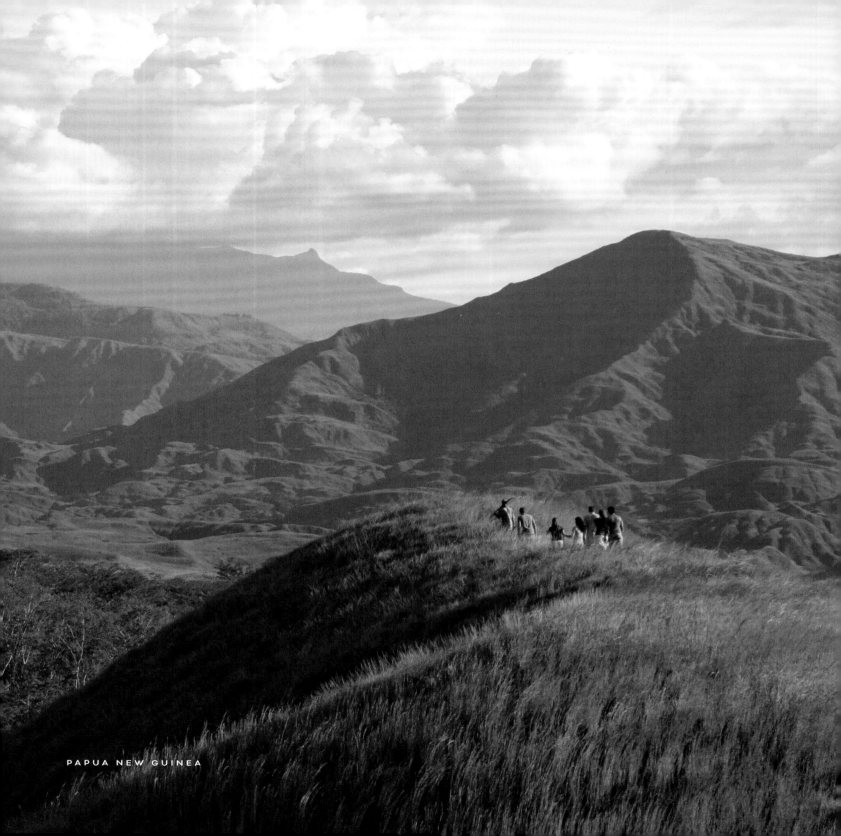

PAPUA NEW GUINEA

TOUCHING GRASS

In 2007, I went on an unexpected adventure that wrecked me in the best of ways. My business partner at the time, Nate, had encouraged me to spend some time in a distant country where he used to live: Papua New Guinea. This trip was designed as one of those full-immersion, educational experiences for young adults who want a taste of what it's like to live and work among remote Indigenous tribes. It was also an opportunity to see the world through a different cultural lens.

The whole experience was eye-opening and humbling, to say the least. One of the most memorable moments was when one of the staff asked me, "When's the last time your feet touched the grass every single day?" That question seemed so simple, yet it really made me think. Grass was never something I really thought about until it got too tall. It was always just . . . there. In plain sight. And taken for granted.

My friend went on to say, "Our bodies rarely touch the Earth back home. Our feet go from the bed, to the floor, to our socks and shoes, to the pavement, into our car, back to pavement, into an office or store or coffee shop, and so it continues until we get back into bed. How often do our bodies actually touch the Earth?"

Once he explained it that way, the issue made complete sense to me. Deep down, I felt this truth bomb drop on my soul. And I started to wake up to the fact that even though I was traveling all over the world, I was rarely touching the Earth.

After that, I started walking around barefoot a little more often. I began caring less about checking emails and texts and more about checking in with the beauty that fills the landscape. Slowly, my eyes widened and my prayers deepened. And I encountered a wild wonder as I walked down red clay roads and hiked through jungles with locals while eating raw sugarcane freshly picked from a nearby field.

Overall, that experience in Papua New Guinea planted a seed of awareness and stirred in me a primal hunger for a more natural connection to the planet we call home. As the years went by, I found myself wanting to get out of the city and into the wild. Even the imagery I was drawn to in my creative work started to reflect the natural world more. The reconnection to my childhood roots had begun, albeit slowly.

But it wasn't only a return to the same experience of nature I had enjoyed in my early years. This reawakened desire for a more grounded, Earth-connected life also brought with it the gift of a new perspective, and I began to recognize in myself an equally life-giving longing: to see our world not just from the ground but from above as well.

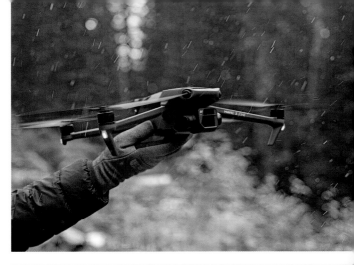

A BIRD'S-EYE VIEW

In 2016, this longing to enjoy different perspectives of our world led me to embrace a new way of seeing: drones. These little bird robots gave me the gift of a third eye in the sky. With a camera-equipped drone, I could hit RECORD and then send it up a mountain, into a cloud, and back down over a forest. Being able to capture my own unique perspectives of the Earth became my new love language. It was, and still is, pure euphoria, especially when I pair the flight with music (more on that later).

Sometimes, I find a scene I could stare at for a while. I might hover in place with the camera aimed down to watch white waves crash on a black sand beach. And for a moment, nothing else in the world matters except those waves and the mesmerizing contrast of the scene. The fears connected to flying thousands of dollars over the ocean start to fade, and a calm begins to wash over me like those waves.

Similarly, the troubles of this world begin to fade. The beauty of nature starts to heal my exhausted, anxious soul, and I once again feel reconnected—to my own body, to Creation, and to the Creator. I'm able to catch my breath and let my shoulders down. As I begin to fully take in the scene through the screen on my remote control, I am reminded that it is not a video game, virtual reality, or some image constructed by AI, but a real, tangible, larger-than-life reality.

Touching both grass and sky has brought my childhood love of nature back to life. Maybe it's the same for you. Because whether you enjoy life with your feet on the ground or your head in the clouds, both perspectives invite us into a wild, childlike wonder. And that's the invitation with this book as well.

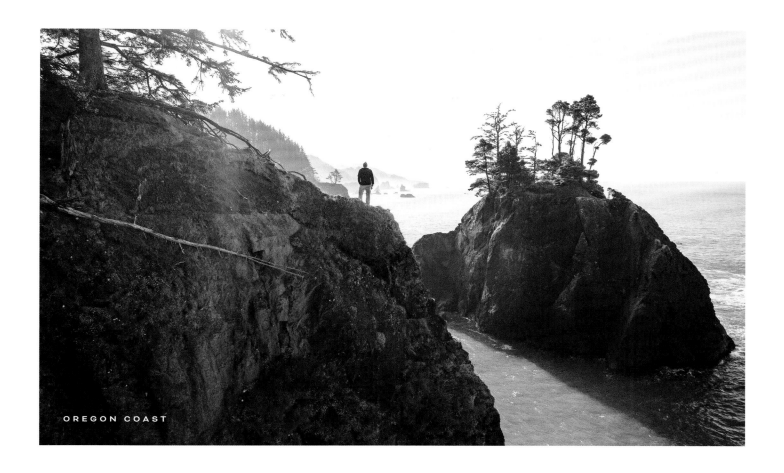

OREGON COAST

EVERY STORY HAS A SOUNDTRACK

Listening to music as I experience the natural world—both from the air and from the ground—makes me feel like I'm in one of my favorite movies. Somehow, beautiful scores always seem to pair well with a moving landscape. And once in a while, I catch the landscape doing visually what the music is doing sonically. As if the two were meant to go together.

These cinematic and synchronous pairings in nature have become one of my favorite forms of inspiration, which is why music is a common theme in this book. You'll notice that I've organized the landscape photos and stories into *suites,* a term borrowed from the classical music world. And in each landscape suite, I've asked a composer to contribute a few thoughts on the relationship of their music with nature.

I truly believe that we can experience our world in a fresh and profound way when we integrate art with the beauty of the created world. (If you'd like a powerful example of this, check out the Creation sequence in Terrence Malick's film *The Tree of Life*.) Because if we really pause to listen, as I invite you to do in this book, we might even hear the symphony of nature itself.

COME FLY WITH ME

One thing I love more than an adventure is sharing that adventure with a friend. And the same goes for flying and filming with my drone. I absolutely love sharing the scenes I've been privileged to witness.

In the pages and photos that follow, let's watch the sun set behind forested sea stacks and listen to the symphony of the seas. Let's breathe in fresh air filtered by foggy forests and stand in awe of woodland cathedrals adorned with both the oldest and youngest of life on Earth. Let's drink in the hypnotic flow of braided glacial rivers that look like abstract paintings hanging in an art gallery. Let's hover in stillness over glaciers and frozen forests where the language of the land is silence. And as a final crescendo, let's ascend to the mountains and behold beauty from above while we ponder our place in this sacred universe.

Most of the images you'll see were taken with my drone, giving us aerial perspectives on various landscapes. Yet while our view will be from above, the stories shared are meant to ground us. In addition to the photos and reflections, I've created an online destination where you can engage with cinematic meditations featuring aerial footage, music playlists curated for each landscape suite, and links to resources that relate to various topics throughout this book. Everything can be found at proktr.com/wildwonder—one link to rule them all!

At the end of each suite, I'll leave some space for reflection and prompted activity—a personal Time to Fly. This is an opportunity to ponder and practice rhythms that might cultivate a deeper connection within yourself and to the world we live in. These sections are not homework, though; there is zero pressure to complete every single prompt. They are merely an invitation for reflection and an opportunity to be present with your thoughts.

You might find that certain landscapes will resonate with you more deeply than others. Pay attention to this resonance. Where do you feel the greatest sense of calm? When does your inner child rise up with wonder and excitement? The answer may reveal to you something hidden about yourself, perhaps a deep longing that needs some exploring.

So let's get our heads in the clouds and let our feet touch some grass. Let's tap into some wild wonder while being centered and grounded like a monk . . . or perhaps like a tree planted by streams of water (Psalm 1:3). Let us behold the beauty of this world and know that it is good.

Let's fly!

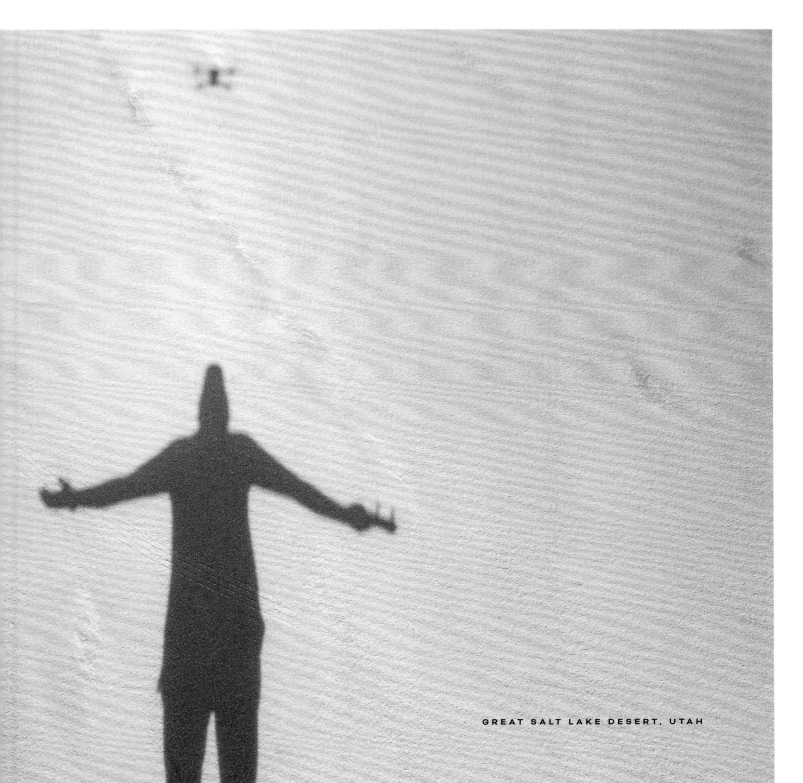

GREAT SALT LAKE DESERT, UTAH

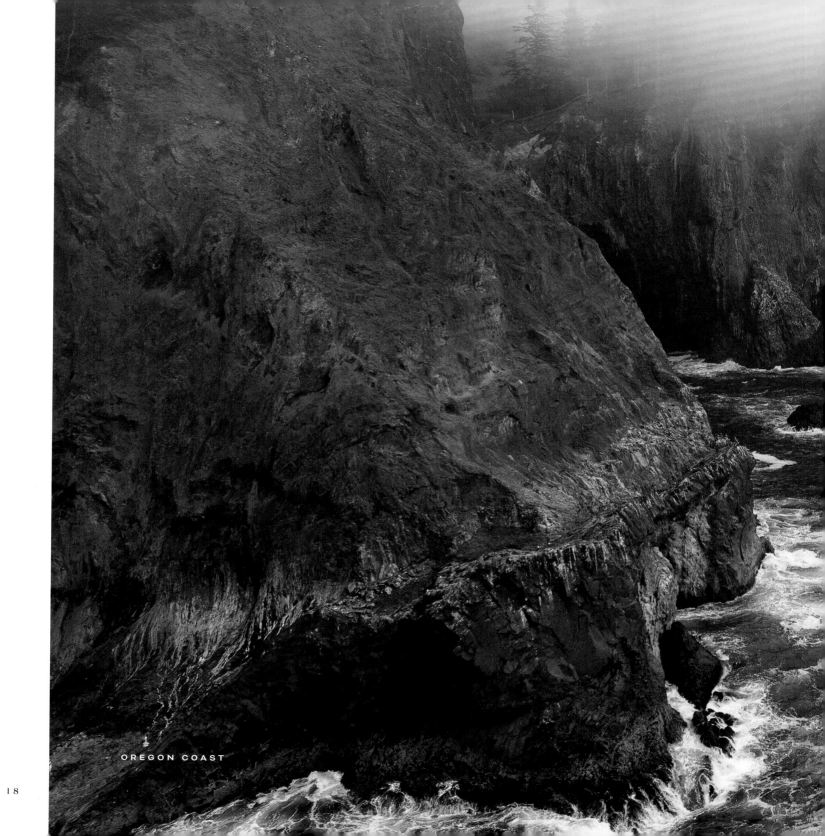

OREGON COAST

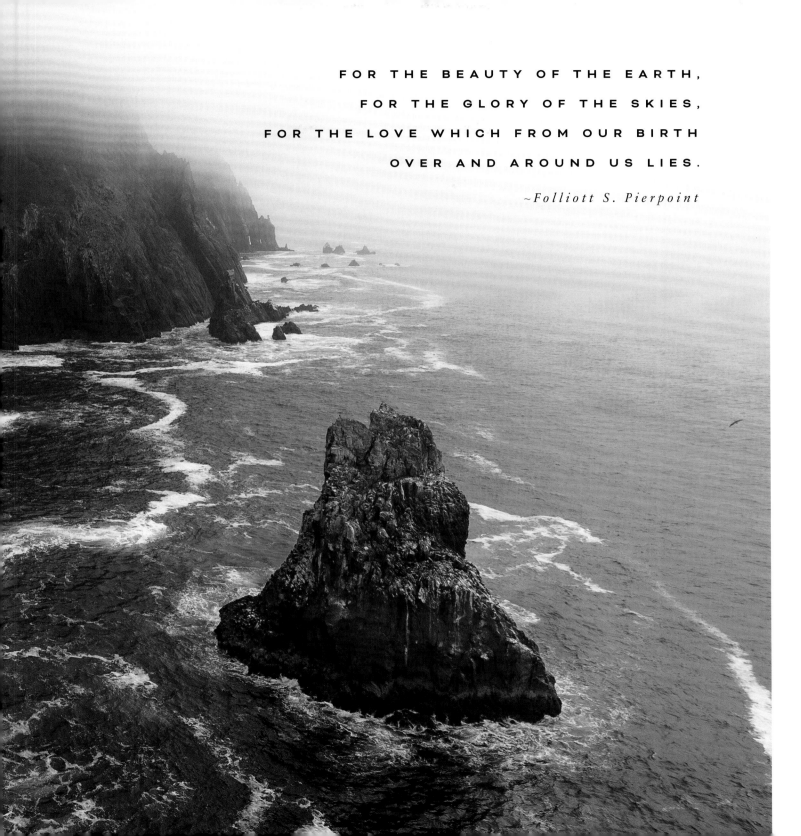

FOR THE BEAUTY OF THE EARTH,
FOR THE GLORY OF THE SKIES,
FOR THE LOVE WHICH FROM OUR BIRTH
OVER AND AROUND US LIES.

~Folliott S. Pierpoint

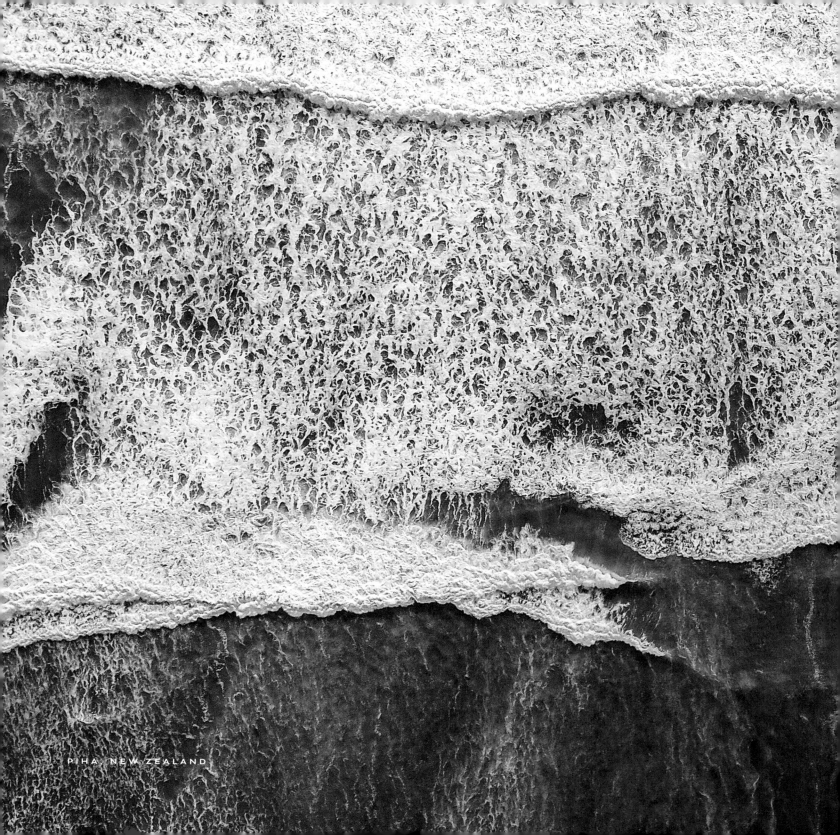

PIHA, NEW ZEALAND

SUITE NO. 1

OCEANS

WAVELENGTHS IN THE WILD

THE
SONG
OF
NATURE

Let the heavens rejoice,
let the earth be glad;
let the sea resound,
and all that is in it.
Let the fields be jubilant,
and everything in them;
let all the trees of the forest sing for joy.
Let all creation rejoice before the Lord.

~PSALM 96:11-13

TARANAKI, NEW ZEALAND

ENCINITAS, CALIFORNIA

All Creation declares the glory of God. What a beautiful perspective. Appreciating nature in this way invites me to see the natural world as a living, breathing being that has something profoundly beautiful to say. And if the words of the psalmist are true, then what are the details of this declaration? What might glory sound like? What language does nature sing in, and how might listening to its song affect us?

One of my favorite sci-fi films is Christopher Nolan's *Interstellar*. In the scene when the freshmen astronauts have just awakened from their first-ever cryogenic sleep, one of them, filled with anxiety, begins to grapple with the reality that he is floating in a vast ocean of nothingness where nothing can survive, and that the only thing protecting him is a few "millimeters of aluminum." But then Matthew McConaughey's character hands his anxious companion a pair of headphones. Both astronaut and audience are then immersed in the sound of crickets chirping at night, followed by rainfall in a forest. Then, as we watch their tiny vessel pass by the rings of Saturn, we hear the sound of thunder rolling in the distance. Nothing is said or explained, but Nolan implies that one of the best ways to adjust to a foreign or stressful environment is by listening to the soothing sounds of nature.

So many of us live in sonically violent environments, inundated with every type of noise imaginable. Rings. Pings. Alerts. Notifications. Trains. Planes. Automobiles. Sirens. Reels and TikToks. Ads and clickbait. The endless barrage of "breaking news" on screens everywhere. "Experts" vying for our attention with their loud opinions on every single matter. This nonstop cacophony of chaos is constantly interrupting our lives and wearing us down.

It's no wonder that "sound bathing" has become a popular form of meditation sought by those wanting to retune their bodies to more calming and healing frequencies. Immersing ourselves in the sonic landscapes of Earth can be an incredible form of therapy because the sounds of nature have the power to gently drown out the noise of our busy world and all its man-made devices. The wavelengths in the wild invite us to reconnect with our own bodies, our friends, and for some, our Creator.

When we learn to slow down and listen, we begin to hear an enchanted world that we often take for granted and sometimes ignore completely. Crickets chirping and frogs croaking on a starry night. Wind whispering through tall pines. Waves crashing on a rocky shore, and pebbles making that weird bubbling sound when the water recedes. Waterfalls rushing and roaring over mossy rocks. Birdsong filling the air. All of it—and so much more—constantly underscores Creation with a symphony of sound. And it reconnects us to the untouched purity of the wild life that fills the Earth.

Nature's soundscape invites us into a peaceful calm. It doesn't need us to *do;* it allows us to simply *be*. It doesn't require anything from us other than to lean in and receive. It gives our souls rest from all the annoying alerts and audible assaults that violate our peace on a daily basis. The song of nature is the universal and unending soundtrack that has been playing long before us and will certainly continue to resound long after humankind has finished its last song. Let's lean in and listen.

NATURE'S NOISE

The Earth has its music for those who will listen.

~REGINALD VINCENT HOLMES, "THE MAGIC OF SOUND"

OREGON COAST

Creation's song is a well-mixed orchestration of treble and bass notes that can be a healing balm for our ears. Even when the world feels out of tune, Earth's eternal symphony is always playing in the right key. And its frequencies are vibrating all around us. The wavelengths of the wild come in a wide spectrum of sonic hues: green, white, pink, and brown.

The ambient sounds of nature are often referred to as "green noise." Green noise lives at the center of the sound spectrum, since it contains a balance of vibrations, though lower frequencies tend to be dominant in a soothing way. It's simply what you hear when you get out of the city and go on a nature walk. By default, it tends to be the most organic and purest of all, but that also means it's often the least accessible. This is why many folks use sound machines to bring a sense of the outdoors into their homes.

The most common type of sound is white noise. White noise contains a mix of low-, mid-, and high-end frequencies. The static of an unused radio frequency, an analog TV with no broadcast, the hum of a box fan or AC unit, and the sound of a waterfall: All of these are examples of white noise. If you hope to drown out unwanted sounds or distractions, white noise might be your solution.

Pink noise has a louder low-end frequency that's lightly accented by higher vibrations. Examples include soft to medium rainfall, wind blowing through trees, rustling leaves, and ocean waves gently washing up onto sand. These lullabies of the land tend to slow down our brainwaves and rock us fast to sleep. If you struggle with sleep or insomnia, play a little pink noise.

Go down even lower in frequency and you will find brown noise, the bass guitar in the band. This kind of noise can be heard in the surge of a strong surf, a powerful waterfall pounding on rocks, or the roar of a thunderstorm with the occasional crack of lightning. These are like nature's subwoofers that hit us more deeply. Brown noise is often good for those needing a boost in focus and concentration. Have a big project at work or assignment at school? Anxious from a high-stress situation? Drop some brown noise beats into your sleep soundtrack.

Researchers from the National Trust in the UK discovered that spending just one minute listening to the sounds of a woodland realm caused people to feel more relaxed and less anxious by an average of 25 percent![1] And according to the National Academy of Sciences (NAS), Earth's soundtrack can significantly reduce stress hormones and positively affect our mood.[2] The NAS also studied the beneficial differences between types of sounds in nature. "Water sounds, such as that of a gurgling brook or a steady waterfall, tended to be the most effective at improving positive affect (the psychological term for a more positive outlook or disposition and the experience of joy and interest), while bird sounds were best for lowering stress."[3] Dr. Rachel Buxton, the lead author on the study, went on to add, "Humans are hardwired to attend to signals of danger and security . . . and an environment that is filled with natural sounds feels safe and allows us to let our guard down." Due to this amazing and restorative effect that nature's noise has on our overall health and mental well-being, no wonder so many of us are drawn to natural soundscapes.

1 "A Guide to Forest Bathing," National Trust, nationaltrust.org.uk/discover/nature/trees-plants/a-beginners-guide-to-forest-bathing.

2 Rachel T. Buxton et al., "A Synthesis of Health Benefits of Natural Sounds and Their Distribution in National Parks," *National Academy of Sciences 118*, no. 14 (March 2021): pnas.org/doi/10.1073/pnas.2013097118.

3 Elizabeth Millard, "Why the Sounds of Nature Are So Good for Health and Well-Being," *Everyday Health*, April 9, 2021, everydayhealth .com/self-care/why-the-sounds-of-nature-are-so-good-for-health-and-wellbeing.

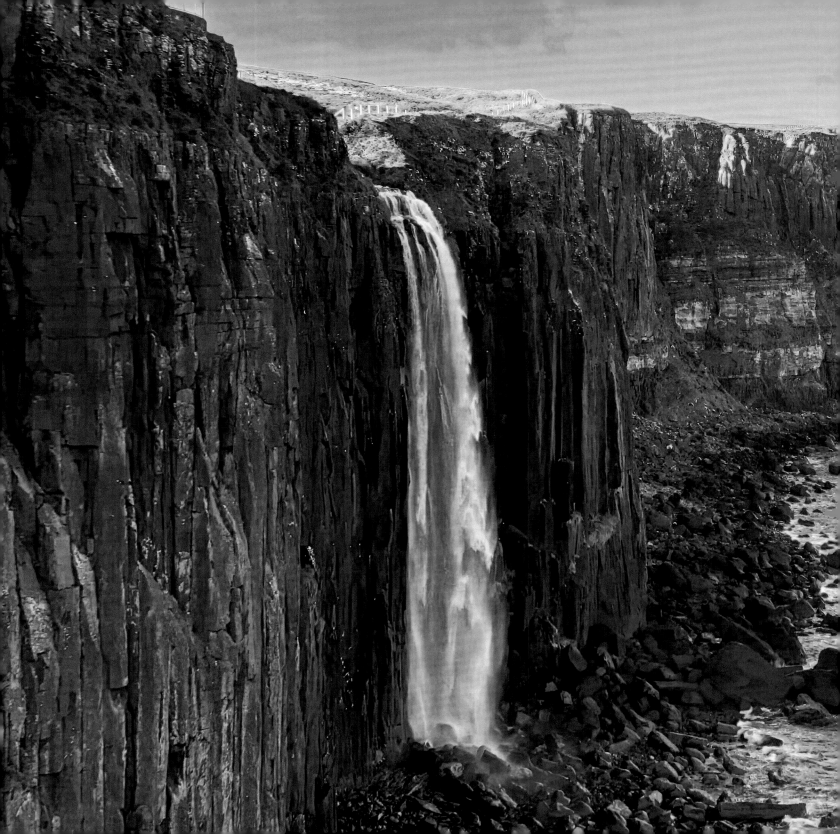

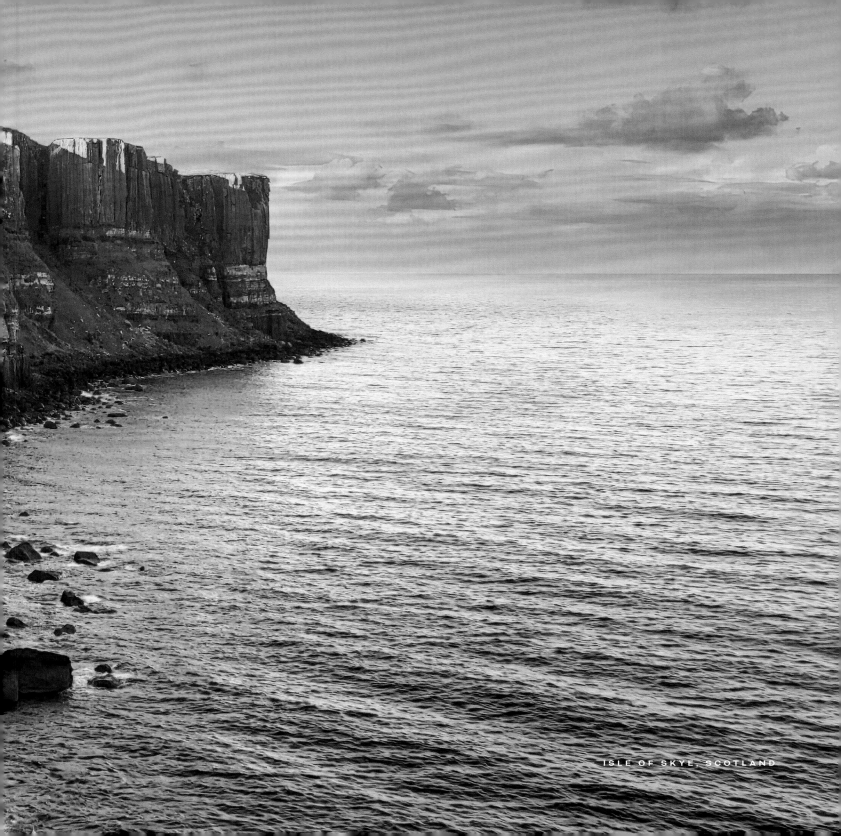

ISLE OF SKYE, SCOTLAND

DOCUMENTING PLANET EARTH

This grand show is eternal. It is always sunrise somewhere; the dew is never all dried at once; a shower is forever falling; vapor is ever rising. Eternal sunrise, eternal sunset, eternal dawn and gloaming, on sea and continents and islands, each in its turn, as the round Earth rolls.

~JOHN MUIR

WASHINGTON COAST

Nature documentaries seem to be experiencing a major surge in popularity. New ones seem to pop up weekly on every single streaming platform. And I think the sudden abundance and variety of these programs is a really good indication that our society, by and large, is longing for inspiring and accessible ways to reconnect with the great outdoors. Thanks to brave and adventurous filmmakers, the beauty of the wildest places on Earth can be brought right into our living rooms for all to enjoy.

GRAY WHALE OFF THE OREGON COAST

The earliest prototypes of the nature documentary began to emerge around the turn of the twentieth century, just as photography was entering the scene. Wildlife photography was becoming more common, and soon local nickelodeons and cinemas began to screen slideshows and stop-motion movies of animals. Sadly, most of these films were associated with hunting, trophy kills, and other forms of violent sensationalism. But violence and cruelty weren't the only narratives, nor did they continue to dominate screens as the years progressed.

In 1922, the silent film *Nanook of the North* entered theaters and showed a documentation of life and love in the Arctic. This film by Robert Flaherty was the first of its kind and has been cited as the first full-length nature documentary ever produced, thereby paving the way for future films.[1] After World War II, newer and more compassionate forms of documenting nature and wildlife began to emerge, following Flaherty's lead. One of the leading producers of this new wave was none other than the original Imagineer himself, Walt Disney. Starting in 1948, his nature documentary series *True-Life Adventures* aired and won several Oscars.[2] Shortly after, the BBC aired *Zoo Quest,* featuring a young naturalist named David Attenborough,[3] who would become the hallmark voice of planet Earth.

Fast-forward to the early twenty-first century, when audiences witnessed the birth of a new generation of Earth-friendly films, such as BBC's *Planet Earth*[4] and countless other offerings from organizations like National Geographic. And while cinematic techniques and technology (including drones!) have changed the game in many ways, there is another aspect of these films that changed and heightened the way we experience nature.

Soundtracks.

1 See Stacie Seifrit-Griffin, "From the National Film Registry: 'Nanook of the North' Released 100 Years Ago," *Now See Hear!* (blog), Library of Congress, June 15, 2022, blogs.loc.gov/now-see-hear/2022/06/from-the-national-film-registry-nanook-of-the -north-released-100-years-ago.

2 Jim Korkis, "Walt and the True-Life Adventures," *The Walt Disney Family Museum Blog* (blog), February 9, 2012, waltdisney.org/blog/ walt-and-true-life-adventures.

3 "Zoo Quest—First On-Screen Appearance by David Attenborough: 21 December 1954," *History of the BBC*, bbc.com/history ofthebbc/anniversaries/december/zoo-quest.

4 Helen Scott, dir., Jo Shinner, prod., *Planet Earth: A Celebration*, BBC, bbc.co.uk/programmes/b006mywy.

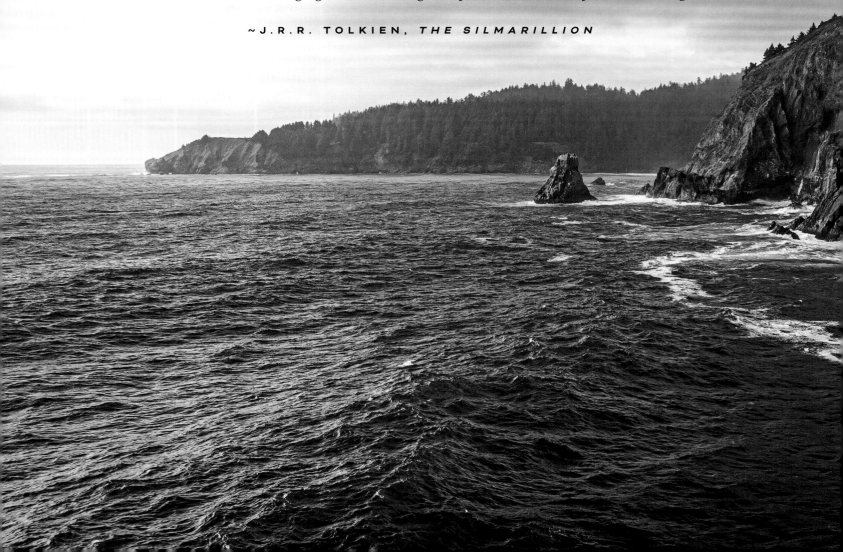

CINEMATIC SOUNDTRACKS

And it came to pass that Ilúvatar called together all the Ainur and declared to them a mighty theme, unfolding to them things greater and more wonderful than he had yet revealed; and the glory of its beginning and the splendour of its end amazed the Ainur, so that they bowed before Ilúvatar and were silent. Then the voices of the Ainur, like unto harps and lutes, and pipes and trumpets, and viols and organs, and like unto countless choirs singing with words, began to fashion the theme of Ilúvatar to a great music.

~J.R.R. TOLKIEN, *THE SILMARILLION*

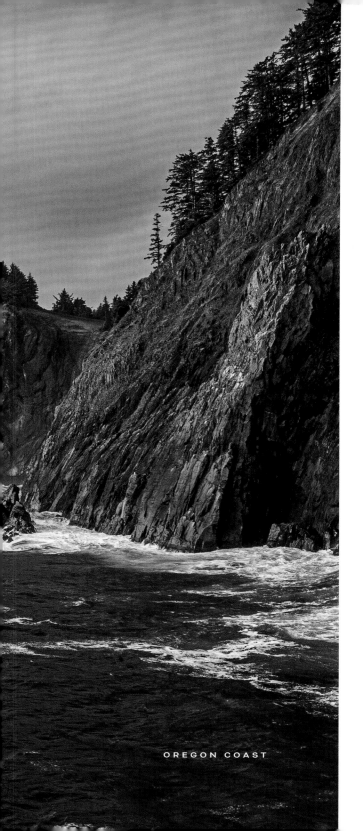

OREGON COAST

When I was growing up, my home was constantly filled with music. My dad loved to play improvisational tunes on the piano, and my mom would often play the flute in church as well as sing in the choir. My sisters and I took piano lessons and were the best of the band nerds in high school, two of us even becoming the drum major for the marching band. If that wasn't enough, we were all involved with the music at our church.

As I experienced in my childhood, I've learned that music has a powerful way of making a moment memorable. Melodies rise to stir our souls and awaken our imaginations. Which is why I think all movies, especially the most adventurous ones, have epic soundtracks to accompany their stories.

Sweeping symphonic scores are a hallmark of nature documentaries as well. In fact, nature documentary soundtracks have become their own subgenre in the music industry. So I guess it's no surprise that these soundtracks have become one of my favorite kinds of music to listen to, especially when on a road trip, hiking a trail, or flying my drone. Though I often enjoy the quiet stillness of nature's green noise, there are definitely occasions when I love to put on my AirPods and experience Creation in a cinematic way. (I highly encourage earbuds and not speakers, which can be quite annoying and disrespectful to others on the trail.)

Soundtracks are the emotion and heartbeat of any story. Larger-than-life anthems accompanied by epic aerials and jaw-dropping scenery usher us into a world of natural wonder and give us a sense of magical awe like a kid might experience when walking into Disney World for the first time. Curious melodies and instrumentation tend to underscore the revelation of scientific facts. Quirky tunes are the music bed for nature's most whimsical and funniest moments. And foreboding variations on similar themes played in a minor key give the audience an unspoken hint that not all is right with our world.

I remember the first time I heard the main suite from *Planet Earth II*, composed by Hans Zimmer, Jasha Klebe, and Jacob Shea. I was on the coast of Northern Ireland on one of my first trips dedicated to filming landscapes. Between watching the first episode of the show with some friends and hearing the incredible soundtrack, my blood began pumping and my wheels started turning. Three minutes into the "suite," the music crescendoed into this majestic motif that sent chills all over my body. The following day, I downloaded the soundtrack and went for a run on a trail that hugged the jagged coastline. Hearing that music while running near the edge of the sea was euphoric! If you're like me, integrating music into our experiences with nature can add a new and deeper dimension.

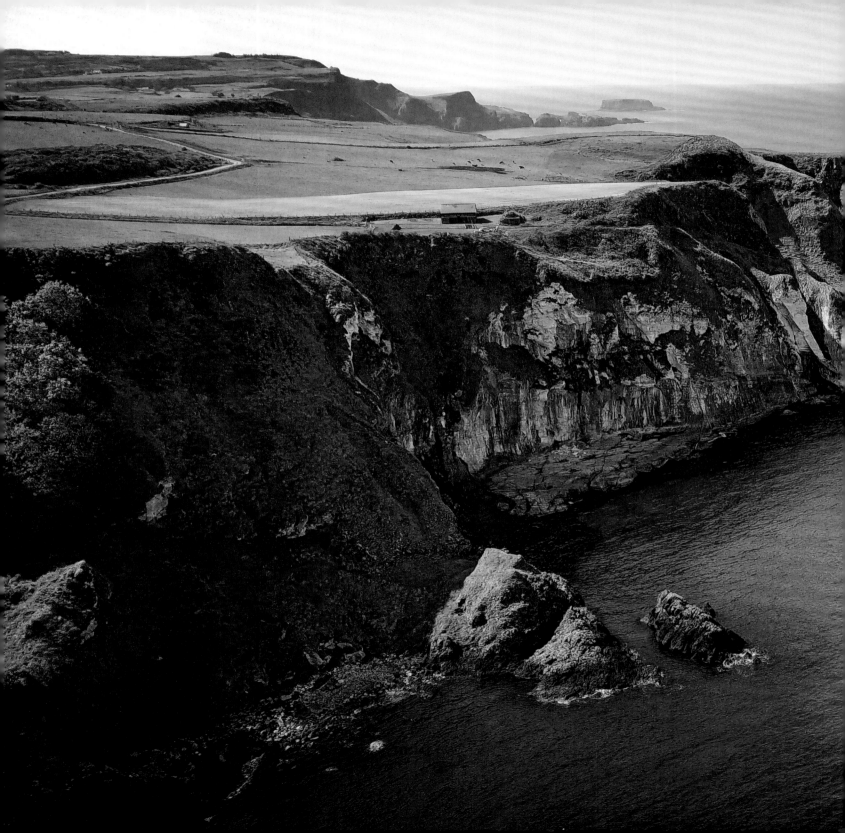

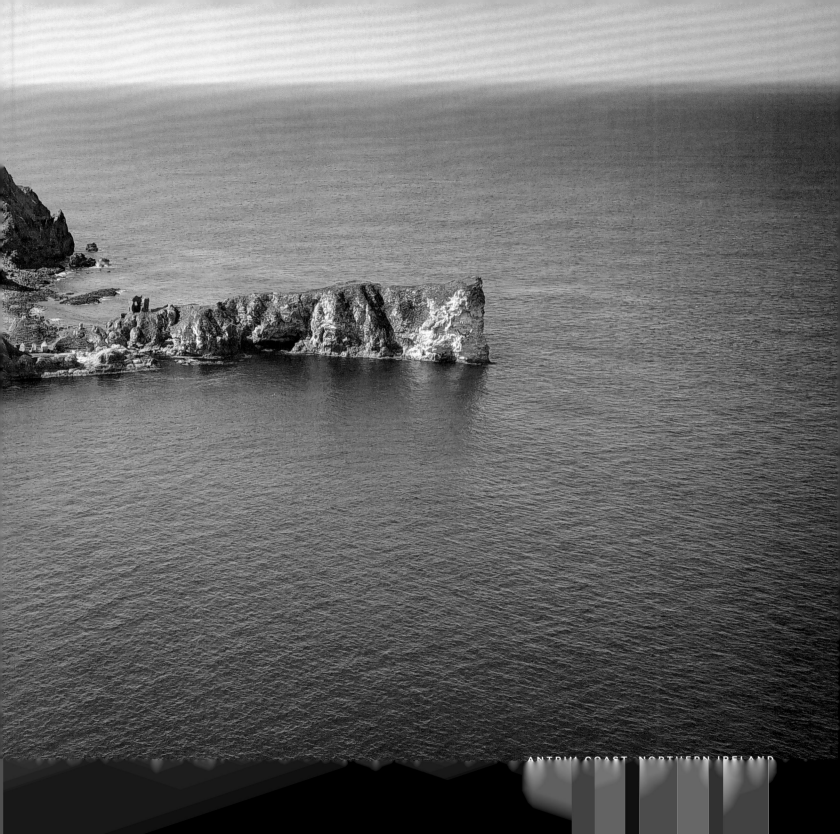

ANTRIM COAST, NORTHERN IRELAND

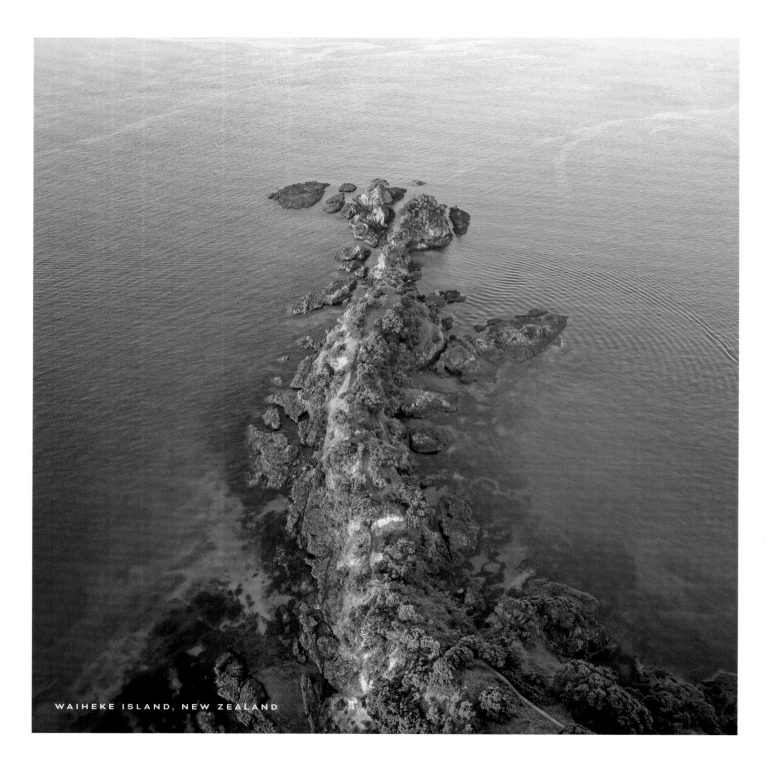

WAIHEKE ISLAND, NEW ZEALAND

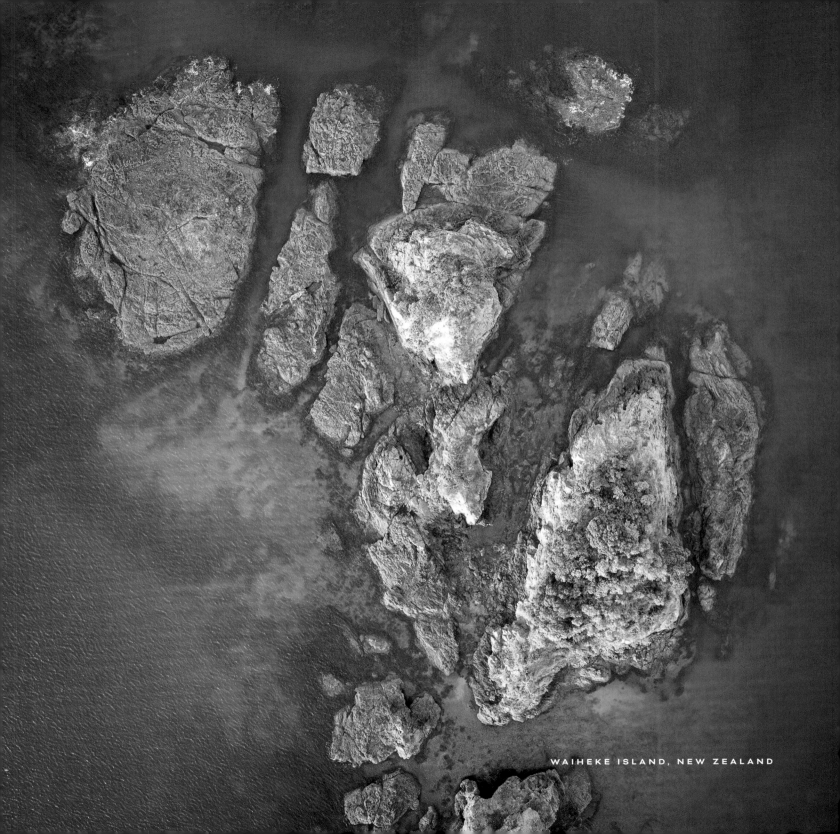

WAIHEKE ISLAND, NEW ZEALAND

SCORING THE SCENE

When the surf was high, the sounds of the sea was one continuous roar, heavy, deep, dark, sombre, with all kinds of variation, and at its height you felt it also came from the very Earth beneath your feet. Composers would have called this the opera of the sea, poets would have called it the expression of the bleeding dawn sky, and priests the voice of God in nature.

~ ÞÓRBERGUR ÞÓRÐARSON

When I am out in the wild or reviewing footage from my drone, I love visualizing music for the landscape. In fact, you could say much of my career has been fueled by the relationship between visuals and music and the fantastical fusion of image and song. While much of this has been influenced by my favorite movies, like *The Lord of the Rings* trilogy, I can't help but imagine the perfect instrument or orchestration for scenes in the real world as well.

For example, French horns do well when the camera is soaring toward a mountain. A string-heavy symphony is perfect for flying above a forest. The voice of a soprano rising as a shaft of sunlight breaks through dark storm clouds. An ominous theme as fog fills the air around a jagged mountain peak. Staccato notes high on a piano scale pitter-pattering as light raindrops do the same on a pond. A cellist gliding her bow over strings as the current of a river swirls into ocean waves in an estuary. (As a reminder, I've curated playlists for every suite in this book, which you can find at proktr.com/wildwonder.)

Following the idea of "seeing" a soundtrack for nature, I would love for us to take a deeper dive into the sonic landscapes that underscore the scenery of Earth. To do so, I would like to invite a few friends of mine, who also happen to be composers, to give us a glimpse into their world of music as it relates to nature. Each of the featured artists has added a rich depth to my personal understanding and enjoyment of both music and the land. Not only have their compositions moved me, but the words they've used to describe their craft have been incredibly illuminating.

The first composer I'd like to introduce you to is Joel Pike from the United Kingdom, who composes eco-acoustic music under the moniker Tiny Leaves.

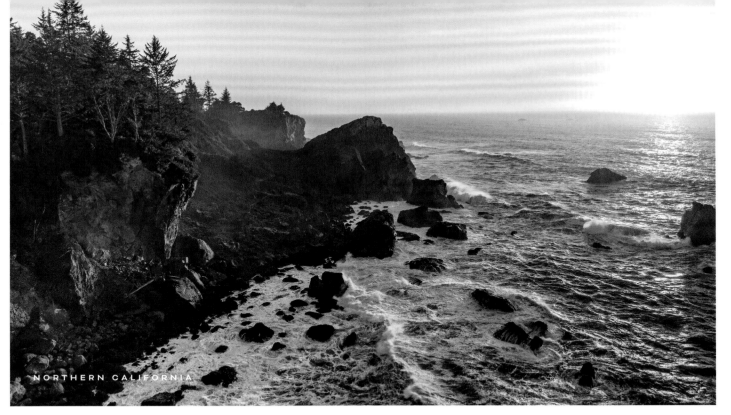

NORTHERN CALIFORNIA

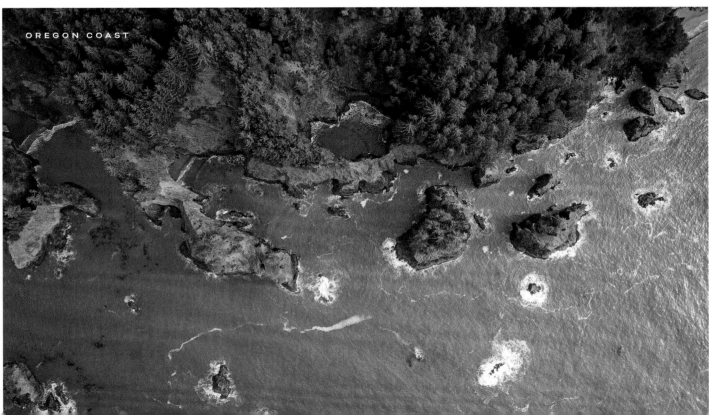

OREGON COAST

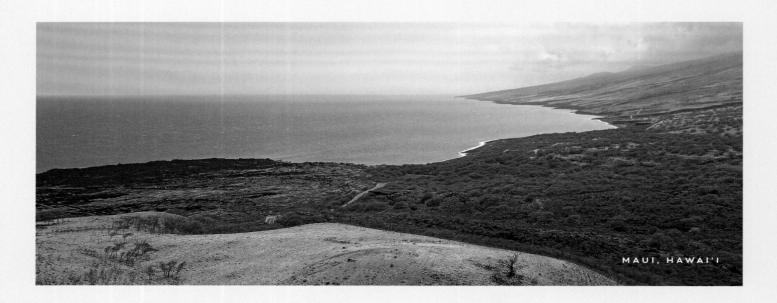

MAUI, HAWAI'I

LISTENING TO THE LANDSCAPE

BY JOEL PIKE OF TINY LEAVES

A few years ago, I relocated back to my homeland in Shropshire. I didn't realize until I returned how much I'd missed the sense of belonging to this landscape and its familiar ridgelines. I had an urge to explore this feeling in my music and to spend time in the lush green hills and valleys.

When the roads fell silent during the Covid lockdowns, the sounds of nature felt suddenly amplified. This inspired me to listen more closely and to record sounds which I then fed into my pieces. When I am out in the wild, there is the feeling of tapping into something beyond myself; like an unfolding mystery, it heightens the senses and centers me at the same time.

I'm interested in fusing the feeling of a place with the actual sounds I find there in my music. I often take my microphone on walks and listen through headphones to hear the birdsong, wind, water, and other sounds of nature up close. I've recently started experimenting with a biodata kit on location, which samples the conductivity in leaves and, when attached to a MIDI synth, produces musical notes from the leaves. This is something I have explored in my latest album, *Mynd,* along with field recording and composing in the landscape.

I also like to create music solely in response to how a particular place might feel, such as awe at a certain view, or intrigue into natural forms. It might also be a lament, as with my track "Runner, Messenger," which tells the story of the Eurasian curlew that are struggling to survive in Shropshire due to several factors, including predation and loss of habitat. I'm a visual person, so scenery and maps provide further inspiration to my music creation, which I have explored in graphic scores made from geological diagrams of the landscape.

I'm interested in the way that music and art can amplify the mystery and beauty of our natural habitats and how vital they are as a way to advocate for the natural world. There's something about coming face-to-face with our humanity when immersed in nature. This symbiosis feels like breathing to me. The beauty and fragility of our remarkable natural world are my inspiration and my song.

TIME TO FLY!

A MOMENT TO REFLECT

Take a few minutes to listen to the natural world. What types of nature sounds are you drawn to the most? A waterfall? Gentle rain? A storm? A big surf breaking near a beach? If you're not sure, spend some time listening to various noises and see what your ears gravitate toward the most. (Nature sounds are available on all major streaming platforms. If you are able, go outside or get away from the city to listen to the real thing!)

Everyone who sleeps to a soundscape resonates with a certain frequency. Which frequency do you resonate with the most? Start with white noise, then work your way down the spectrum to pink and brown, focusing on what brings you the most calm and peaceful rest. It may take more than one night's sleep with each to notice a difference. If this practice doesn't help you sleep, then skip the extra sounds and enjoy a silent night.

Spend some time listening to the soundtrack from a favorite movie. And if you're able, take that soundtrack on your next hike or walk through a park. What emotion does the composer evoke in you? Do you see a correlation between the music and the land?

Listen to *Mynd* by Tiny Leaves. Think about Joel's creative approach to listening to the land. What are the natural sounds of your own homeland?

If you're interested in learning more about this practice, look up percussionist and composer Susie Ibarra, who created an online course called Drum Labs to study the rhythms of nature, including birdsong, oceans, deserts, forests, and the resonance in canyons. She also dives into technical recording aspects, such as field recording, spatial mapping, transcriptions, and more!

WE LIVE IN A STATE OF
FORGETFULNESS. WE ARE
ONTOLOGICAL AMNESIACS,
AND WHAT WE HAVE
FORGOTTEN IS THE WONDER
OF BEING.

SOMETIMES BEING BREAKS IN
ON US: A STUNNING SUNSET,
AN EAGLE IN THE SKY OR
A SNAKE UPON A ROCK, A
SOUL-STRETCHING MOVEMENT
OF BEETHOVEN'S QUARTET,
AND AT THOSE MOMENTS OF
GLORY, BEING BREAKS INTO
OUR BLACK-AND-WHITE LIVES
IN BRIGHT COLOURS.

~Peter J. Leithart, Shining Glory

OREGON COAST

40

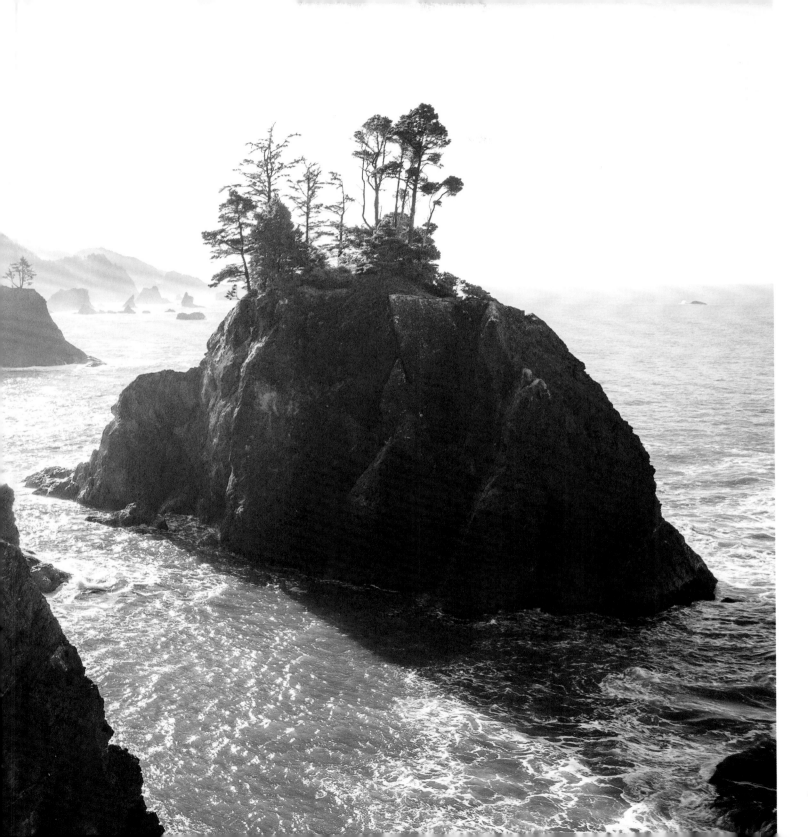

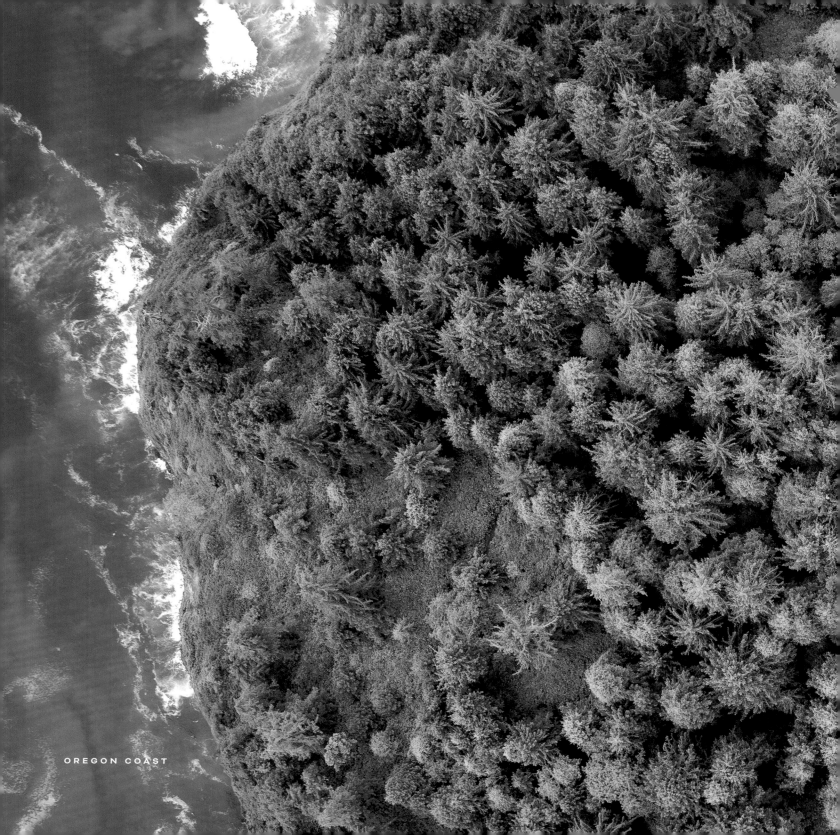

OREGON COAST

GIFFORD PINCHOT NATIONAL FOREST, WASHINGTON

SUITE NO. 2

FORESTS

THE CATHEDRALS OF CREATION

TEMPLES OF TIMBER

You spoke to me through her. You spoke to me from the sky . . . the trees. Before I knew I loved you, believed in you. When did you first touch my heart?

~THE TREE OF LIFE

PORTLAND, OREGON

Growing up in Arkansas, I was always surrounded by an abundance of trees. Between makeshift treehouses, rope swings, and the small cabin my family owned outside of town, most of my childhood was spent around oaks, hickories, maples, and pines.

As an adult, I've become a projectionist who curates visually immersive experiences, and one of the main visual themes I've been drawn to is the forest. Being the "man behind the curtain" is incredibly fun. Feeling the energy of the room shift as I change the seasons and hearing the gasps of little children as I layer in softly falling snow is pure magic. Sometimes after an event, people will find me to share how calming the augmented forest was and how, at times, they momentarily stopped paying attention to the program onstage and daydreamed of being in a real forest—whether sitting on a rock or lying in a hammock between two redwoods.

I love bringing the forest to audiences in a unique way. There's nothing quite like transforming a blank and barren venue into a woodland realm using projectors. (Think virtual reality but without the goggles.) And this fascination with projecting trees began to reveal a deeper desire. I was longing for a life in the forest.

So in 2018, I left Nashville, my city of old dreams, and moved out to the Pacific Northwest. My new dream was to find a piece of property filled with evergreens. In the summer of 2022, that dream became a reality when I moved into a newly built cabin surrounded by tall Douglas firs and complete with a covered deck where I spend most of my time (weather permitting). I remember one of the first times sitting on the deck under the forest canopy with my neighbor, Jerry. I had been mulling over what to call this part of the house. The porch? The deck? But it was Jerry who came up with the perfect name.

The Cathedral.

Sacred spaces are one of my love languages. I just love the idea of a place set apart for prayer and contemplation. Many sanctuaries and temples are designed to lift our gaze upward and pull our soul toward Heaven. The ancient architecture transports us to a distant time and speaks of deeper truths beyond our understanding. Cathedrals also have a consistent track record of slowing my pace and quieting my thoughts, while at the same time illuminating my eyes with splendor and filling my imagination with wonder.

Walking among trees often has the same effect on me, which is why evergreen forests have often reminded me of cathedrals. I see

OREGON COAST

parallels in the structures and shapes, as if the forest were the original inspiration for the hallowed halls of old. Flying over a forest of firs with my drone results in one of my all-time favorite scenes: an endless sea of steeples and spires pointing toward the heavens. Eagles perch on high branches and keep watch over their domain like angels heralding the glory and splendor of God. And the occasional hemlock, with its leaning top, breaks the pointed pattern, reminding me that beauty isn't always expressed in perfect symmetry.

From the ground, these great halls of moss and limb tower high above the forest floor like ancient stone columns. Their green canopies, like the vaulted ceiling of a Gothic nave, pull my spirit upward. The fragrance of juniper, pine, and cedar accents the air like incense blessing the altar. And birdsong fills the realm like a choir singing a hymn. Perhaps all of Creation—with its majestic mountains and awesome waterfalls and towering pines—is God's original cathedral.

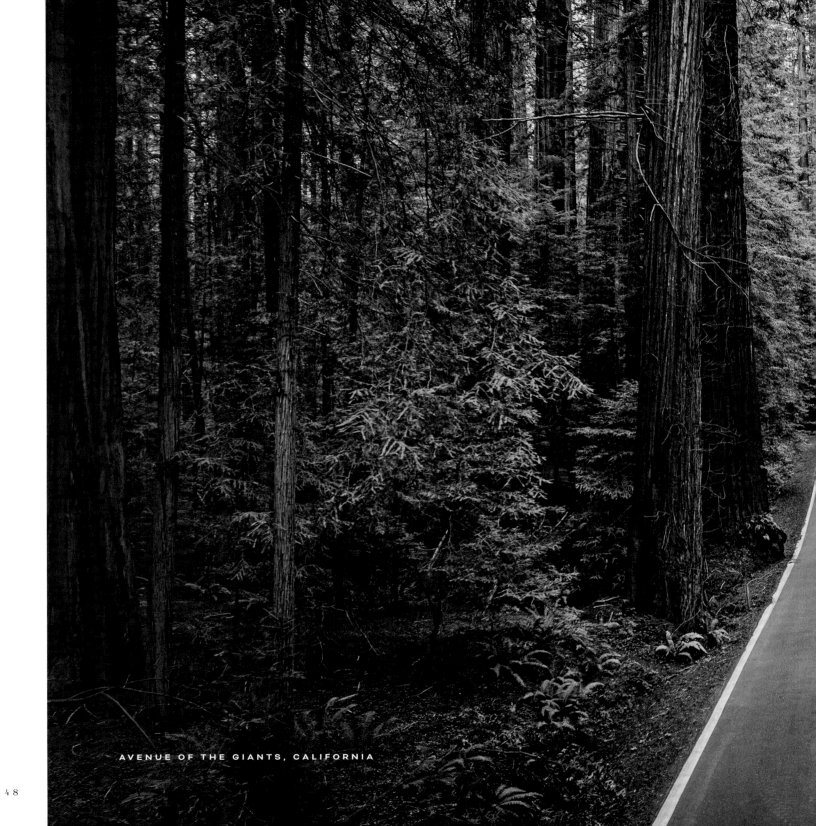

AVENUE OF THE GIANTS, CALIFORNIA

WHEN YOUR TONGUE IS SILENT, YOU CAN REST IN THE SILENCE OF THE FOREST. WHEN YOUR IMAGINATION IS SILENT, THE FOREST SPEAKS TO YOU. IT TELLS YOU OF ITS UNREALITY AND OF THE REALITY OF GOD. BUT WHEN YOUR MIND IS SILENT, THEN THE FOREST SUDDENLY BECOMES MAGNIFICENTLY REAL AND BLAZES TRANSPARENTLY WITH THE REALITY OF GOD.

~*Thomas Merton*, The Sign of Jonas

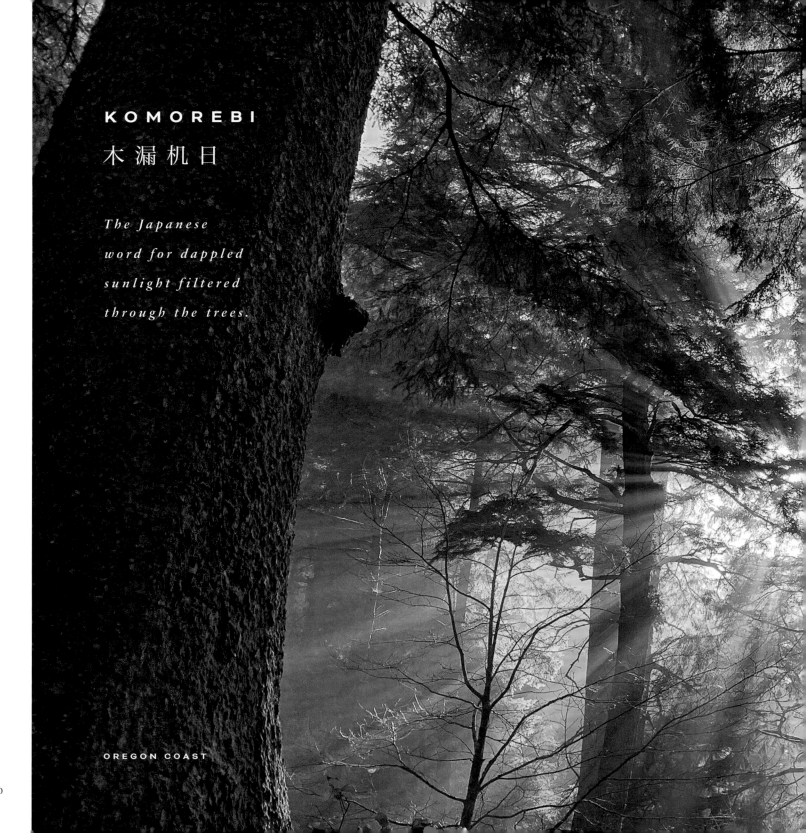

KOMOREBI

木漏机日

The Japanese
word for dappled
sunlight filtered
through the trees.

OREGON COAST

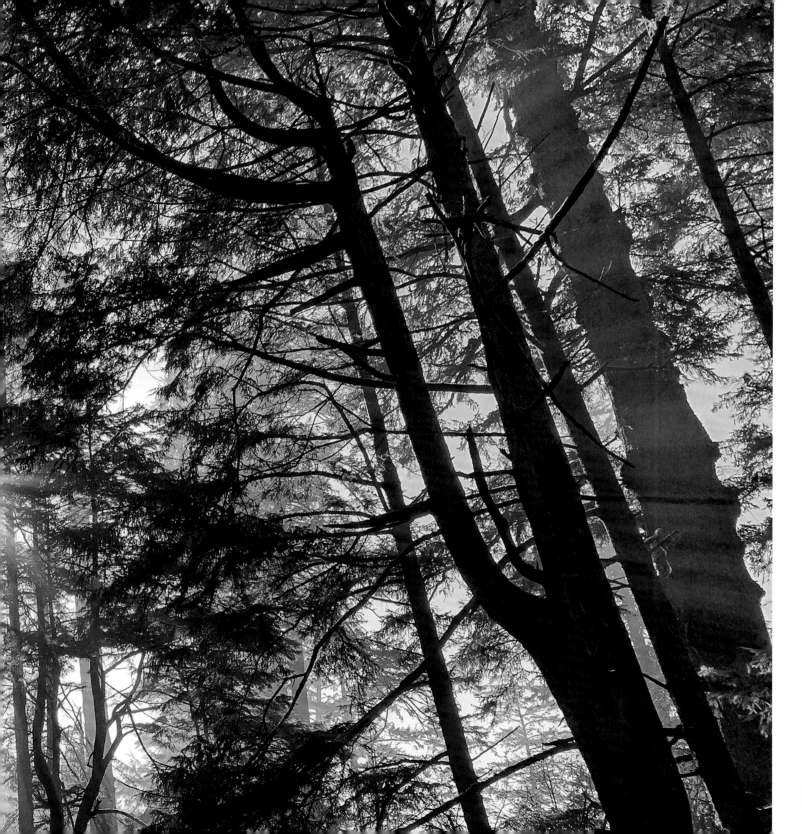

NURSE LOGS

For the growing good of the world is partly dependent on unhistoric acts; and that things are not so ill with you and me as they might have been, is half owing to the number who lived faithfully a hidden life, and rest in unvisited tombs.

~GEORGE ELIOT,
MIDDLEMARCH

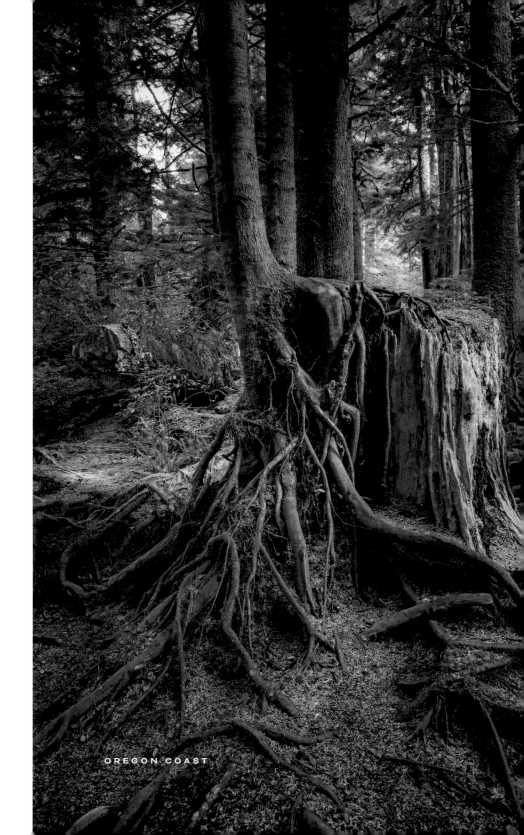

OREGON COAST

If you've ever been inside an old cathedral, especially one in Europe, you might've noticed how many people are buried there. Cathedrals have often doubled as tombs for famous monarchs, artists, scientists, and other historical figures. Walking alongside the tombs of these greats offers a vivid reminder of all those who have gone before us. And visiting them reminds me that we are all standing on the shoulders of giants, including those with grand legacies and ornate marble sarcophagi, as well as those who've been forgotten and lie in unmarked graves.

Just as the cathedrals of old give us a chance to walk among ghosts, ancient forests allow us to do the same. This is because the decay of death and the resurrection of new life can be found dancing together on the oldest of forest floors. "Old growth" is the term used to describe virgin vegetation and well-aged areas that have gone untouched by human hands. In these primeval ecosystems, you might notice something seemingly odd: trees growing out of trees.

When an old tree finally falls, its rotting corpse and the stump that remains become a nursery for new life. As the tree decays, it creates the perfect conditions for seedlings to grow and multiply. Though dead, it retains incredible amounts of moisture and nutrition. Fewer pathogens surround these areas, too, which allows for healthier growing environments.

The Oregon Coast is one of my favorite places to find this slow miracle unfolding. The Old Growth Trail in Oswald West State Park contains an abundance of fallen giants. Because the trail needs to be maintained, some of the decaying trees have been cut down, leaving giant stumps the size of a Brachiosaurus leg. But rising from the mossy decay are tree saplings, some small and some quite large. You can often see intricate root systems crawling down the large stump toward the ground, reaching for life. It's a wild sight to behold.

These "ghosts upon the Earth" are called "nurse logs," and they've become one of my favorite teachers. They've shown me a visible representation of new life coming out of death. Of the old giving way to the new. Of small wonders emerging and standing on the shoulders of fallen giants. There is much wisdom to glean from these silent elders who, even in death, are bearing witness to new creation.

Nurse logs also remind me of what's happening in our world today. It seems there are so many cultural constructs falling and institutions failing. The old ways are being tossed out, and new pathways of doing life are being explored. From politics to religion to corporate environments, it seems no one is immune from the changing times. And the slogan of the day seems to be this: *Adapt or die.*

But nurse logs teach us that simply throwing out the old may not be the best course of action for new life.[1] Even while we strive toward the new, we can still include and honor those who have walked ahead of us. Tradition and progress make strange bedfellows, but I have found that a healthy, creative future is often informed and inspired by the wisdom of the past. As Richard Rohr puts it, "transcend and include."[2]

So even though they might appear to be well beyond any form of purpose or usefulness, nurse logs offer a picture of healthy, natural death at work. Through them, we get to witness redemption and transformation unfolding in super slow motion. And through them, we also must face the sobering reality that eventually, we all have to let go. Death is inevitable. But nurse logs teach us that *this is not the end.* There is hope and new life on the horizon.

1 There are, of course, exceptions to this statement, such as toxicity in the Earth's soil. If there's toxins, disease, or pollution in the water table, it will eventually infect any life drinking from it. So the cause of that toxicity needs to be illuminated and dealt with. The same goes for toxicity and abuse within traditions, organizations, and cultural systems that govern society. All these roads of injustice eventually lead to a premature death. But that's another conversation for another time.

2 "Transcend and Include," Center for Action and Contemplation, cac.org/daily-meditations/transcend-and-include-2016-12-07/.

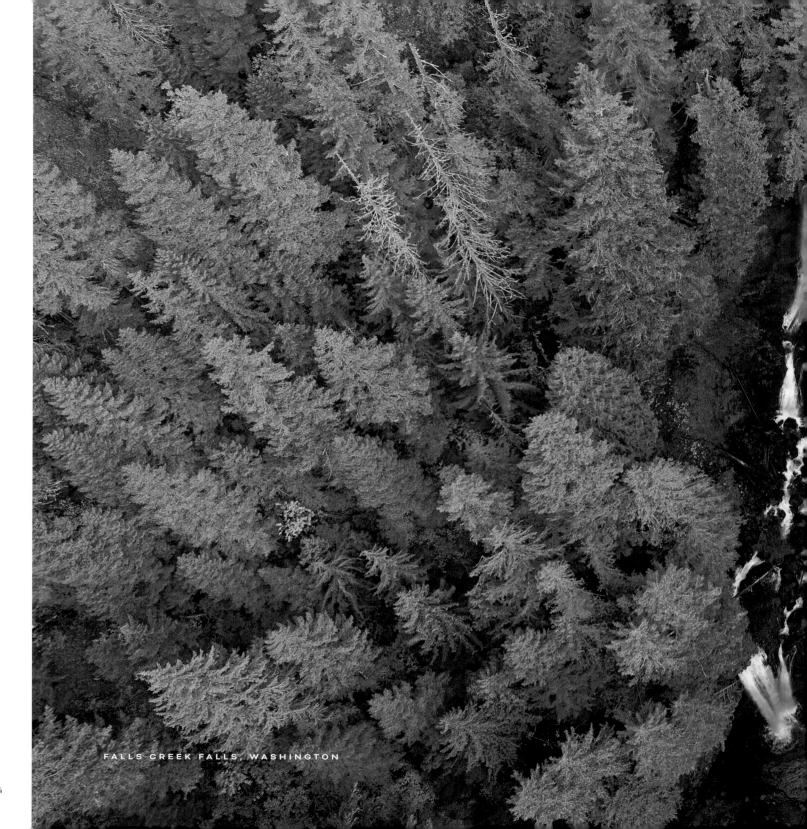

FALLS CREEK FALLS, WASHINGTON

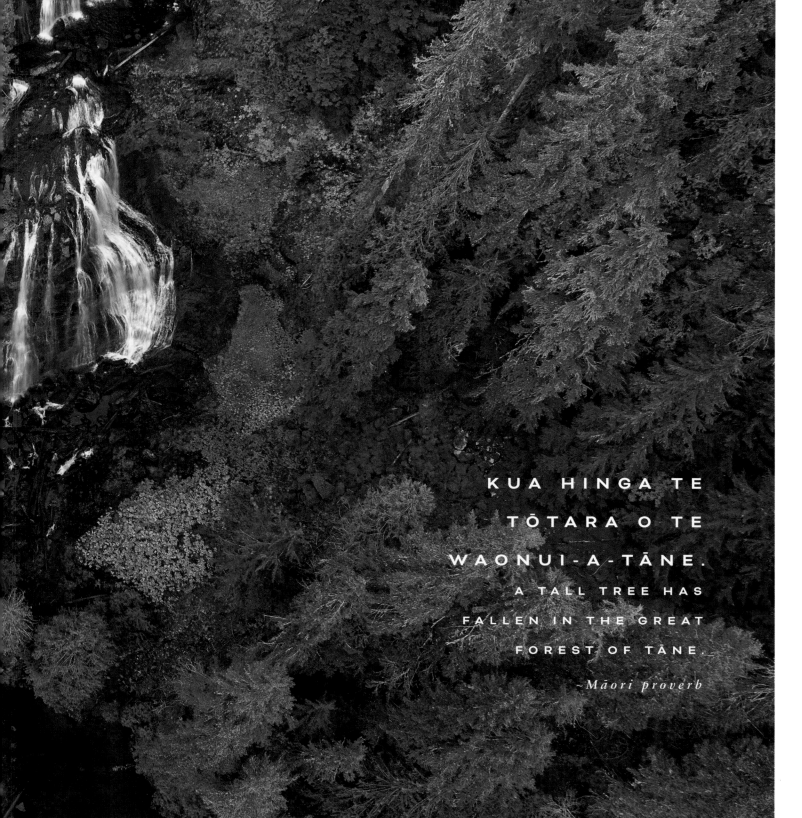

KUA HINGA TE
TŌTARA O TE
WAONUI-A-TĀNE.
A TALL TREE HAS
FALLEN IN THE GREAT
FOREST OF TĀNE.

~Māori proverb

AWAITING REDEMPTION

Death is just another path, one that we all must take. The grey rain-curtain of this world rolls back, and all turns to silver glass, and then you see it. . . . White shores, and beyond, a far green country under a swift sunrise.

*~THE LORD OF THE RINGS:
THE RETURN OF THE KING*

EFFECTS OF THE EAGLE CREEK FIRE IN THE COLUMBIA RIVER GORGE, OREGON

In 2020, the entire world experienced death in many terrible ways. One was the death of our former way of living and working. When everything came to a screeching halt, most of us were left disoriented as we frantically dealt with the confusion and chaos of the moment. My friend Chad Jarnagin, a priest in Nashville, offered two simple questions to ponder during this trial:

What's the invitation?

What does this make possible?

In other words, when life deals you a bad hand, what is the invitation? When everything you've hoped for starts to fall apart, what other and maybe different things become possible?

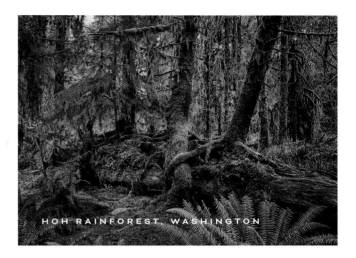

HOH RAINFOREST, WASHINGTON

Having suffered through many instances of loss in my own life, I do not write the previous words lightly, and I hope you are able to receive them not as cliché or trite, but in the spirit in which they are intended. I'm not saying that choosing hope is easy or that we shouldn't grieve the losses in our lives. Creation itself groans with words that cannot be expressed every time a tree falls or a tornado causes devastation or an animal's life is unjustly taken. Because even Creation knows this is not how the world ought to be, and it longs for the day of renewal and redemption.

I experienced my own profound loss during the writing of this book. In March of 2023, my mother suffered a medical emergency, which was the culmination of decades of health issues. This crisis in her body ultimately took her life on the twenty-first of March, forever changing my world.

The metaphor of the nurse log became the image I clung to as I processed my mother's death and the legacy she left behind. In life, Irene Proctor was a nurse, and in death, she became like a nurse log. Her story will continue to bring life to those she leaves behind and even to those who will come after her. Generation after generation will be blessed because of her faithful, hidden life in Christ.

One of the last things I ever did with my mom was plant a redwood sapling, which came from California, the state of her birth. It was my last Christmas gift to her, and we planted it together the day before I flew back to Portland. As she placed the sapling in the dirt, she spoke a sweet and simple blessing. May her words also be spoken over the "saplings" emerging in your own life.

DEAR LITTLE TREE, THOUGH YOU ARE SMALL, SOMEDAY YOU'LL BE BIG AND MIGHTY.

~Irene Proctor

Whether or not you've lost a loved one yourself, you have undoubtedly experienced some kind of loss, disappointment, or challenge. Perhaps you've lost a job or find yourself in a situation that isn't quite working out. Maybe a relationship you've clung to is beginning to slip away. Maybe you're grieving the slow death of a dream you've invested a lot of time, money, and faith in. Whatever your unique situation, you are likely facing one of three common responses.

The first is to live in denial, ignore reality, and carry on with business as usual. This option leaves little room for discussion, much less healing and growth. The next is to give the failing situation a makeover, perhaps by adding a fresh coat of paint to an old idea. While this option involves some awareness of needed change, it also carries a significant amount of denial and only delays the inevitable. The third way is to let go and let death do its full work. When choosing this way, we embrace a sense of uncertainty and mystery, but we also welcome hope and healing into our lives and our world.

When we acknowledge a death and allow ourselves space to fully grieve, we receive the gift of new perspective, both because of what was lost and because of what might be reborn. Because our disappointments, pain, and tears are never in vain. Think of the countless skills you might have learned or experiences you might have had in past jobs. Ponder the mistakes you might have learned from and consider any new relationships you might have forged along the way. With every failure, we have an invitation to gain wisdom, humility, and understanding. Just as with nurse logs, what we carry with us into the future are the nutrients for new life.

Yes, I know this is a tough subject for a book on nature, but I also don't want to gloss over this important lesson we can learn from the forest. Death is inevitable—both for us and for Creation—but it also won't have the last word. And it's a gift to be invited into the New, even when it hurts. Eventually, there will come a time for our own tree to fall, and something new will grow out of the life and legacy we leave behind. Let's live in such a way that causes our death to nurture new life, rather than living a life that brings death to those around us. Though sacrifice can be costly and painful (and usually is), we can find hope in believing that resurrection is buried just beneath the surface and will one day rise from the ashes of the grave.

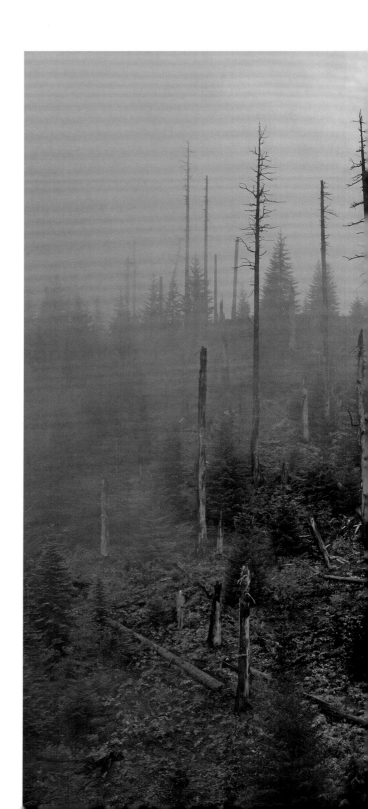

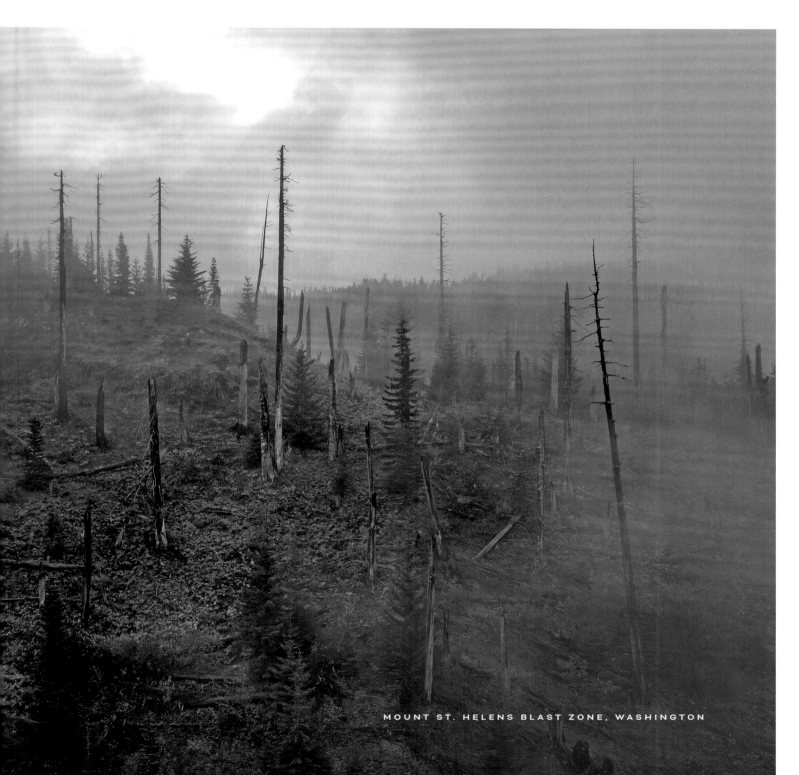

MOUNT ST. HELENS BLAST ZONE, WASHINGTON

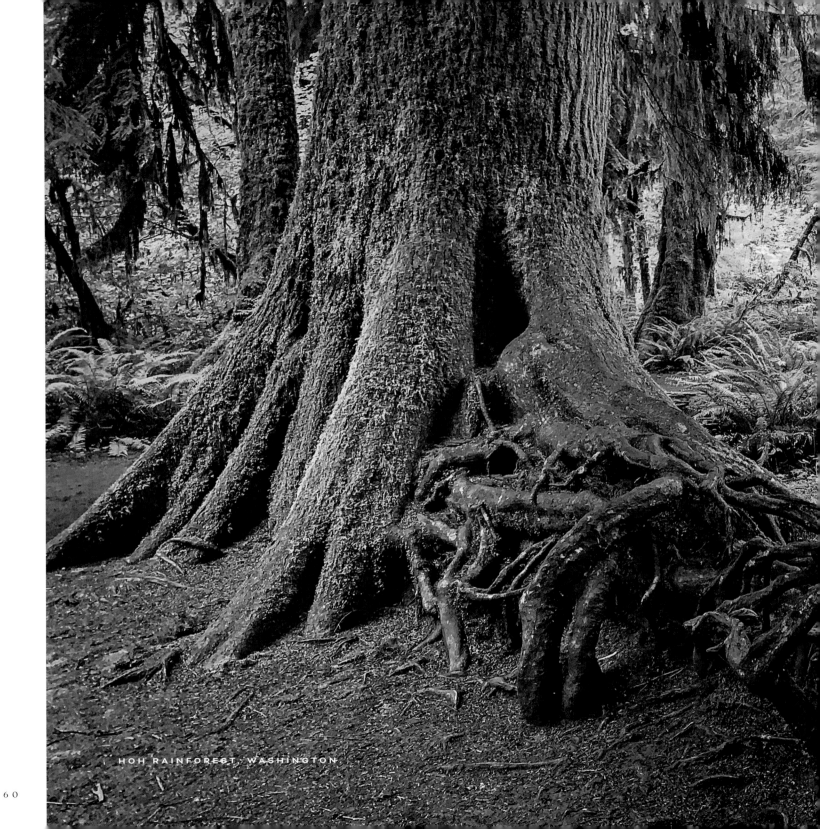

HOH RAINFOREST, WASHINGTON

FOR THOSE WHO GRIEVE IN ZION . . .
THEY WILL BE CALLED OAKS OF
RIGHTEOUSNESS, A PLANTING OF THE LORD
FOR THE DISPLAY OF HIS SPLENDOR.
THEY WILL REBUILD THE ANCIENT RUINS AND
RESTORE THE PLACES LONG DEVASTATED;
THEY WILL RENEW THE RUINED CITIES THAT
HAVE BEEN DEVASTATED FOR GENERATIONS.

~Isaiah 61:3–4

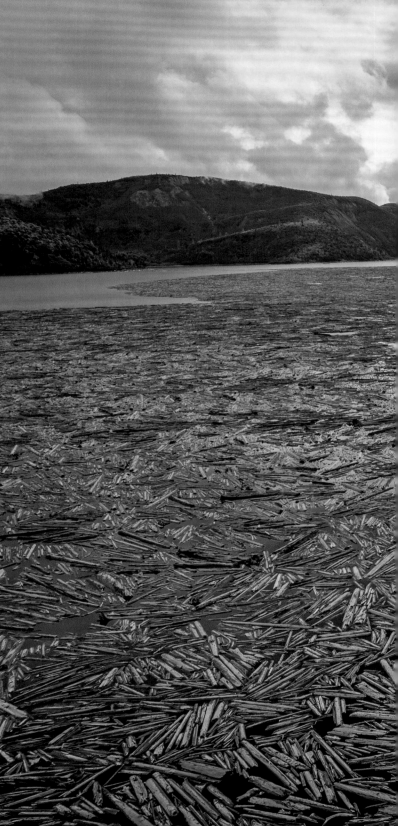

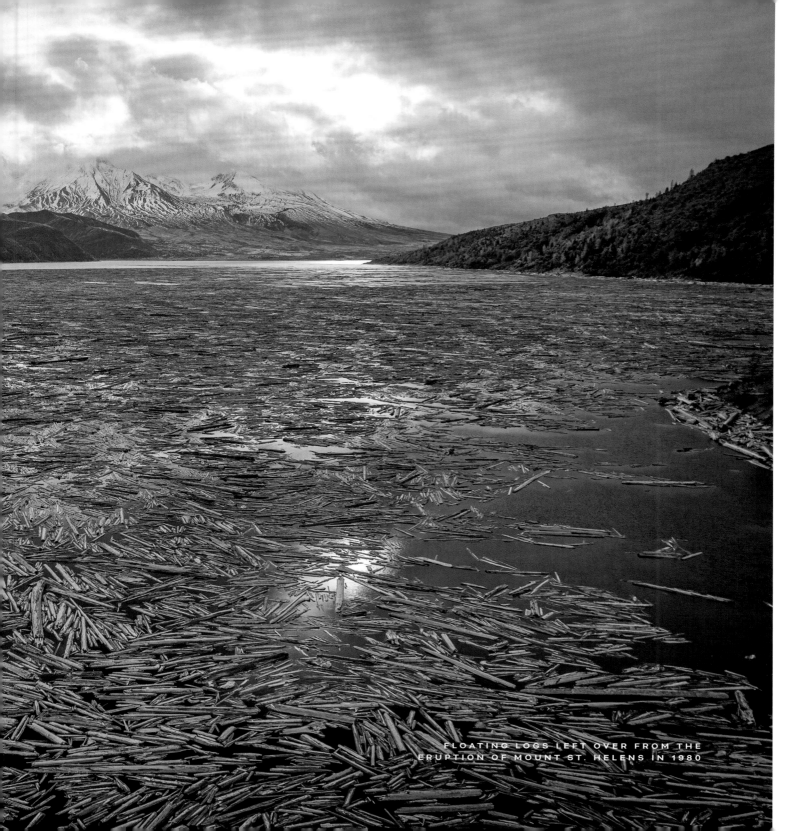

FLOATING LOGS LEFT OVER FROM THE
ERUPTION OF MOUNT ST. HELENS IN 1980

TREES
OF
LIFE

Squirrel!

~ UP

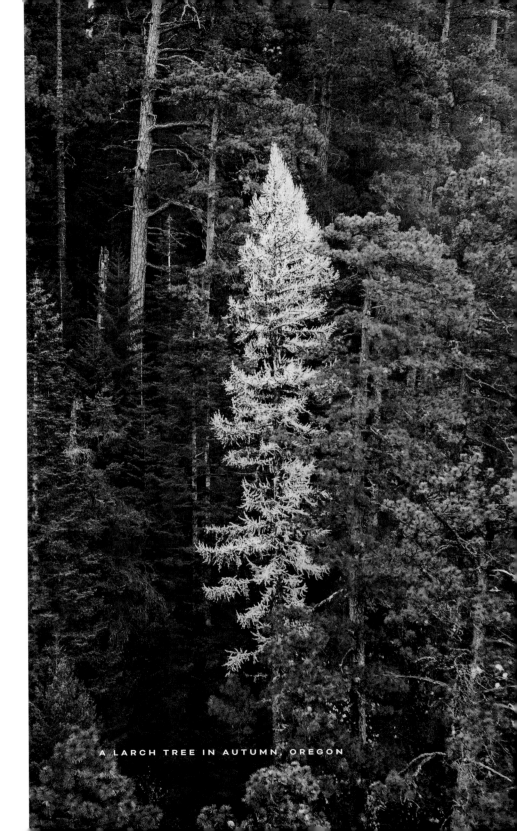

A LARCH TREE IN AUTUMN, OREGON

As we see from nurse logs, trees are an unbelievable source of nutrition. For one, the fruits they bear are some of the sweetest, tangiest, and most colorful flavors that nature's grocery provides. Even my favorite drink, coffee, comes from trees. Scott Davis, a coffee guru in Nashville, frequently reminds me that coffee beans are not actually beans but rather the seeds of a fruit: the coffee cherry. He goes even further to say that if an average cup of joe contains around a hundred seeds, then your morning coffee contains the potential energy of an entire forest! Or as my friend Jeremy Stanley says, great coffee can taste like all your hopes and dreams in a cup. (I should stop the coffee talk here, or I won't be able to shut up.)

Coffee aside, in the past few years, I've been introduced to two other tree-based resources that have had a major impact on my peace and well-being.[1] The first is called *ashwagandha* (pronounced aush-wah-**gone**-duh), a tree root extract that is all natural and nontoxic. It can be ingested as a powder or tincture, and even made as a tea. And believe me when I say the benefits are incredible.

First of all, ashwagandha is amazing at regulating and reducing stress and anxiety. It enhances your mood while bringing a genuine smile to your face. And, yes—it's perfectly legal! Far from being a psychedelic drug, it won't give you a high, and you shouldn't even feel much, to be honest, other than having less stress than the day before. And the health benefits don't stop there! Ashwagandha is also great for lowering blood sugar, increasing muscle strength, and sharpening memory and focus. It's even been known to improve one's fertility and sexual health.

Another tree-based miracle that's improved my workflow is called *pycnogenol* (pronounced pick-**naw**-jin-all). This supplement is extracted from European white pine bark. Its main function is to improve blood flow and circulation. In that sense, it's really good for your heart, arteries, and skin. Some studies even show that taking pycnogenol can help with weight loss.

But the main reason I take pycnogenol? Well, before I tell you that, let me back up a bit.

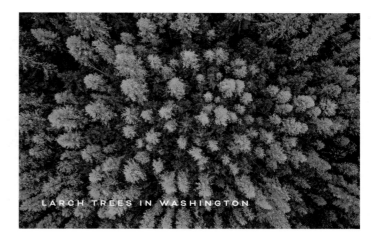

LARCH TREES IN WASHINGTON

I was diagnosed with Attention Deficit Disorder so long ago they hadn't yet added in the H (for Hyperactivity). I got through most of junior high and high school on daily doses of Ritalin. And while the drug did wonders for my focus and ability to retain information, it also subdued my personality and turned me into a lesser version of my true self. But it was the price I had to pay in order to have the necessary concentration to read books, get homework done, write papers, and take exams.

Now that I'm an adult, my ADHD is less severe and hasn't been bad enough for me to consider getting a prescription for Ritalin or Adderall, especially since I don't want to deal with the negative side effects or risk any addiction. And thankfully, I've chosen a career and life that works better with my crazy squirrel brain. But still, I can often sense a lack of focus, clarity, and mental energy when I'm trying to power through big projects.

So when a fellow artist with ADHD told me about how pycnogenol also acts as an all-natural alternative to Adderall, I had to give it a try. And, boy, does it work! It's given me all the benefits I remember from taking Ritalin but without all the negative junk. Since then, I've recommended it to several friends, and it's become a great alternative solution for many of them. (It's even helping me write this book!)

1 Both ashwagandha and pycnogenol can be found in some wellness and nutrition stores, as well as online. But before you try either of them, please consult your doctor and therapist, especially if you have any heart conditions or issues with mental health. None of this is medical advice, so please do not take it as so. These two nutrients are but a small example of the life-giving benefits that the forest provides.

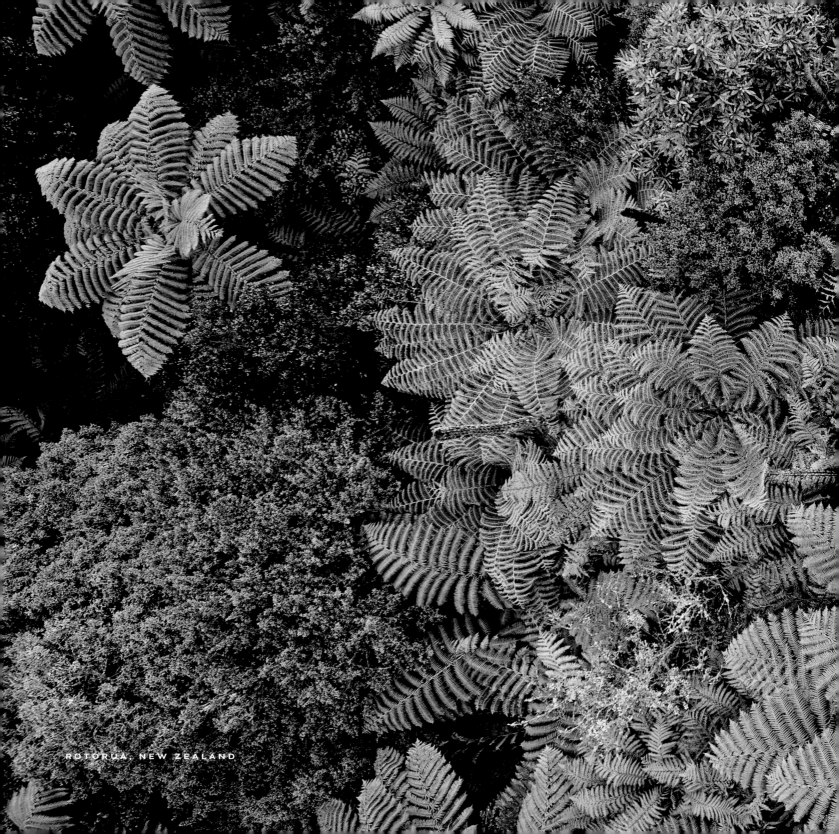

ROTORUA, NEW ZEALAND

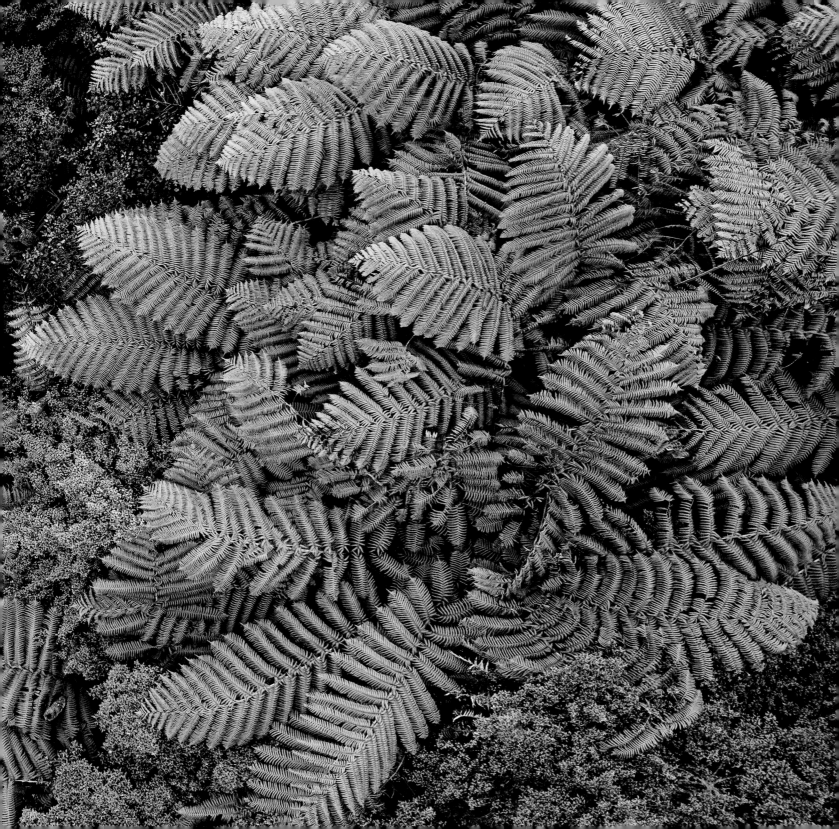

THE LUNGS
OF THE EARTH

*Let the breeze come and fill the wood; watch the
copper-coloured leaves cloud the air in a moment's sudden light.*

~KENNETH STEVEN,
"INSTRUCTIONS FOR AUTUMN"

GIFFORD PINCHOT NATIONAL FOREST, WASHINGTON

Trees are how our planet breathes. Even their structure resembles the inside of a lung. Their leaves, which absorb pollutants and contaminants, act like giant air purifiers for our atmosphere. They breathe in carbon dioxide and exhale oxygen. On average, one large tree can breathe out a day's worth of oxygen for up to four people![1] Because of their process of photosynthesis, trees are often referred to, metaphorically speaking, as the "lungs of the Earth"!

Not only do trees play an important role in producing oxygen, but they also contribute significantly by removing carbon dioxide from the atmosphere, which helps cool our planet. The Amazon rainforest is one of the most vital ecosystems on Earth and plays a crucial role in balancing our planet's temperature, along with regulating rainfall on a continental scale.[2] As amazing as this is, we should also be concerned for the current state of the Amazon. It is estimated that between 13 to 20 percent of the Amazon has been cut down and destroyed in the past few decades.[3] Deforestation, without proper reforestation, is like a lung cancer that seeks to take our planet's breath away. We could also liken it to turning off the air conditioner on a hot summer day. As a result, forest restoration has become a hugely popular avenue for mitigating man-made climate change. And it can be an activity anyone can join in.

While it may seem like a drop in the ocean, even planting a single tree, though simple, can be a significant and symbolic act of beauty and justice. It's a tangible way for all of us to participate in the sacred practice of Creation Care, as well as investing in future generations.

The origin of breath can be traced all the way back to the book of Genesis, when the Creator breathed life into the human body. You can also see the spiritual significance of breath throughout history and language. For example, the original word for "spirit" in Hebrew is *ruach* (רוח), which also means "breath" and "wind." And in Latin, the word *anima* translates to "breath of life" and "soul," which points to the very essence of our being that sustains and animates us.

The ancient practice of breathwork has become a growing trend in recent years. Simply put, breathwork is the exercise of breathing slowly and intentionally. This practice can be a form of meditation, in which you are invited to focus on your breath and be present with your body.

Today, breathwork is a therapeutic practice that offers many different benefits. For one, it helps reduce stress and anxiety, as well as PTSD and the ripple effects of trauma. Because when we take in larger-than-normal amounts of oxygen, our bodies release toxins and stress hormones while balancing blood pressure and strengthening respiratory and immune systems.

In addition to providing multiple health benefits, breathwork can be practiced using multiple patterns designed for different outcomes, such as calming oneself, boosting performance, and going to sleep. One typical breathwork pattern is to inhale steadily for four seconds, then exhale for the same amount of time. Box breathing goes a step further with a four-squared structure in which you inhale for four seconds, hold your breath for four, exhale for four, and then hold again for four. People generally repeat the cycle for at least five minutes, but many choose to go much longer.

Good times to practice breathwork are first thing in the morning, during a break at work, and at bedtime. This intentional act of focusing on your breath is a wonderful way to center yourself and clear your mind, not to mention vastly improving your quality of sleep! As you can imagine, this simple daily exercise can enhance both your mood and your entire body.

To be honest, I'm fairly new to the whole breathwork thing, but I can already feel a difference. Taking deep, focused breaths helps lift my brain fog and fills my whole being with a renewed sense of energy. And the best part is that breathwork doesn't require much more than setting a few minutes aside each day. For optimum results, head outside and take some deep breaths alongside the lungs of the Earth. There's nothing like taking in a breath of fresh air.

1 "The Power of One Tree - The Very Air We Breathe," U.S. Department of Agriculture, usda.gov/media/blog/2015/03/17/power-one-tree-very-air-we-breathe.

2 Katarina Zimmer, "Why the Amazon doesn't really produce 20% of the world's oxygen," National Geographic, nationalgeographic.com/environment/article/why-amazon-doesnt-produce-20-percent-worlds-oxygen.

3 "Maap #164: Amazon Tipping Point—Where Are We?" Amazon Conservation, maaproject.org/2022/amazon-tipping-point.

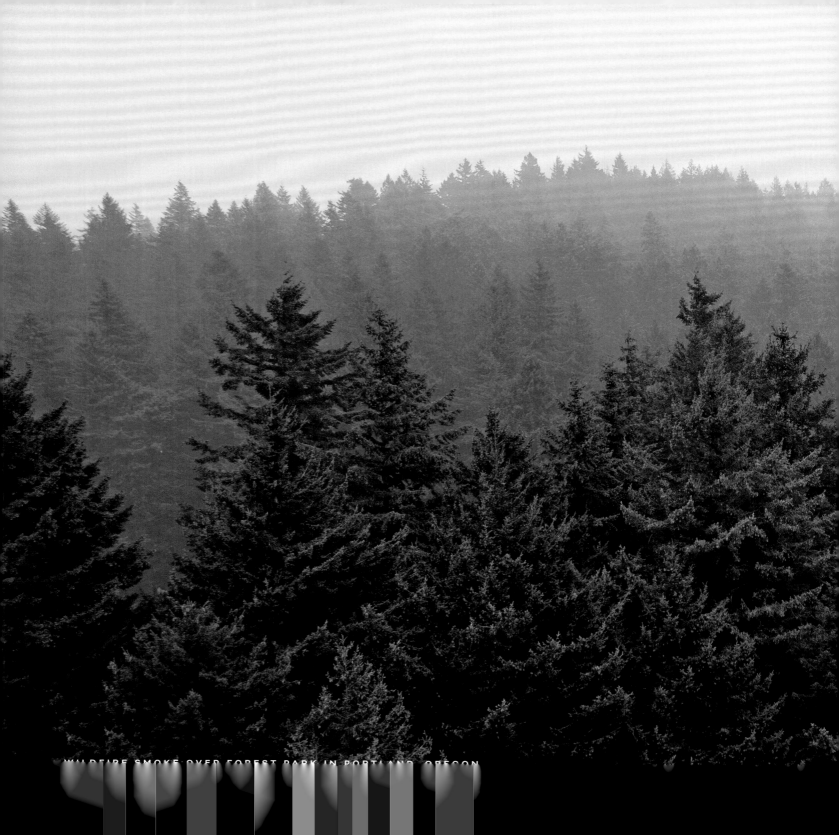

WILDFIRE SMOKE OVER FOREST PARK IN PORTLAND, OREGON

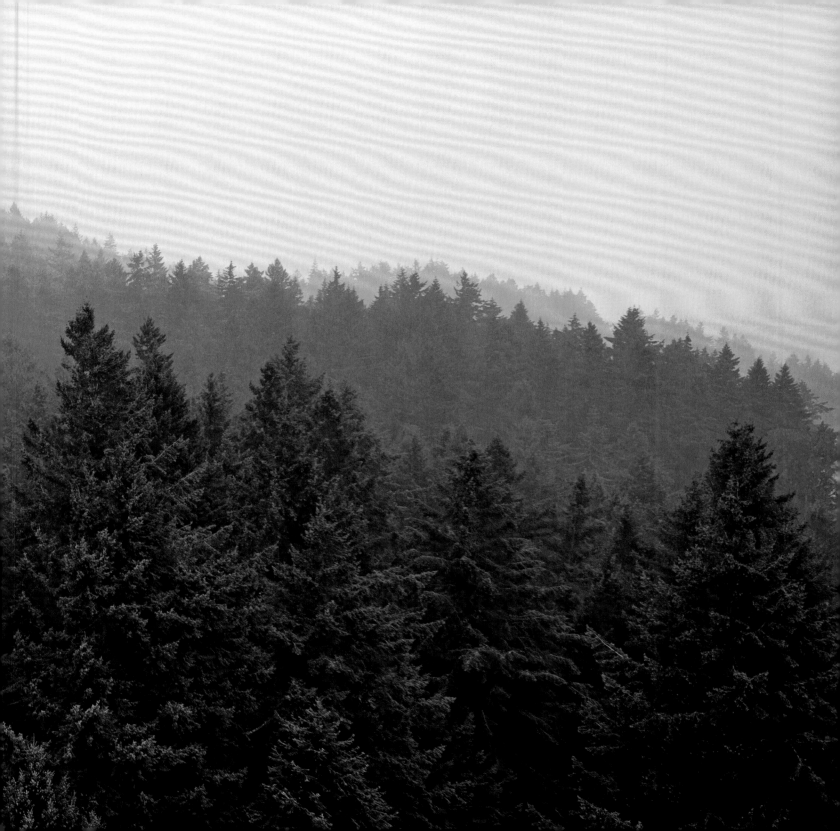

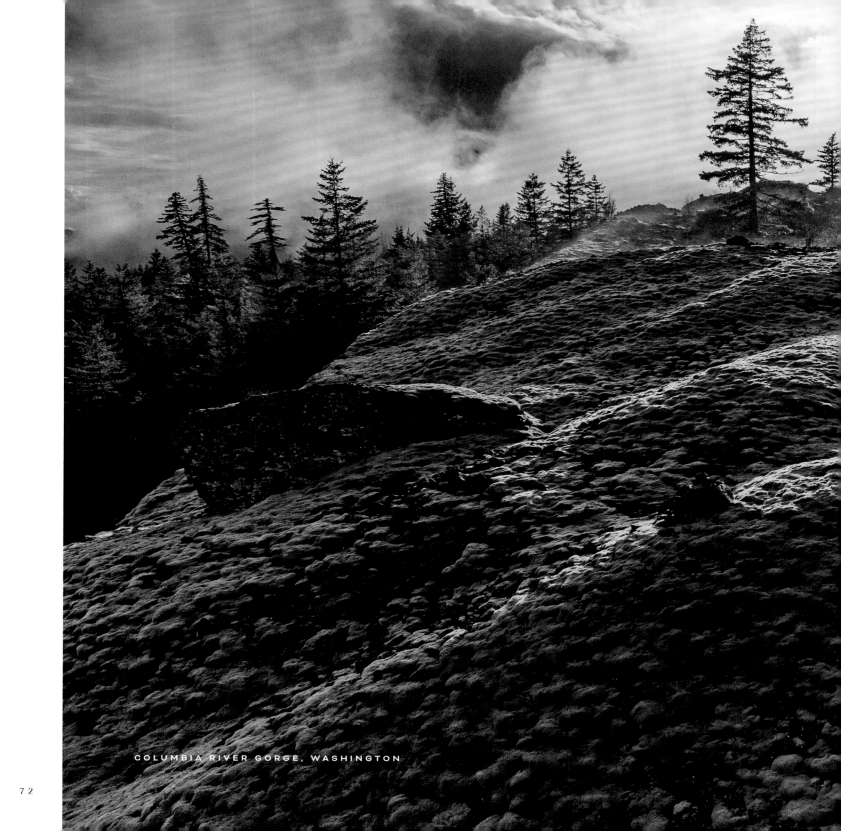

COLUMBIA RIVER GORGE, WASHINGTON

SHINRIN-YOKU

森林浴

"Forest bathing" is the Japanese practice of spending intentional time around trees and allowing all of your senses to soak in a woodland realm. This meditative form of ecotherapy benefits us by reducing stress, anxiety, and blood pressure while simultaneously boosting our mood, immunity, focus, and creativity. This exercise is also a great antidote to tech and digital burnout.[1]

1. Qing Li, "Forest Bathing Is Great for Your Health, Here's How to Do It," *Time*, May 1, 2018, time.com/5259602/

SCORING THE SCENE

Nothing has ever been said about God that hasn't
already been said better by the wind in the pine trees.

~THOMAS MERTON

SNOQUALMIE PASS, WASHINGTON

David Swick, a folk singer-songwriter in Nashville, is a prolific composer of minimalist music and also a good friend. A few years ago, he was exploring ways to incorporate meditation and calmness into his music, and he ended up composing a unique project called *Breathing Strings*.

The concept of *Breathing Strings* is centered around practicing presence through simple compositions orchestrated for string quartets. Generally, musicians are trained to play to a predetermined time signature and to keep time at a certain pace, and classical musicians are held to an even higher standard when performing. Otherwise, symphonies would spiral into a convoluted cacophony, right? But not with *Breathing Strings*.

Instead of playing to a metronome or to the waving wand of a conductor, the players are instructed to play to the pacing and rhythm of their own breath. With each inhale, they bow their strings, and with every exhale comes the following note. This method of playing invites them to focus on their breath and to let their respiratory pacing conduct their individual parts, all while playing and breathing together as a quartet. The result is a soothing, hypnotic listening experience, much like the sound of waves crashing on the beach.

In the spring of 2018, I accompanied David on a short European tour where we collaborated with local musicians on a series of *Breathing Strings* performances. We flew to three locations: Iceland, England, and Northern Ireland. In each location, we worked with a local string quartet and invited a handful of people from each community to join us. I brought a few projectors with me to illuminate the concerts with meditative, immersive visuals that harmonized with the music.

Each setting was completely unique, ranging from a house show to a school of music. But my favorite was in Iceland. There, we packed our gear, the quartet, and about sixty local people into a man-made cave. The cave was carved out by Celtic monks over a thousand years ago; some historians believe it even predates the Vikings. You could say the entire place had an ancient energy and mystery about it.

In a fusion of the distant past and modern day, we lit candles and fired up projectors, illuminating the intimate cavern with imagery from my drone, including scenes I had filmed in Iceland on a previous trip. As white waves crashing on a black sand beach hung like curtains on the cave walls, the string quartet mimicked the same with their playing. In and out. Back and forth. Over and over again, until each composition was finished. It was one of the best concert experiences of my career. And one I will truly never forget.

David made a recording of each concert, including the original performance in Nashville. As I went back and listened to each variation, something interesting stood out to me: The timing of each song was drastically different for each quartet! For example, on the piece titled "Agnus Dei," the Nashville quartet performed it in 3 minutes and 48 seconds, London in 2:47 (a whole minute less!), Northern Ireland in 3:29, and Iceland in 4:43. In other words, the quartets from Nashville and Northern Ireland were pretty much in step, but the difference between London and Iceland was two whole minutes. I found it fascinating that the music school in England held the fastest time, while the quartet in an Icelandic cave performed much more slowly. The difference confirmed something I've heard to be true: Our environment has much more influence over us than we might ever consider.

The fast-paced, structured life of the city might just be causing everyone in that setting to breathe at a quicker pace. Conversely, the slower, unhurried life found in the countryside encourages our bodies to breathe with a slower, calmer pace. This isn't scientific research; it's just a curious observation.

As we near the end of our time in the forest, I would like to invite David to share a few words by describing the heart behind *Breathing Strings*.

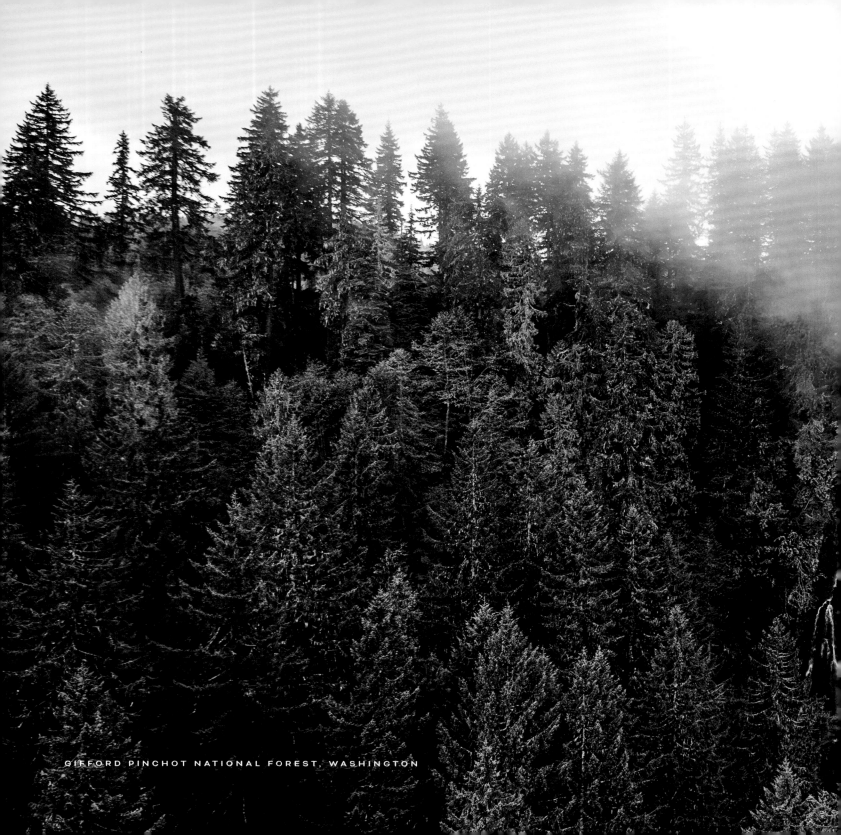

GIFFORD PINCHOT NATIONAL FOREST, WASHINGTON

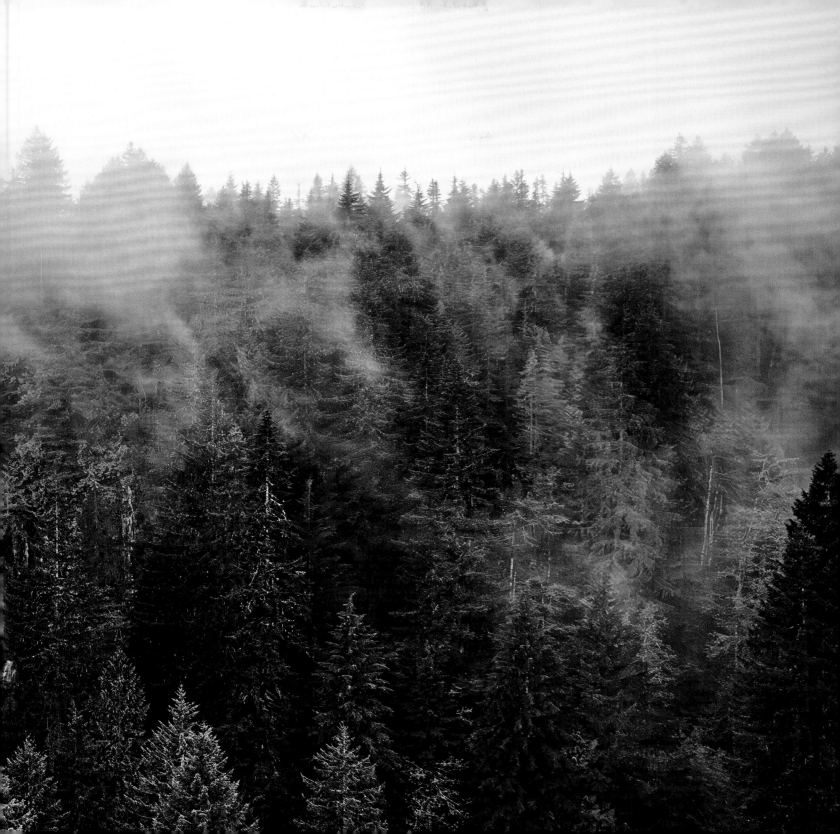

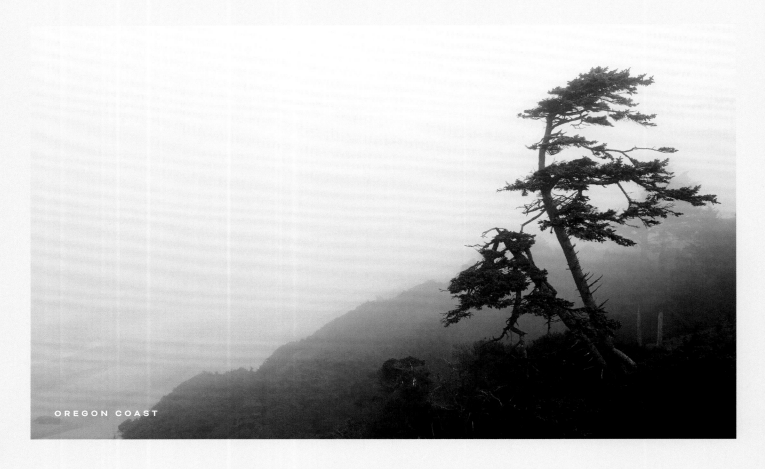

OREGON COAST

BREATHING STRINGS

BY DAVID SWICK

Breathing Strings began with the idea to tie music to poetry, meditations, and prayers as an active accompaniment. The hope was initially to create musical triggers that assist the listener in practicing reflection and presence. This first incarnation was individualistic—focused on the listener's personal experience.

When breath became the rhythmic basis for the project, new metaphors were revealed at the communal level. With each musician breathing their own rhythms and melodies into the music, it mirrored the dynamic of a community engaged and living together—every unique perspective weaving together to create moments of harmony and dissonance in one piece of music.

For all the planning and meaning-making I did before performing this music, playing these pieces with real people in communities across the United States and Europe distilled this project to its core element: a tool for slowing down and reflecting on our role within our greater community and, by doing so, learning to see each other with more gracious eyes.

TIME TO FLY!

A MOMENT TO REFLECT

Try some forest bathing by spending intentional time near trees. If you are able, plan a time to get out of your normal environment and immerse yourself in a forest. If you aren't near a forest, visit a park or local green space. There's nothing you need to think about. Simply be, rest, and let the trees do their work on you.

Practice some breathwork. Inhale deeply for four to five seconds, then exhale for the same. Repeat this pattern for at least five minutes. If you would like some guidance, use a breathwork app. (See proktr.com/wildwonder for recommendations.)

Who or what are the "nurse logs" in your life? Spend some time reflecting on what you may need to let go of, and then dream about what might take its place. Make space for your grief, as well as your hope. As you ponder, think about Chad's questions: *What does this situation make possible? What's the invitation?*

Listen to *Breathing Strings* by David Swick on any major streaming platform. Listen just for enjoyment at first, but if you really want to dive into the deep end, practice some unstructured breathwork along with the string quartet.

As with each suite, you can enjoy cinematic meditations created in tandem with this book, found at proktr.com/wildwonder.

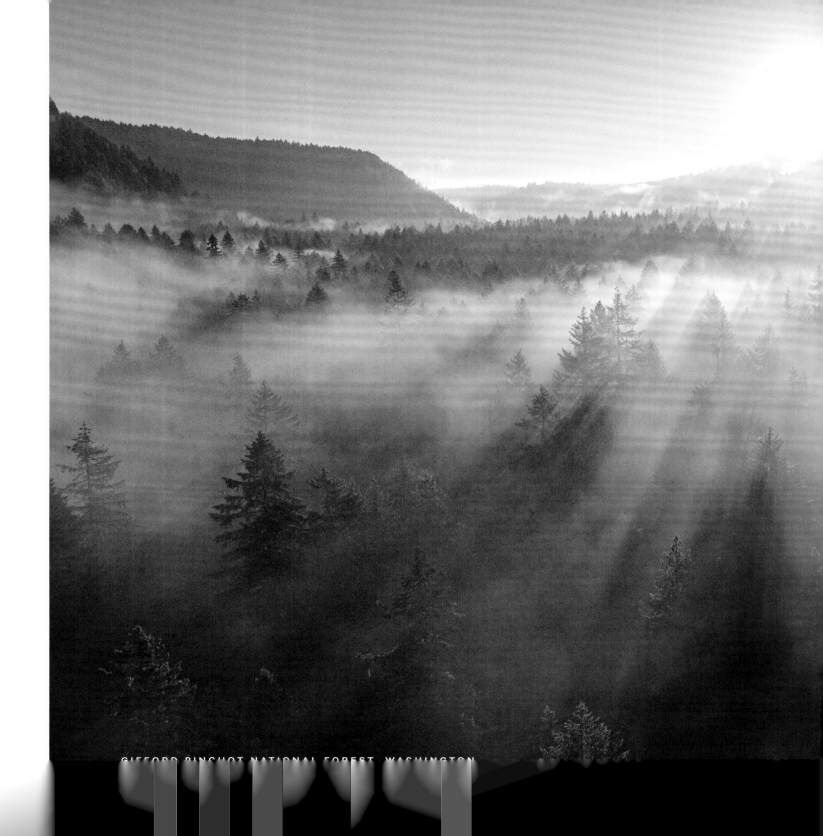

GIFFORD PINCHOT NATIONAL FOREST, WASHINGTON

THERE'S A CATHEDRAL HUSH HERE. PERHAPS THE THICK SOFT BARK ABSORBS SOUND AND CREATES SILENCE. THE TREES RISE STRAIGHT UP TO ZENITH; THERE IS NO HORIZON. THE DAWN COMES EARLY AND REMAINS DAWN UNTIL THE SUN IS HIGH. THEN THE GREEN FERNLIKE FOLIAGE SO FAR UP STRAINS THE SUNLIGHT TO A GREEN GOLD AND DISTRIBUTES IT IN SHAFTS OR RATHER IN STRIPES OF LIGHT AND SHADE. TO ME DAWN AND DUSK ARE QUIET TIMES, AND HERE IN THE REDWOODS NEARLY THE WHOLE OF DAYLIGHT IS A QUIET TIME.

John Steinbeck, Travels with Charley

THE ROAD TO HANA, MAUI, HAWAI'I

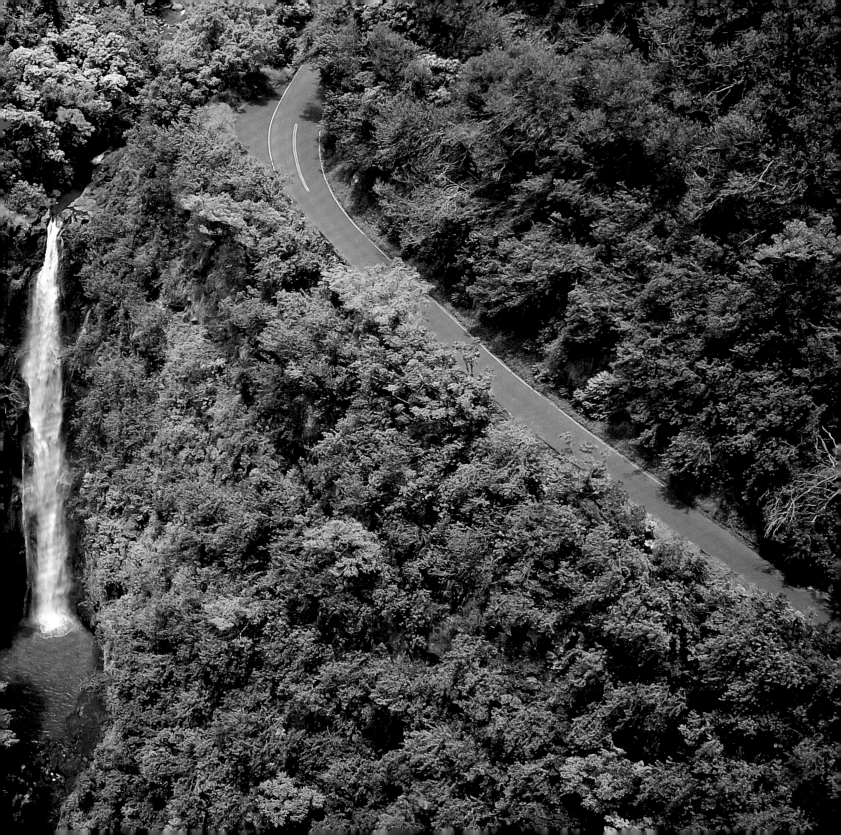

LAKE PUKAKI, NEW ZEALAND

SUITE NO. 3

RIVERS

THE WAY OF GRACE

BAKER LAKE, WASHINGTON

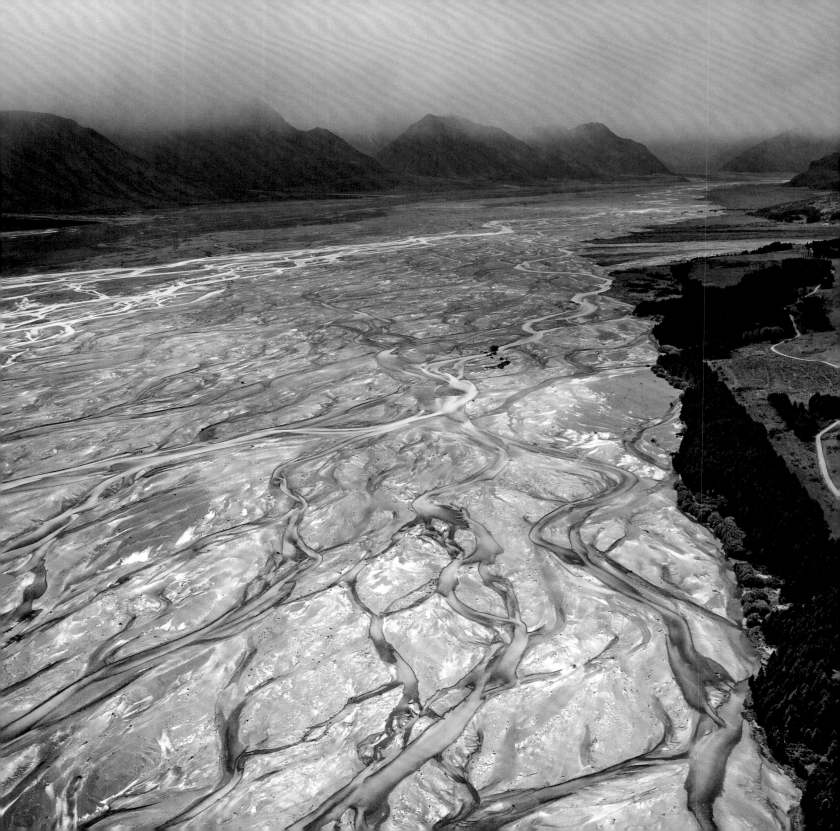

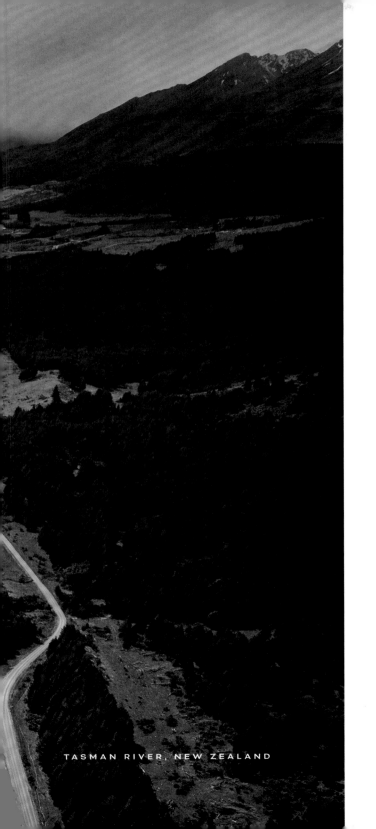

TASMAN RIVER, NEW ZEALAND

THE GREEN EUCHARIST

The nuns taught us there are
two ways through life:
the way of nature[1] and the way of grace.
You have to choose which one you'll follow.
Grace doesn't try to please itself.
Accepts being slighted, forgotten, disliked.
Accepts insults and injuries.
Nature only wants to please itself.
Get others to please it, too.
Likes to lord it over them.
To have its own way...
They taught us that no one who loves
the way of grace ever comes to a bad end.

~ THE TREE OF LIFE

1 "Nature" is defined here as "the original, natural, uncivilized condition of humankind."
See dictionary.com/browse/nature, definition 12.

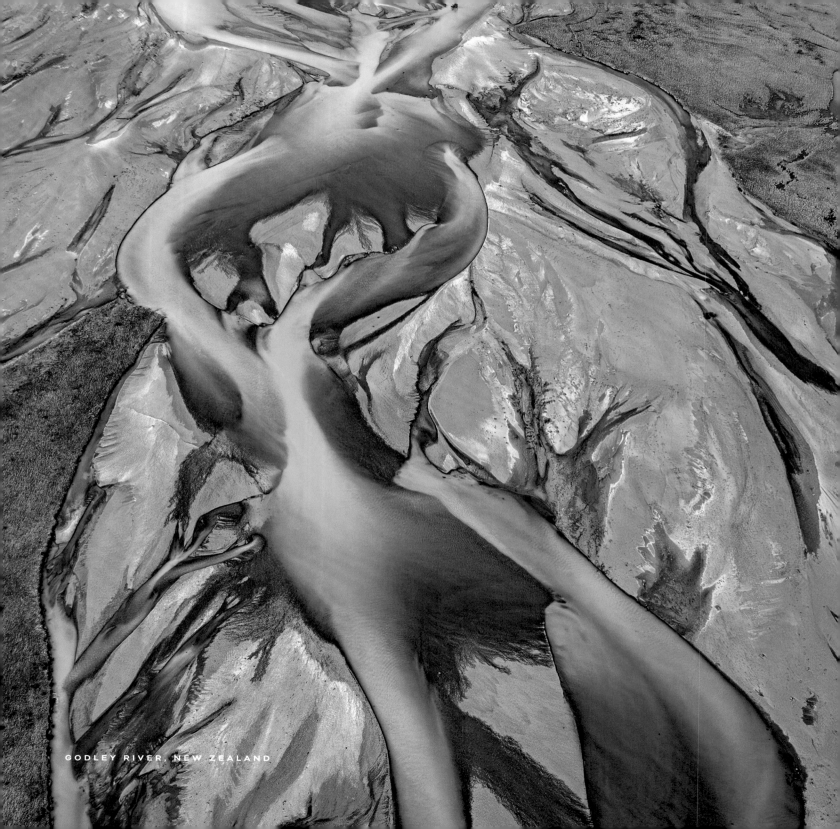

GODLEY RIVER, NEW ZEALAND

One of the humblest people I have ever met is a woman from Japan named Keiko Yanaka. I met Keiko at a gathering of artists hosted by our mutual friend, Makoto Fujimura, who graciously wrote the foreword in this book. The night before the gathering started, Mako invited a group of us artists out for dinner. I ended up sitting next to Keiko at a California Pizza Kitchen, alongside a dozen or so of Mako's friends. When I asked Keiko what her art was, she said, "Tea!"

At the time, Keiko was entering her twelfth year of studying the ritual of Japanese tea ceremonies, a tradition started by Sen no Rikyū in the 1500s. She told me that it takes an apprentice sixteen years to become a tea master.

Sixteen. Years.

Let that sink in.

That's basically kindergarten through high school, plus college. To become a tea master. Talk about discipline! Imagine applying to be a barista at a local coffee shop and finding out that your training will last for that long! Would you commit to it?

Of course, Keiko is not training to serve matcha lattes at the local shop around the corner. Rikyū tea ceremonies are on a completely different level. These extremely slow and symbolic rituals have been practiced for centuries and have been used in all kinds of cultural contexts, including spiritual and political. They've been used to stop wars and to mark times of peace.

Some even suspect that the earliest days of these tea ceremonies took place in sixteenth-century Japan, when Christianity was outlawed. Believers would often meet secretly in their homes, since going to church on Sunday morning was not exactly an option back then. Still, as had been the case for most believers before them and all around the world, the gravitational center of Japanese Christian gatherings was Holy Communion. But because Christianity was illegal and often punishable by death, they chose instead to have tea ceremonies as a covert way to "keep the Feast." They would use green tea as a substitute for wine, which wasn't easily available, especially in impoverished and oppressed communities. That way, if anyone barged in on them during a service and asked what they were doing, they could honestly say they were drinking tea!

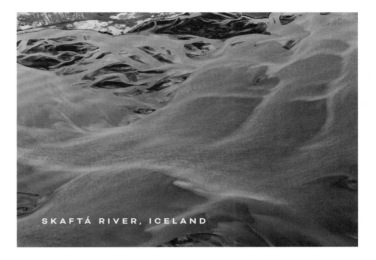

SKAFTÁ RIVER, ICELAND

Because of this clever and life-saving substitution, many referred to these secret tea ceremonies as the Green Eucharist. Eucharist is one of the original names for the Sacrament of Communion (i.e., the Lord's Supper), one of the most sacred rituals in the Christian faith, and it simply means "thanksgiving."[1] And here was Keiko, a Christian hundreds of years later, carrying on the same tradition and practice, and sharing it with anyone who was willing to receive and give thanks.

And receive I did. Many times. One tea ceremony led to another, as we would all return yearly to the same gathering. Each time, I noticed more subtleties in the ritual and would converse with Keiko afterward about what I saw. After all, the ceremony was filled with metaphors just waiting to be unpacked and interpreted. On occasion, I was invited to bring a projector or two to add a luminous layer of art to the ceremony, which almost felt sacrilegious, since these sacred rituals definitely do not need anything added to them! But Rikyū meant for the invitational posture of these ceremonies to be one of hospitality and beauty, and much of Keiko's apprenticeship has been focused on practicing tea ceremonies in unusual settings. So I didn't want to refuse. And as I've learned throughout the years, if you receive an invitation with openness and humility, unexpectedly beautiful things can happen.

1 "Eucharist," *Encyclopedia Britannica*, updated November 14, 2023, britannica.com/topic/Eucharist.

THE TEA IS STRONG
WITH THIS ONE

The rivers flow not past, but through us, thrilling, tingling, vibrating every fiber and cell of the substance of our bodies, making them glide and sing.

~JOHN MUIR

TASMAN RIVER, NEW ZEALAND

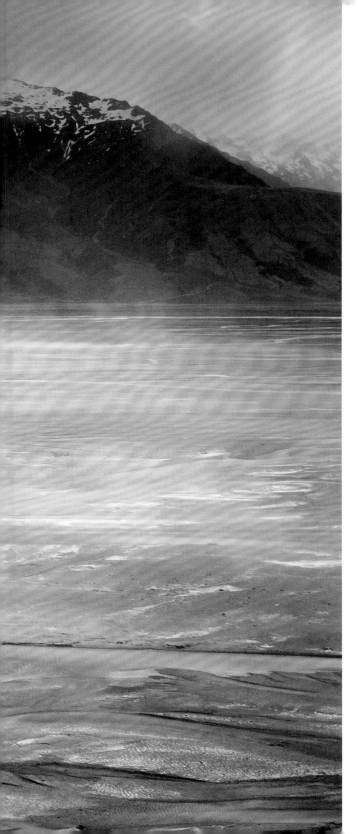

A few years after my first tea ceremony, Mako invited a handful of artists, including Keiko and me, on a pilgrimage to Israel-Palestine. Keiko brought her tea setup, and I brought my laptop, a projector, and my drone. Our agenda was to meet with various local artists, which included refugee women from Eritrea, a Jewish Kabbalah artist, a Buddhist musician who makes his own instruments, and a transgender atheist involved in the underground art scene in Tel Aviv. This was quite the experience, to say the least. Along the way, we stopped at various "holy sites" that were meaningful and historic to the life of Jesus. And in a few of these sacred spaces, we performed a tea ceremony as a quiet act of peacemaking and as a prayer for a war-torn land so desperate for peace.

After spending some time on the shore of the Sea of Galilee, we visited the venue of our first ceremony: an underground chapel built around the newly excavated floor of a first-century synagogue in Magdala. So much happened that morning that I would have to write another book to unpack it all. But I will share one memorable thing that took place: *It rained.* Like, a lot. When we had arrived, it was hot, dry, and sunny. But when we walked back outside after the tea ceremony, everything was soaked and steaming. Vapors were rising all around us as the sun came back out. And the fragrance of freshly fallen rain on a hot summer's day filled the air.

Our local guides were perplexed by this rare deluge and told us that they had not seen it rain in the month of June for seventeen years. They also remarked that rain was a sign of blessing. And outside of Magdala? Dry as a bone.

Our next tea ceremony took place in the Garden of Gethsemane in Jerusalem, the place where Jesus prayed just after having celebrated the Last Supper before his crucifixion. And right before we started? You guessed it. It rained again. Thankfully, it wasn't enough to rain us out. And again, one of our local guides made an interesting comment: They had not seen it rain in Jerusalem during June for two generations.

Do with that what you will.

After that trip, I started referring to Keiko as The Rainmaker. I also call her a Jedi. Because the *tea* is strong with her. She's just making green tea instead of fighting with green lightsabers! Whatever she's doing, it seems to be blessed in some powerful and mysterious ways.

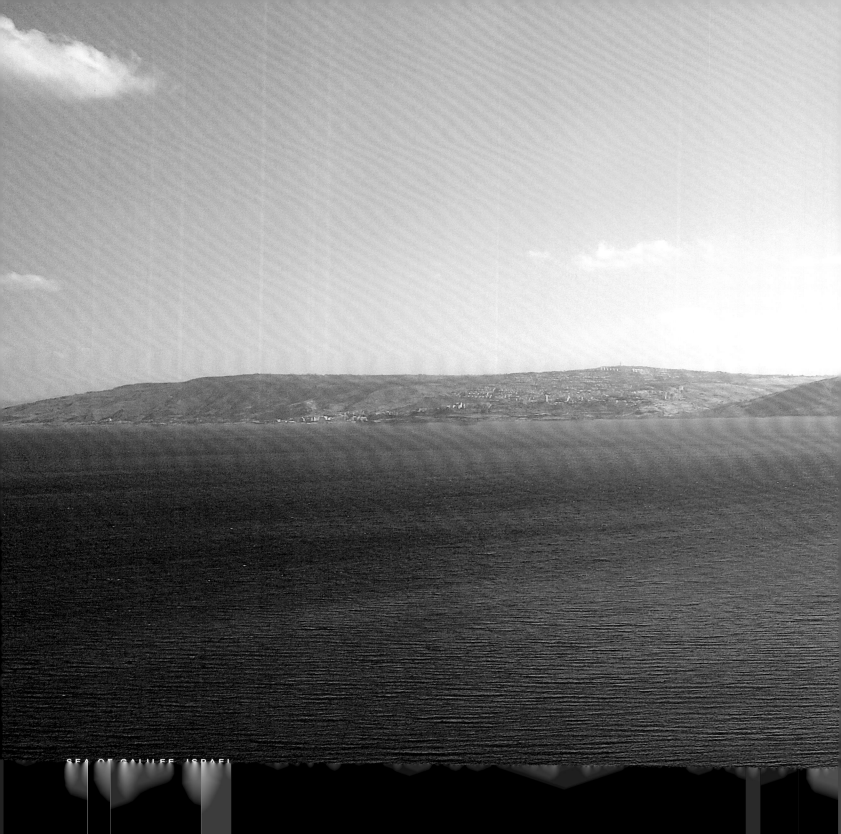

SEA OF GALILEE, ISRAEL

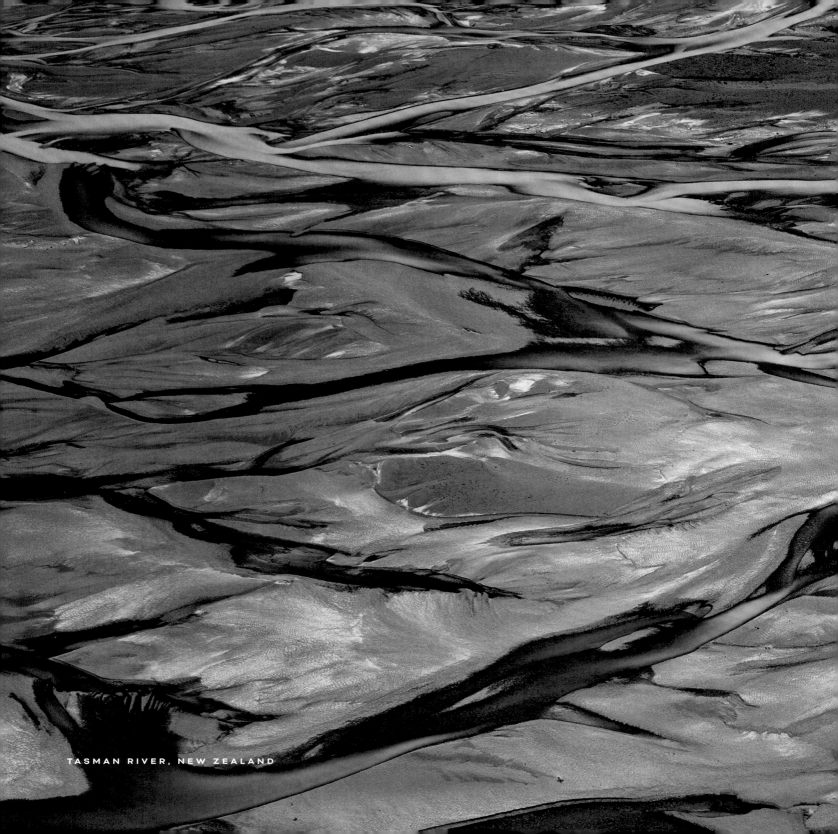

TASMAN RIVER, NEW ZEALAND

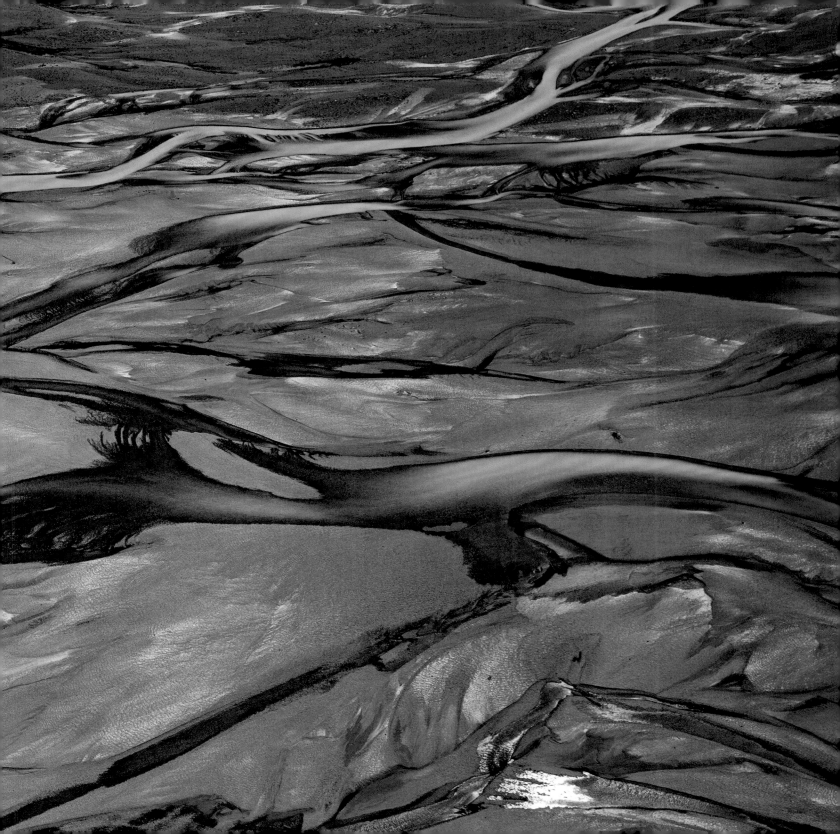

STREAMS OF LIVING WATER

Have you also learned that secret from the river; that there is no such thing as time? . . .
That the river is everywhere at the same time, at the source and at the mouth, at the waterfall,
at the ferry, at the current, in the ocean and in the mountains, everywhere and that the present
only exists for it, not the shadow of the past nor the shadow of the future?

~ HERMANN HESSE, *SIDDHARTHA*

When Keiko and I were collaborating on what visuals I should project for the tea ceremony, she pointed out that water played a central role in the ritual. She loved the idea of weaving in images of water, especially ocean waves, rivers, and any other water I had filmed with my drone. Some of the best waves I've captured have been in Iceland, New Zealand, Hawai'i, and the Oregon Coast. I also incorporated some stock footage of rain falling and water streaking down glass. All these visuals flowed seamlessly together to create a water-based narrative.

So, with permission, I set up my projector and illuminated the painting in the Magdalene chapel with various forms of water. This fusion of art and light served as an ancient-future backdrop for the experience. This creative expression also honored Rikyū's design of the tea ceremony, which always included a piece of visual art.

In the moment, I didn't really think too deeply about the meaning of the imagery. Instead, as is usually the case with event production, I was more focused on technical challenges and making sure everything ran smoothly. After all, setting up an immersive projection installation in a first-century synagogue wasn't exactly ideal, from a production standpoint. So it wasn't until I looked back in hindsight that the unspoken symbolism began to speak to me.

There we were, near the Sea of Galilee, in the same place where Jesus walked on water and calmed the storm, being blessed by a rare and out-of-season shower. And at the same time, I was projecting images of water from across the world while Keiko and Mako led our group and a few locals in a tea ceremony.

I didn't know the significance of all those coinciding elements at the time, and to this day, I still can't fully comprehend the weight of the moment. But I know it was profound. It certainly felt like it. As I look back on that experience now, my thoughts drift to the concept of time.

Much like the Eucharist, all of time was brought together in that single moment through the presence of water. The past became present, not only through the historic architecture but also in relation to the miraculous events that took place there two thousand years ago. Water from the recent past was also brought into our present moment through the projection of waves, rivers, and rain captured across the world. Water from the present played a huge role both inside during the tea ceremony and outside as it rained.

The waters of the past and present were brought together in that moment to point us all to the streams flowing from the future. A future that is overflowing with peace and reconciliation. As Isaiah prophesied, "I will pour water on the thirsty land, and streams on the dry ground" (Isaiah 44:3). And ultimately, everything we were doing there flowed from the Source of Living Water. "Whoever drinks the water I give them will never thirst. Indeed, the water I give them will become in them a spring of water welling up to eternal life" (John 4:14).

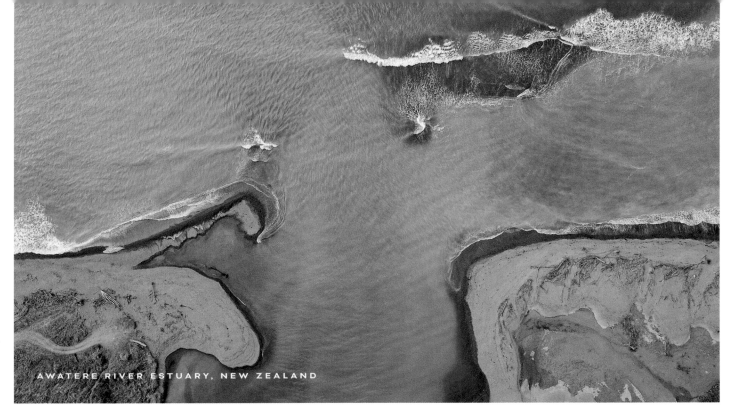

AWATERE RIVER ESTUARY, NEW ZEALAND

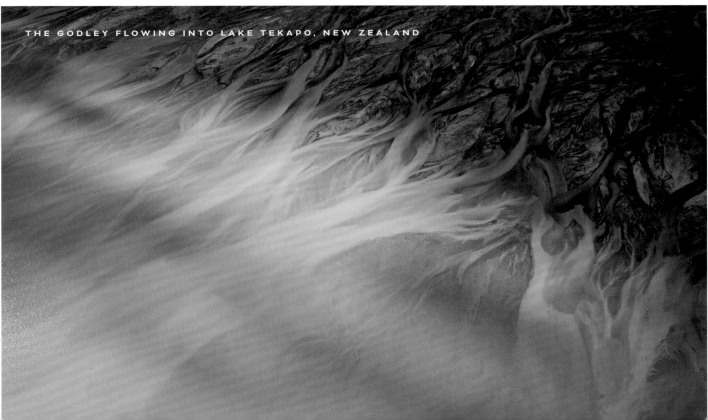

THE GODLEY FLOWING INTO LAKE TEKAPO, NEW ZEALAND

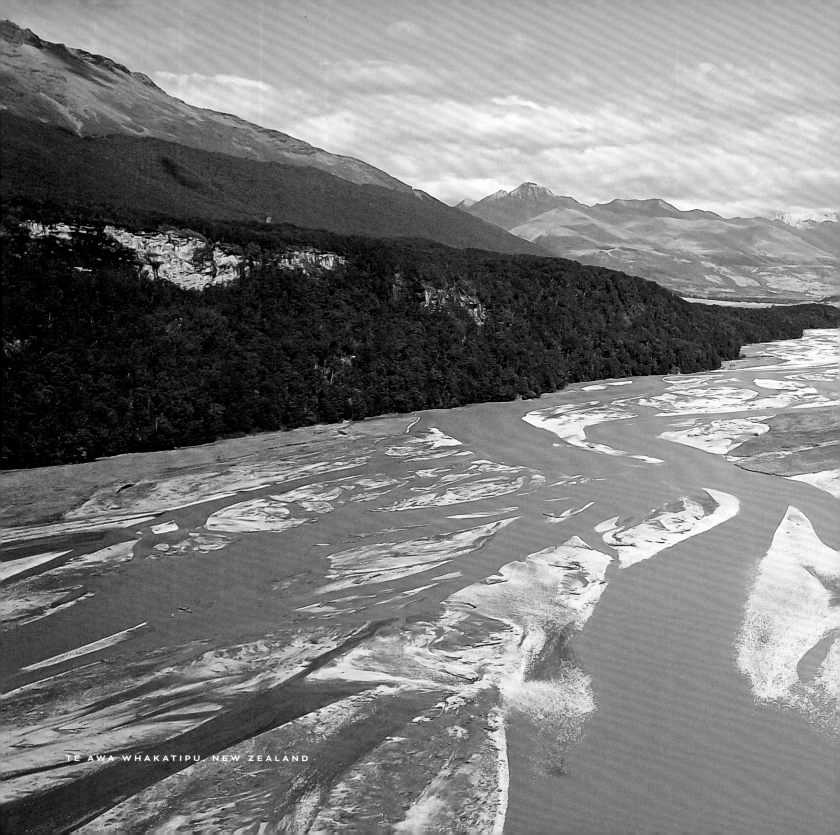
TE AWA WHAKATIPU, NEW ZEALAND

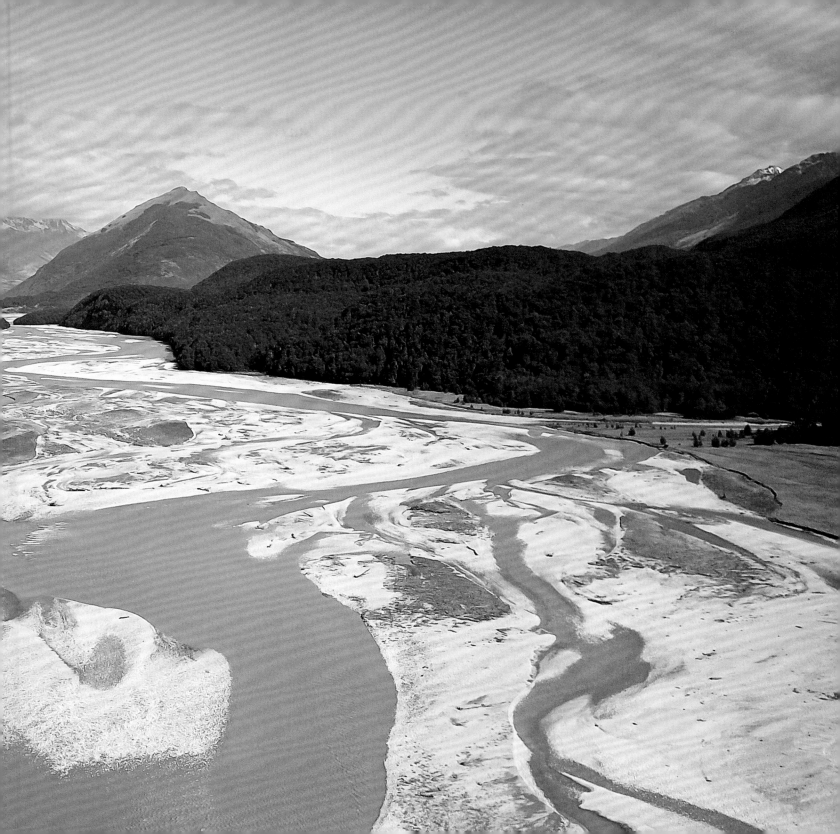

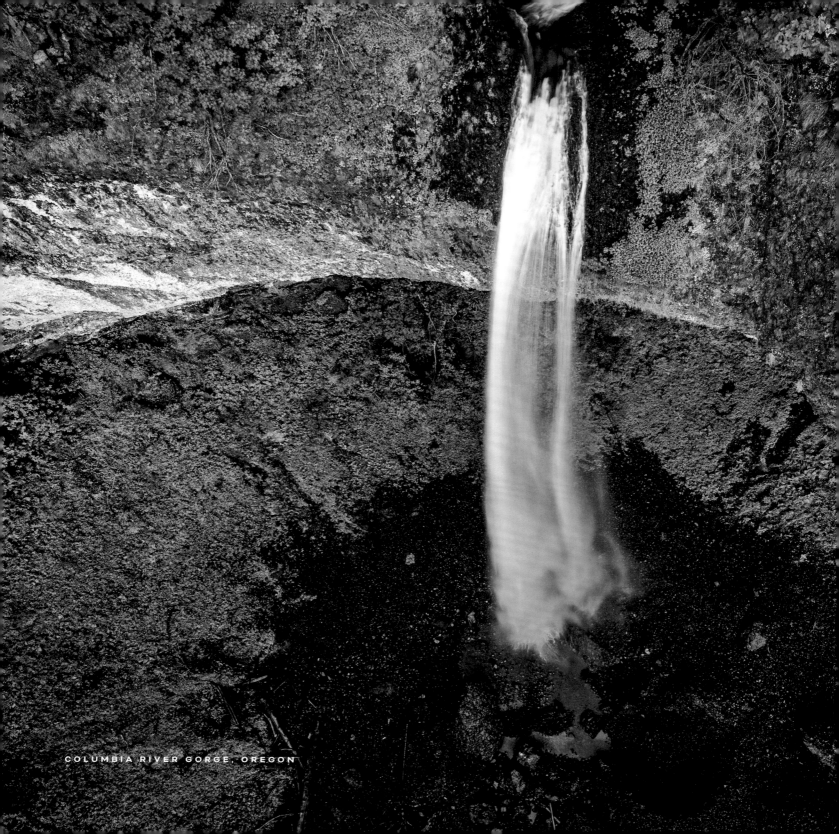

COLUMBIA RIVER GORGE, OREGON

KISSAKO

喫 茶 去

When you hear the splash of the water drops that fall into the stone bowl,
you will feel that all the dust of your mind is washed away.

~ SEN NO RIKYŪ

Two years after Keiko "made it rain," we all found ourselves in the thick of the most tumultuous year my generation has ever known: 2020 (or as I like to call it, the Year of the PPP). We were in the early days of the **pandemic**. We were witnessing or participating in a new era of **Protest**. And, at least in America, we began to enter the most divisive season since the Civil War, all because of **Politics**. And if you were lucky, like me, you were surviving on a PPP (Payroll Protection Program)!

That summer, Mako, Keiko, and I decided to host a tea ceremony on Instagram Live. After our experience in the Holy Land, we thought a humble response to the cultural moment would be to connect with others and share some tea. Through our little screens, people were able to receive this quiet offering, followed by thoughtful conversation about the difficult moment our world was having.

So there we were, sheltering in place, trying to connect in a meaningful way through our smartphones, with Keiko in Japan making matcha tea in her apartment alongside her husband, Osamu. In the moment, it was simple and sweet. Looking back, it felt like an oasis in the desert or a stream in the wilderness.

Before we wrapped up, Mako asked Keiko a question: "Keiko, if there is anything you'd like to say to encourage us in this time of crisis, what would it be?"

Keiko, as she so often does, took her time and sat with the ques-

tion. Finally, she said, "I only have one word to offer. It is a Japanese word: *Kissako*. This means, 'Remember to have some tea.'"

And that's all she said.

No big speech or preachy sermon. No platitudes or clichés. And certainly no mind-blowing answers to the world's complex problems. Just a simple reminder to stop in the middle of all the madness and enjoy some tea.

I knew what she was hinting at with her simple suggestion. And it landed like a ton of bricks. Because the tea Keiko speaks of is so much more than matcha powder mixed with hot water. It's warmer than Earl Grey—even when it's hot. Tea is so much more than the drink itself.

Kissako invites us into the practice of hospitality, humility, and honor.[1] Because tea is a way of blessing one another and being blessed in the process. Tea is also an act of peacemaking, an act of quiet defiance and protest in the face of great division. Tea is like communion, where our dismembered relationships become re-membered and are brought back together in unity. Tea is eucharistic, inviting all who receive to be blessed and give thanks. Tea ceremonies are like the liturgies of my faith that point us to the Way of Grace by reminding us to clothe ourselves in humility, to serve others with hospitality, and to share peace with the broken world around us.

Kissako. Remember to stop and have some tea.

1 John Bowker, "Kissako," *The Concise Oxford Dictionary of World Religions* (Oxford, UK: Oxford University Press, 1997).

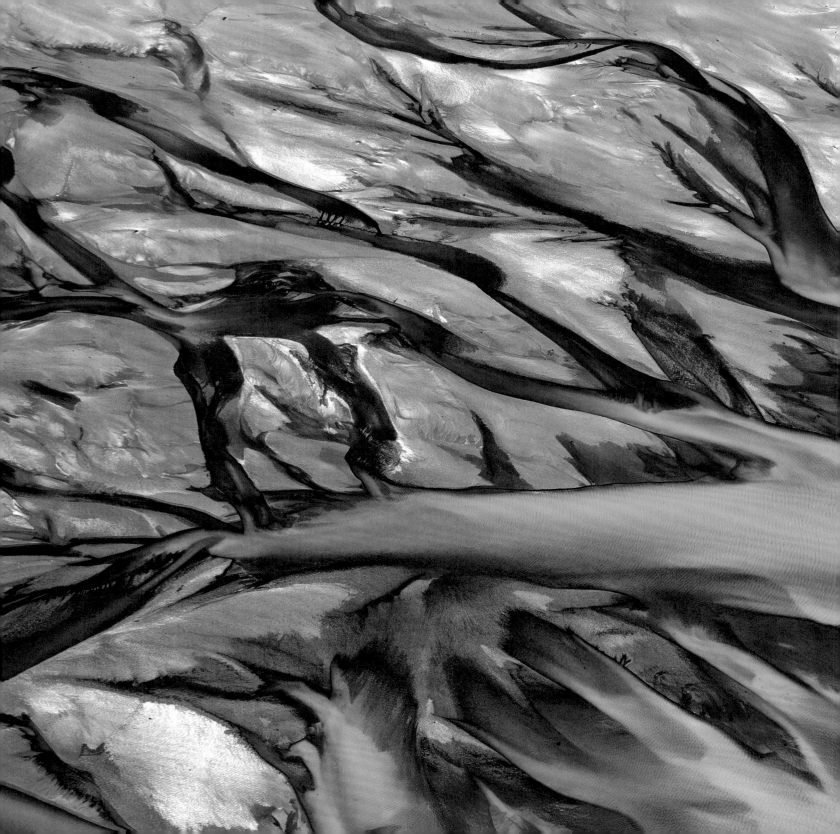

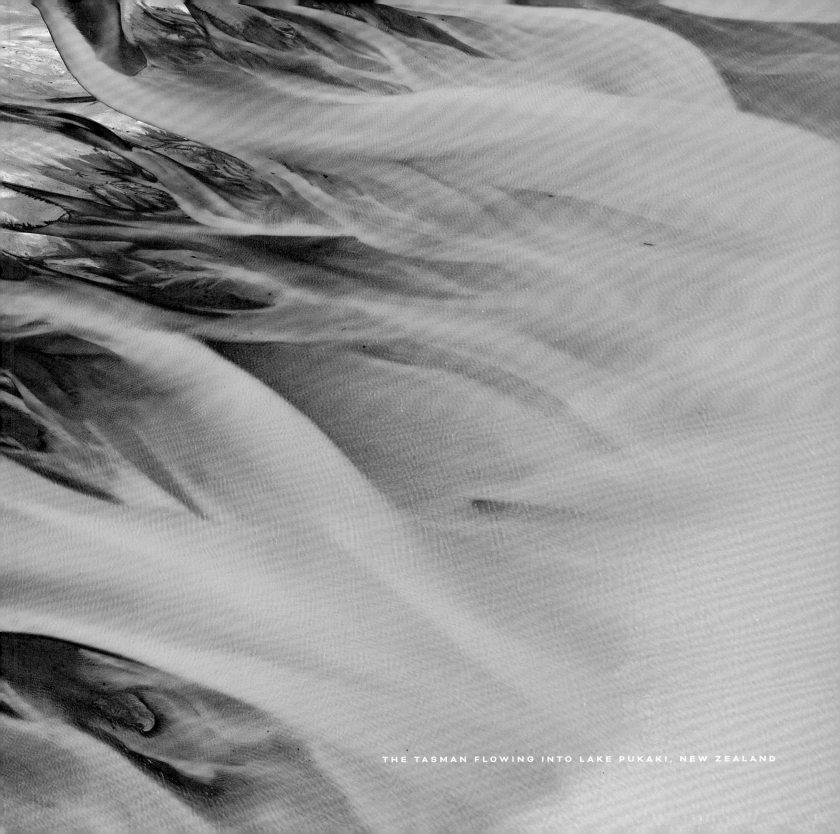

THE TASMAN FLOWING INTO LAKE PUKAKI, NEW ZEALAND

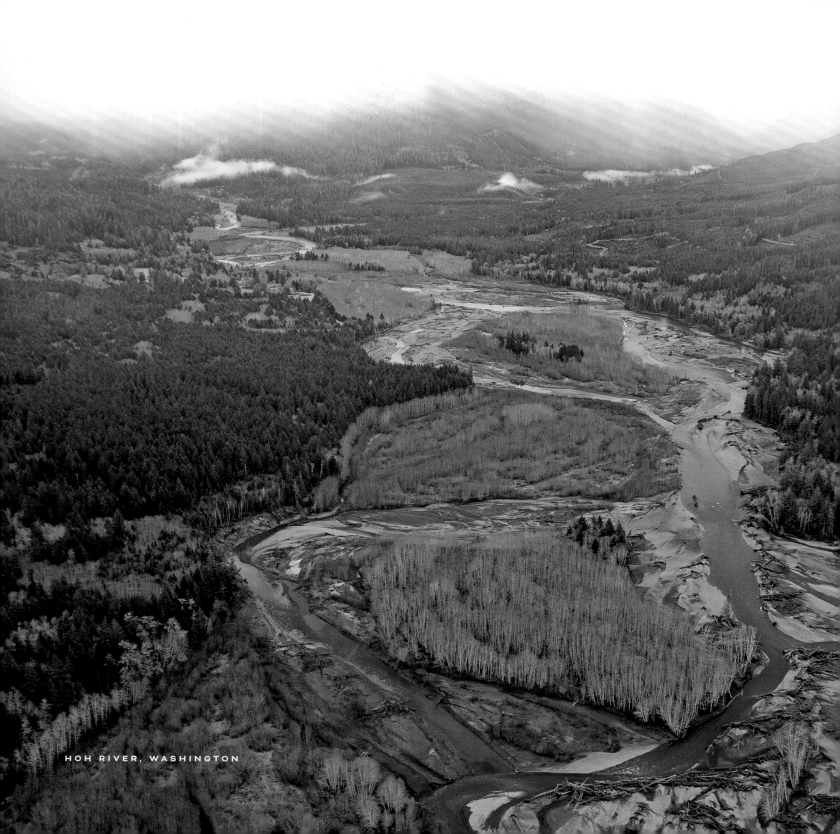

HOH RIVER, WASHINGTON

KEEP CALM AND DRINK TEA

Consider the lilies of the field, how they grow:
they neither toil nor spin.

~MATTHEW 6:28 (NKJV)

The current climate of our culture has been heating up. Every week feels like we're about to reach a boiling point. It doesn't seem to take much to get sucked into the never-ending outrage loops that plague this cultural moment, especially when both mainstream and social media are designed to keep us on the edge of our seats. Speaking from experience, it's so easy to get angry about a post we see online or to react in frustration to a poorly timed comment.

It's one thing to be empathetic to suffering. After all, anger and outrage are definitely valid and needed responses to the evils and injustices of this world. But I've learned the hard way that being stuck in endless reactionary cycles is the greatest enemy to living a meaningful and transformative life.

I want my story to be a purposefully and thoughtfully curated response to the world, not a constant knee-jerk reaction to it. The difference between a reaction and a response can be a wide chasm.

Keiko's tea ceremonies remind me that I don't have to have all the answers to the world's problems. In fact, I don't have to have any. (How arrogant to think that I even could!) Perhaps the greatest gift I can offer the world instead is to figure out what my "tea" is and serve it humbly to all who might receive. This book you hold in your hands and the imagery that comes with it is my own version of a tea ceremony. As Keiko reminds us, when the world seems to be spinning out of control: *Kissako!*

A prayer that has been helpful in recalibrating my jaded, cynical soul back into a state of peace and humility has been attributed to Saint Francis of Assisi. I offer it to you here in hopes that it might do the same for you, especially when you are experiencing moments of frustration with the world around you. May these words comfort and guide you in times of trouble and despair.

THE PRAYER OF SAINT FRANCIS

Lord, make me an instrument of your peace:
where there is hatred, let me sow love;
where there is injury, pardon;
where there is doubt, faith;
where there is despair, hope;
where there is darkness, light;
where there is sadness, joy.

O God, grant that I may not so much seek
to be consoled as to console,
to be understood as to understand,
to be loved as to love.
For it is in giving that we receive,
it is in pardoning that we are pardoned,
and it is in dying that we are born to eternal life.
Amen.

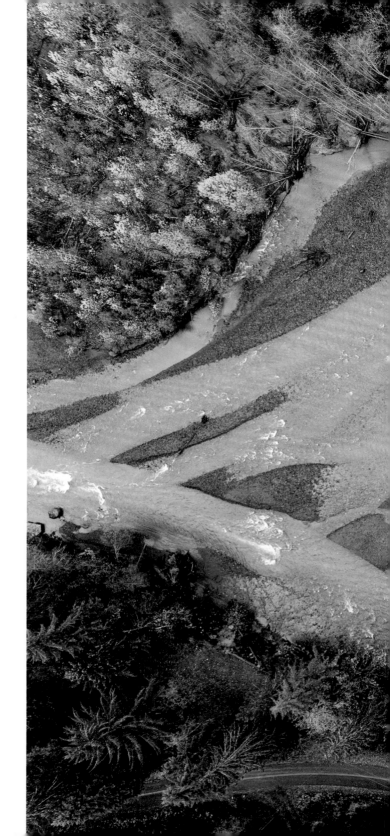

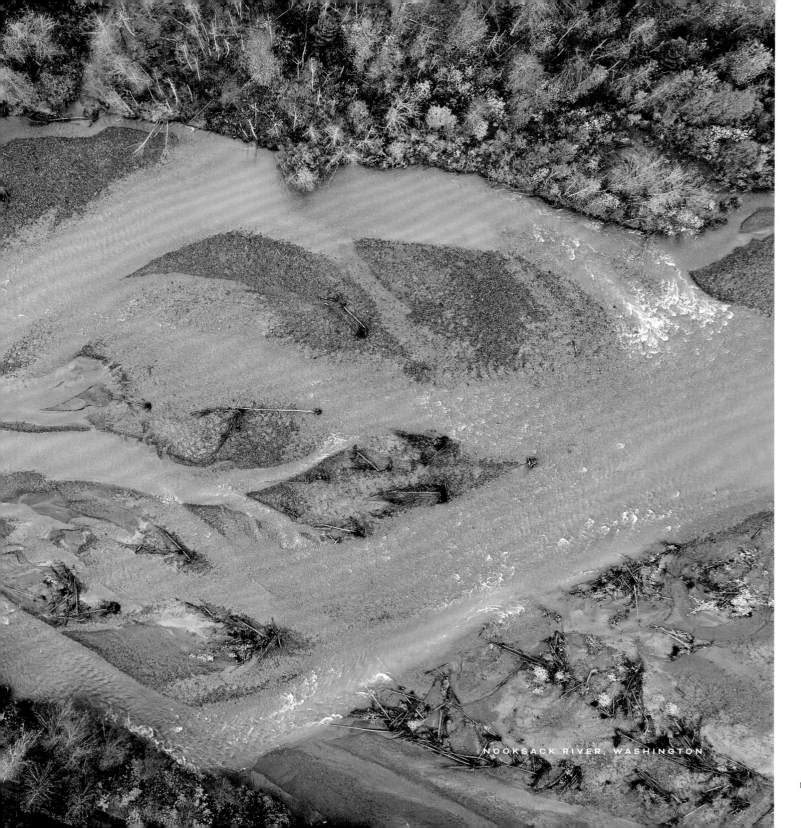

NOOKSACK RIVER, WASHINGTON

DO UNTO THOSE DOWNSTREAM
AS YOU WOULD HAVE THOSE
UPSTREAM DO UNTO YOU.

~Wendell Berry

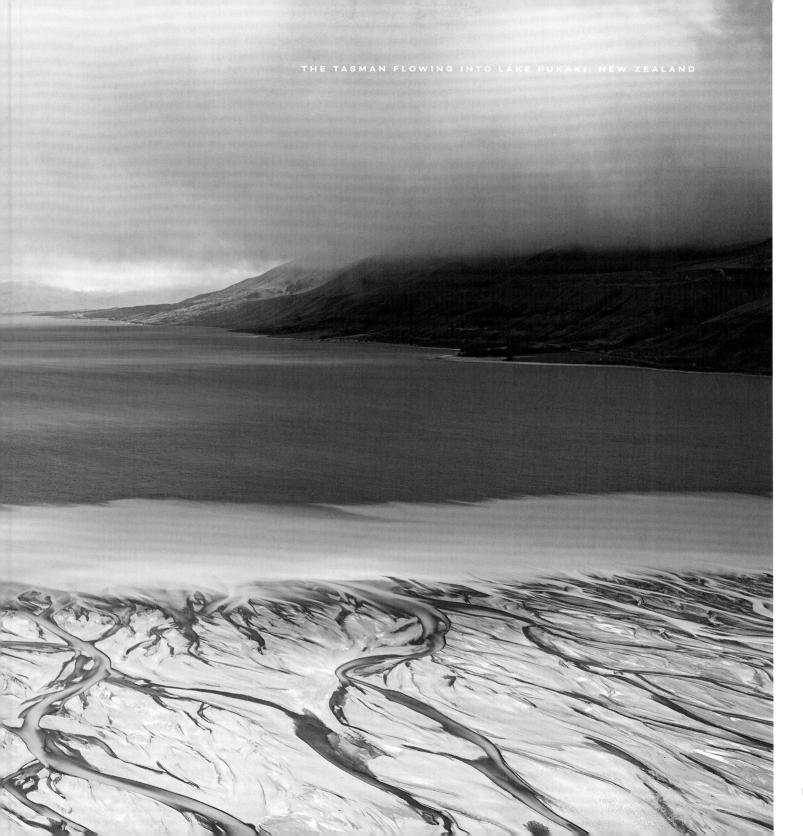

THE TASMAN FLOWING INTO LAKE PUKAKI, NEW ZEALAND

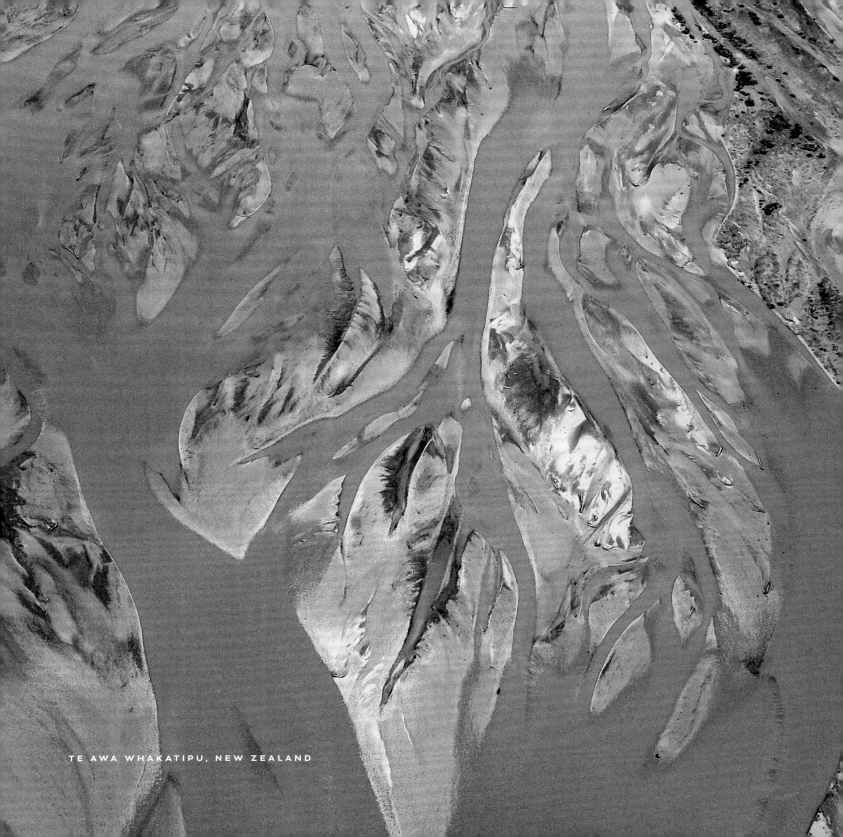

TE AWA WHAKATIPU, NEW ZEALAND

SCORING THE SCENE

Underneath all the texts, all the sacred psalms and canticles, these watery varieties of sounds and silences, terrifying, mysterious, whirling and sometimes gestating and gentle must somehow be felt in the pulse, ebb, and flow of the music that sings in me. My new song must float like a feather on the breath of God.

~ HILDEGARD OF BINGEN

Glacial river systems have mesmerized me for years. Their feathery blue veins flow through scraped landscapes like abstract art. As a glacier melts, it releases a chalky sediment called "rock flour" that gives the water a bright blue hue. These braided rivers flow through valleys carved by glaciers from the Ice Age and fill deep lakes that resemble blue Powerade. They are incredibly hypnotic to look at, especially from a bird's-eye view. And even on the cloudiest of days, their waters still seem to glow with a radiant vibrance.

The image of one river existing in multiple streams that ultimately flow into a unified oneness is a metaphor that resonates deeply. It speaks to me of how the landscapes of our lives may be filled with separate streams that are seemingly disconnected but actually belong to one great river flowing toward greater wholeness.

Yet this reality brings a sobering reminder of death as well. The slow recession of a melting glacier can yield the most stunning of sights. Like a dying star that explodes into a technicolor nebula, a glacier's glorious death is a beautiful lament for the eye to behold. As artist Nick Cave reminds us in his "Song of Joy," "All things move toward their end."[1]

For years, I have hunted this natural phenomenon, just hoping to capture it with my drone. A few times, I have had success in finding these braided beauties in places like Iceland and New Zealand, but the timing was never quite right to see them in their full majesty. These river systems tend to be seasonal and only "bloom" during certain times of the year, typically during a country's wet season.

But in 2018, while on the South Island of New Zealand, my dream came true. After driving down a road less traveled on a very windy day, I bravely sent my drone up into the gust. And then my jaw dropped to the ground. Looking down from above via the preview monitor on my remote control, my eyes were treated to nature's creativity on full display. When I saw these aquatic abstractions, I heard the sound of a cello. Not literally, mind you. But in my mind, I imagined the beautiful, slow bowing of a cello as I saw the bending and bowing of these blue braids weaving through the landscape.

When I returned home and posted my adventures from "Middle-earth" on Instagram, I felt the need to hold these specific images close to the chest. While I love sharing my art and travels, these particular images felt extra special to me. It didn't feel right to quickly slap them up on social media for a few likes. They were meant for something else. Something special. And that something had to involve a cello.

1 "Song of Joy," Nick Cave and the Bad Seeds, track 1 on *Murder Ballads*, Mute Records, 1996.

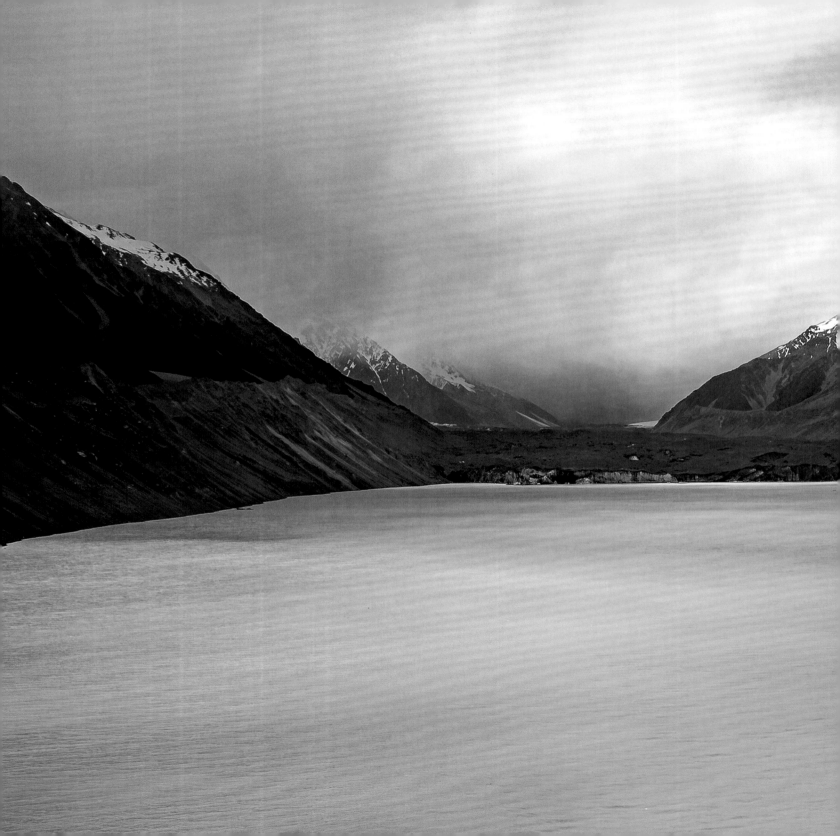

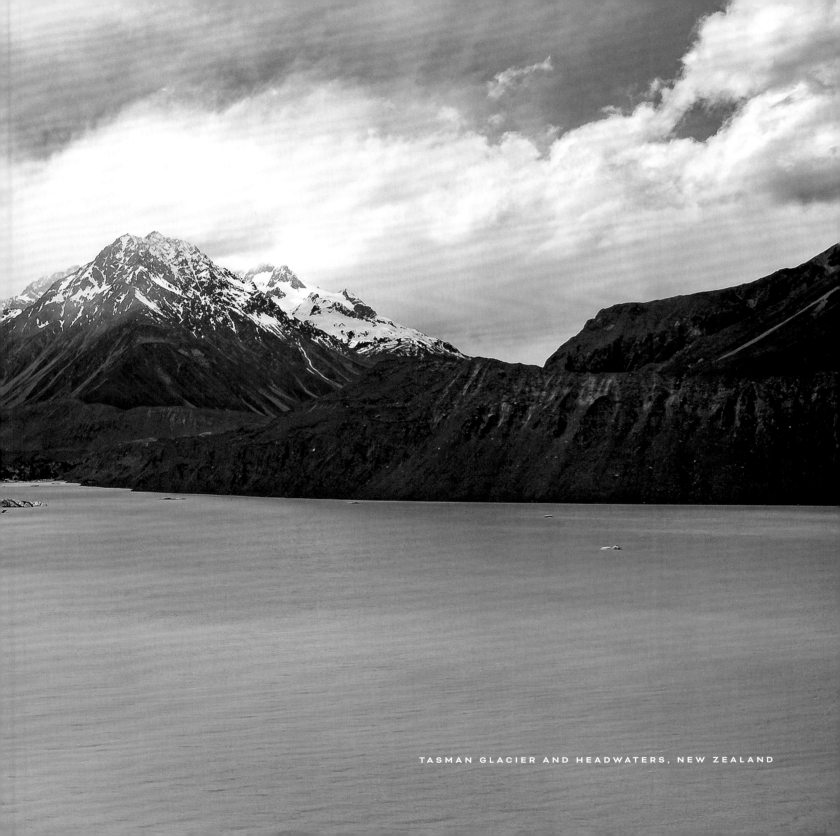

TASMAN GLACIER AND HEADWATERS, NEW ZEALAND

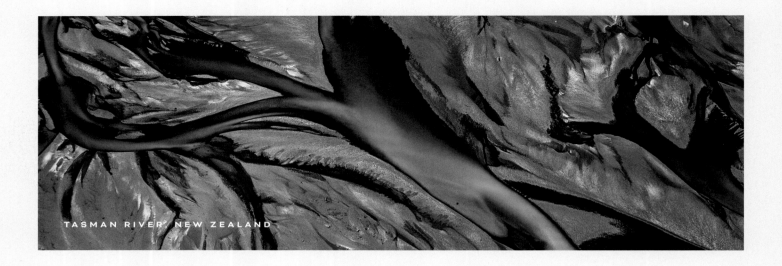

TASMAN RIVER, NEW ZEALAND

THE PRESENCE OF ABSENCE

WITH PETER GREGSON

Two years later, while the world was shutting down because of Covid, I met a British cellist and composer by the name of Peter Gregson. I had just discovered Peter's music through the HBO series *The New Pope* and decided to follow him on social media. One day, he did a live-streamed performance of his album *Bach: The Cello Suites—Recomposed* from his living room, and I decided to tune in. I thanked him on Twitter for his calming performance. He replied, then direct-messaged me, and next thing I knew, a friendship had been kindled across the pond.

Peter ended up inviting me to collaborate with him on a project. He wanted to create a visual identity around an album he was writing called *Patina*. This was a slow, thoughtful collaboration that was spread out over the first few months of the pandemic, when we were all experiencing "the presence of absence," as Peter so eloquently described it.

The vision of *Patina* was to capture this presence of absence, both sonically and visually. With this in mind, Peter intentionally scored pieces that sounded like something was missing, as if the main melody were stripped away, leaving an audible patina in its place. Peter

described this effect by saying, "I wanted there to be space in this music to allow the natural sound of the cello to breathe."

When I started listening to the early recordings of his compositions, I immediately thought of the braided rivers from New Zealand. I sent the images over to Peter to see whether he thought they would provide a fitting visual to accompany his music. When he reflected on the image of the braids as related to his music, he wrote this:

> There was something about the scale, colour, and serenity of the scene that drew me in early on when writing the record. I love how it teeters on the edge of reality but retains a grandeur that could only be natural. This was the foundation of the artwork and aesthetic of the whole record. Something that was so real, it almost looked artificial.

The presence of absence is an awareness I will carry with me for many days to come. And for me, this idea, along with Peter's thoughtful music and the patina left behind on certain landscapes, will be one of the ways in which I look back and remember life in 2020.

TIME TO FLY!

A MOMENT TO REFLECT

Kissako! Go make yourself a cup of tea, coffee, or another warm drink that brings you comfort. And then ponder these questions:

When is the last time someone served you in a way that caused you to feel blessed and give thanks? Or when is a time that you served somebody in this way?

In what ways would you like your life to be a response to the world around you?

What is your "tea" or unique gifting that you can't help but serve to others?

End your time of reflection thinking about the Prayer of Saint Francis. Whether or not you are a person who prays, hold some space for the current troubles of the world and imagine how Francis might live in response to them.

As you sip and ponder these questions, look up Peter Gregson. While all his music is breathtaking and calming, put on his album *Patina* and let the presence of absence wash over you.

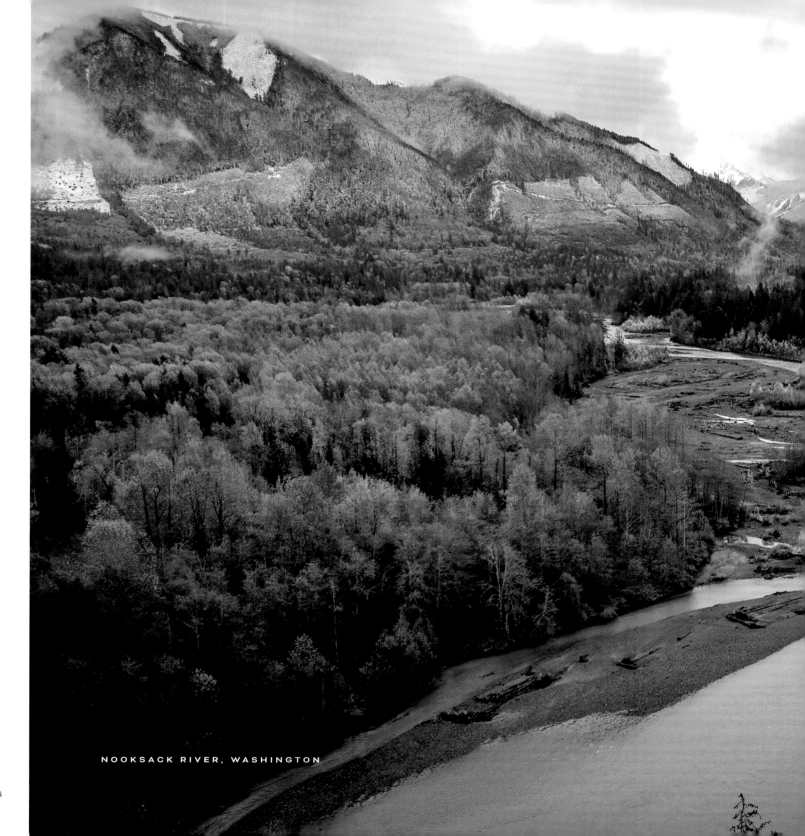

NOOKSACK RIVER, WASHINGTON

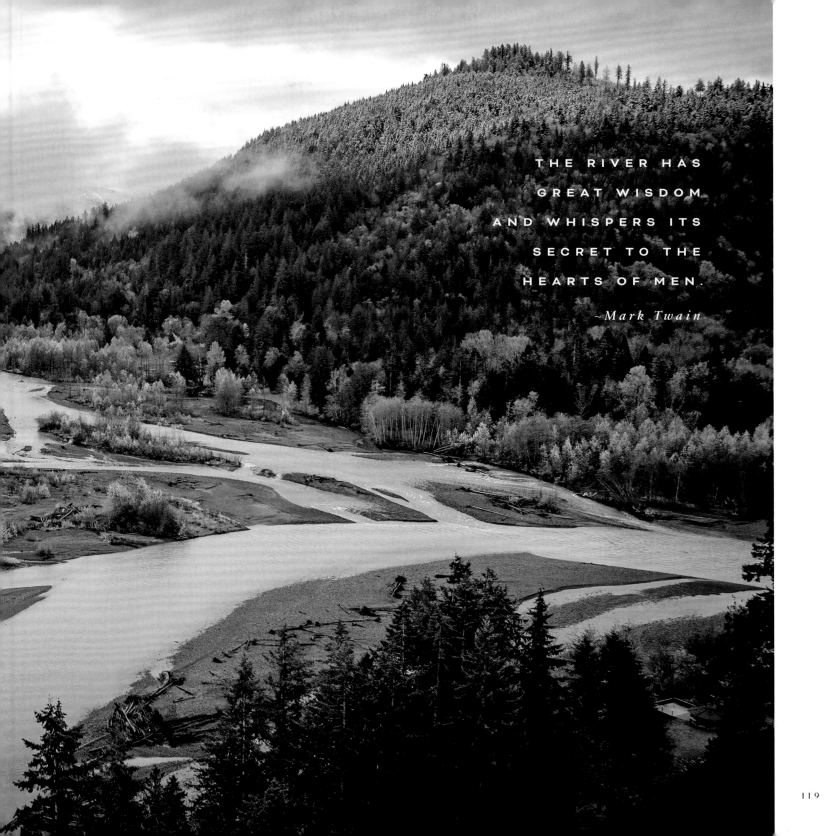

THE RIVER HAS
GREAT WISDOM
AND WHISPERS ITS
SECRET TO THE
HEARTS OF MEN.

~*Mark Twain*

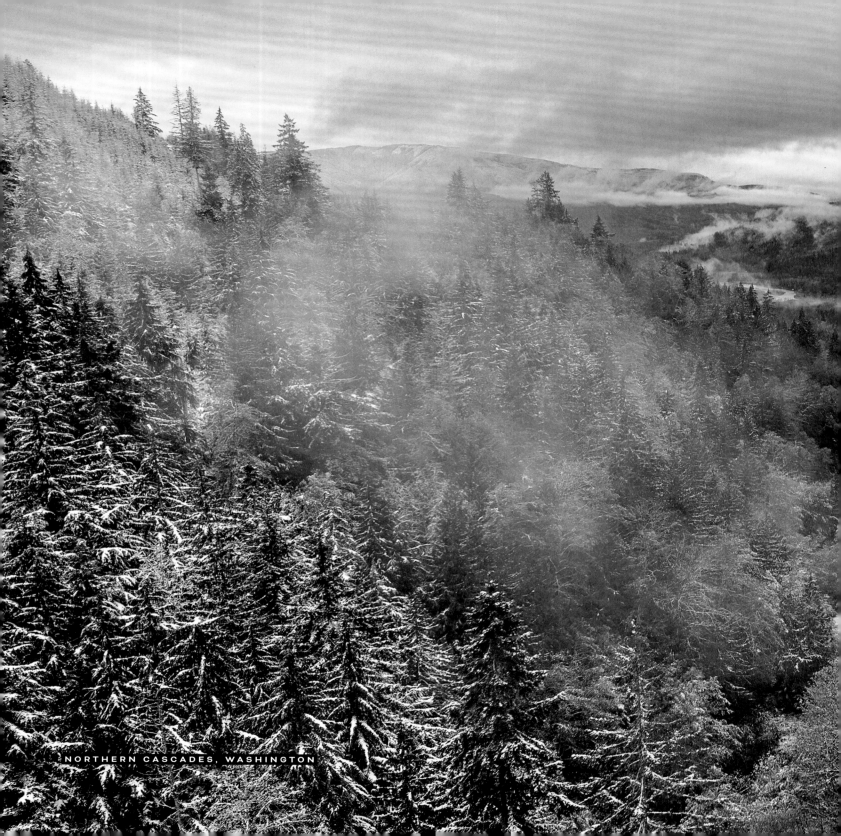

NORTHERN CASCADES, WASHINGTON

SUITE NO· 4

ICE

THE SOUND OF SILENCE

SNOW DAYS

Thank goodness for the first snow, it was a reminder—no matter how old you became and how much you'd seen, things could still be new if you were willing to believe they still mattered.

~CANDACE BUSHNELL

No matter how old I get, I never seem to lose the wonder I feel when waking up to freshly fallen snow, especially when it's the first snow of winter. On those days, when I crawl out of bed and look out the window, I gasp. Every. Single. Time. It's like Christmas has come early, even if it was only Christmas a few days ago. You know the feeling, right?

For those of you who live up north, it may just be another frozen Friday. But for those of us who grew up in warmer climates, such as the American South, a snow day is a rare, exciting gift that momentarily pauses everyone's lives. If you're a kid, your first thought is usually, *Is school canceled?* And if it is, oh boy, get ready for an epic day with friends. Because snow days mean play! From sledding to snowball fights to building snowmen, a wintry playground is a child's best friend. If you grew up in a family like mine, then you might spend the afternoon feasting on my favorite frozen dessert: snow cream! And if you live near the mountains, snow days offer the chance to hit the slopes and enjoy some fresh powder!

I have countless memories of being layered up in cushy clothing and thick coats like Ralphie's younger brother in *A Christmas Story*. Once insulated against the ice, I would waddle out the door and meet up with my neighborhood friends to explore our very own version of Narnia. Inevitably, we would end up grabbing our sleds and discs. And just like Clark Griswold in *National Lampoon's Christmas Vacation*, we would try to set records on how far we could slide and how high we could fly when hitting the snow ramp at the bottom of a nearby hill, a competition that usually led to someone flipping an unexpected way, resulting in an epic wipeout and a bloody nose that colored the snow. *Bingo!*

I hope I never grow tired of snow days. While these days I don't usually grab a sled and head for the nearest hill, snow days still evoke in me a sense of childlike wonder, as if the world has wandered through a wardrobe and woken up in a wintry wonderland.

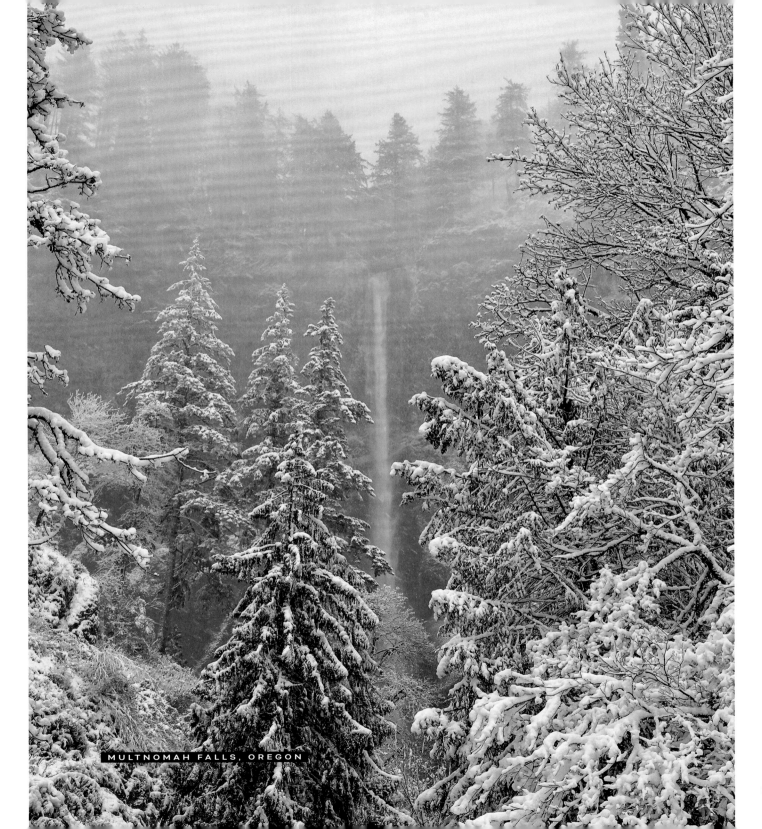

MULTNOMAH FALLS, OREGON

ATTUNE YOUR EARS

I'm very concerned that our society is much more interested in information than wonder, in noise rather than silence.

~FRED ROGERS

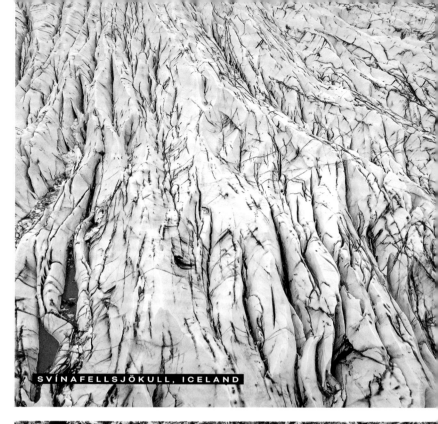

SVÍNAFELLSJÖKULL, ICELAND

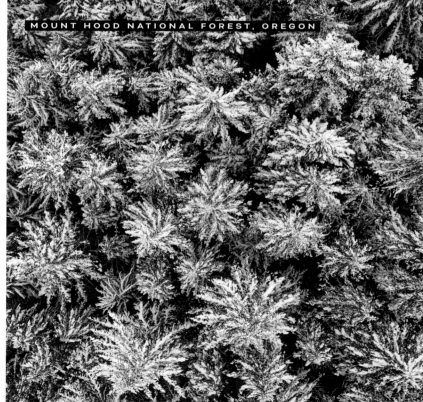

MOUNT HOOD NATIONAL FOREST, OREGON

After a heavy snow, have you ever noticed how quiet and slow the world becomes? Snow is nature's mute button. Thick blankets of white powder wrap the world like a soundproofed studio decked out in foamy acoustic paneling. The noise of the world is brought to a hush. And if we let them, snow days can teach us to slow down and to be still.

Besides snow, another of nature's silent teachers is the glacier. Scarred by time, these icy giants are some of the oldest, slowest, and often quietest beings on Earth. But though they seem completely still, these frozen rivers are always on the move, ever flowing and cascading down from our planet's past. And though seemingly silent, they actually have much to say and many stories to tell.

Glaciers are frozen time capsules, remnants of the Ice Age long ago. They carry our world's story, providing scientists a snapshot of historical climate data, like an old-timey photograph. Bubbles trapped deep in the ice contain ancient air, revealing what Earth's atmosphere used to be like eons ago. Understanding prehistoric carbon dioxide levels is the key to unlocking the mystery of climate change, both past and present.

Glaciers are also maestros at visual art. Few things affect the landscape as much as a glacier. As they slowly scrape by, they mold and form the ground like a potter spinning clay on his wheel in extreme slow motion. Deep ditches are dug out of the mountains. Fjords are filled to the brim with melted ice and rainfall. And where water doesn't wait around, mud and sediment settle, creating vast valleys and grassy plains.

As I explain in the River Suite, glacial melt clouded with rock flour turns into braided blue streams that flow through leftover sediment like abstract art. Similar to the rivers they feed, glaciers themselves tend to mimic contemporary art. When viewed from high above, glaciers reveal hypnotic markings. These monochromatic patterns are formed by deep crevices and long lines of sediment left over from pulverizing the land around them.

Glaciers also have their own language. Just as birds have birdsong, these frozen worlds sing a subtle song through cracking and hissing. As the ice melts, it releases pockets of air and gas that result in a bubbling sound. Together, these noises can almost sound like a snake, which is fitting since their movement mimics the slow slithering of a serpent. And with all the melting and shifting, the sound of cracking and moaning travels deep down and throughout its frozen body. But you have to lean in and listen, for only those who have ears to hear are able to hear the glacier's song.

My priest friend Chad (the same one from the Forest Suite) once had the chance to fly into the interior of Alaska. Because they were leagues away from any civilization, he experienced a profound sense of silence during their excursion. He and his companions landed near a glacier, and as they began to settle into the moment, their guide told them to be quiet and listen. After a while, they were surprised and delighted by the sounds of the glacier resonating and echoing throughout the valley. But if they hadn't been silent and still, they never would have heard a thing.

Attune is a key word Chad used when describing the experience: "You had to befriend the stillness and the silence to attune your ears past the wind and allow yourself to hear the glaciers crack and calve."

Chad's story makes me think of all the quiet beauty we miss out on and never hear because of the lack of silence in our lives. Silence is a gift. It invites us to lean in, listen, and attune our ears to the world around us.

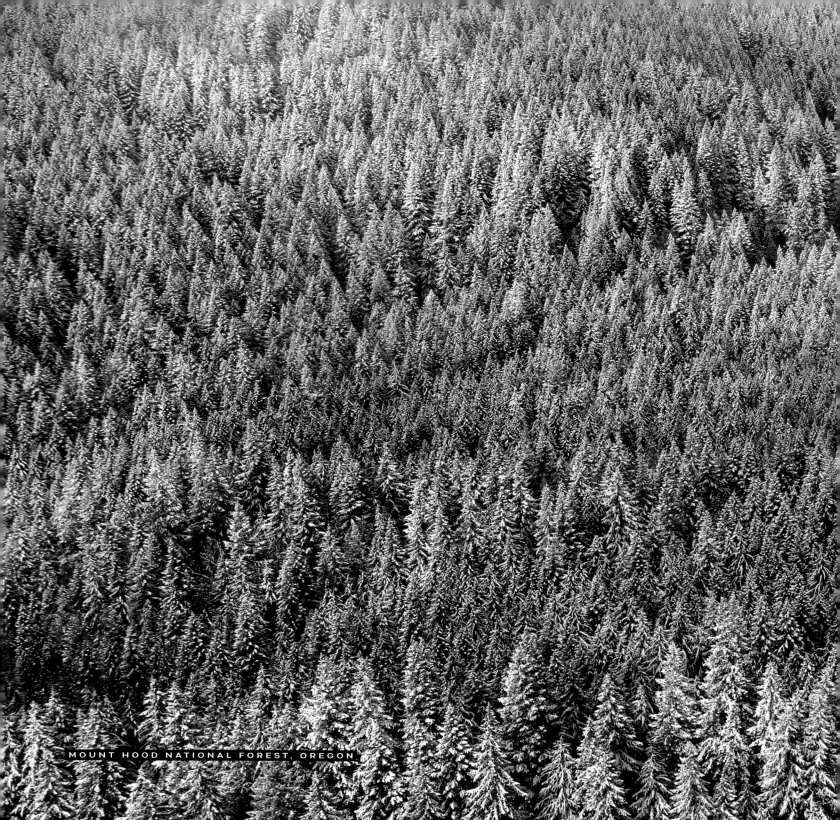

MOUNT HOOD NATIONAL FOREST, OREGON

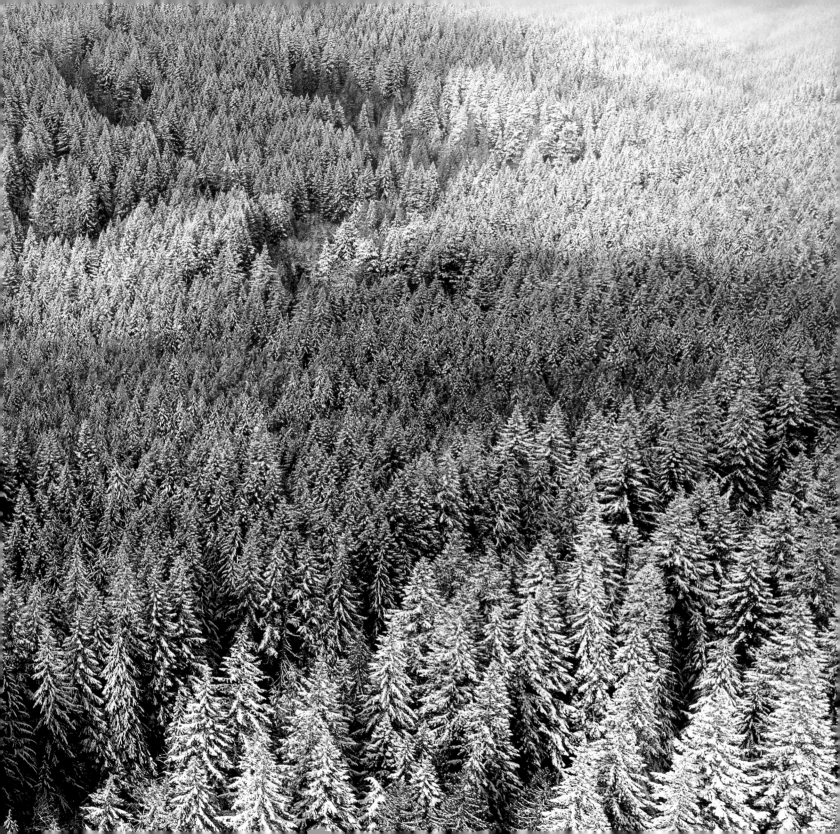

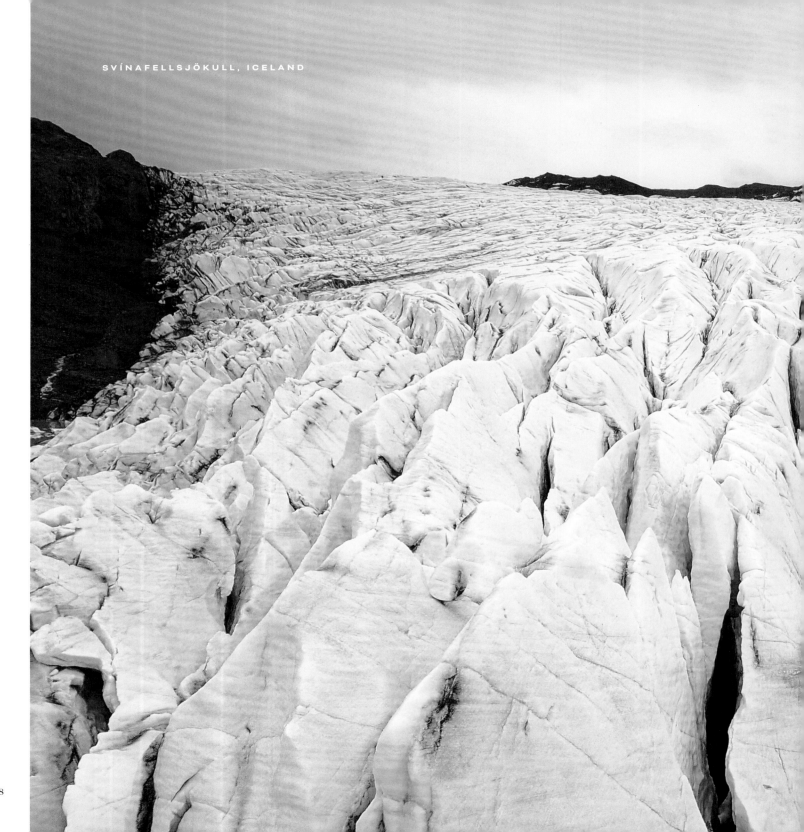

SVÍNAFELLSJÖKULL, ICELAND

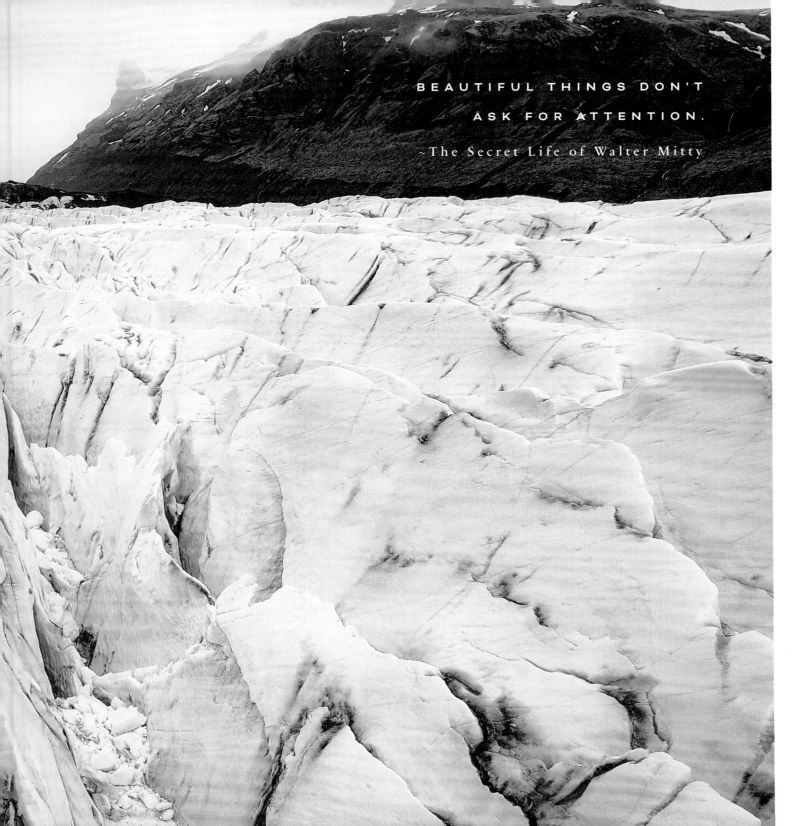

BEAUTIFUL THINGS DON'T
ASK FOR ATTENTION.

~The Secret Life of Walter Mitty

SEEKING SILENCE

Silence is God's first language; everything else is a poor translation.

~THOMAS KEATING

MOUNT HOOD NATIONAL FOREST, OREGON

One of our society's main addictions is noise. Thankfully, I believe the practice of silence, both visual and audible, can help break the cycle of addiction. However, even though escaping the ambient chaos around us can lead to greater health and interior calm, the initial act of doing so can be quite jarring. The vacuum of sound can stir up an anxious feeling of withdrawal within us. After all, since our ears are so used to noise, going without it for an extended period of time can feel both foreign and awkward.

Often when we experience a quiet moment, our bodies become really loud. Heartbeats and breathing begin to dominate our hearing. And if you're "blessed" with tinnitus like me, you'll be treated to a loud ringing that you might have forgotten was there! As it turns out, silence can be quite deafening.

I've experienced this silent sensation in some of the quietest places on Earth. Mirror Lake at the base of Mount Hood is one such place. The altitude of that reflective pond along with the bowl shape of the land and enclosing forest make it a sanctuary of silence. The summit of Haleakalā on Maui is another such place. Due to its ten-thousand-foot elevation and its setting in the middle of the Pacific Ocean, this massive shield volcano is cut off from the noise of civilization like few other places on Earth.

Seeking silence has not always come easily for me. I've usually been the loudest one in the room, always expressing my opinion, trying to get a rise out of someone, or digging hard at the deeper things with too many words.

And then there's social media.

Now everyone has a stage and a microphone to air their grievances, sell their wares, or promote their "personal brand"—all in service to the gods of platform and influence. Of course, there are wonderful things about social media. But I think many of us can agree that all the self-promotion, hot takes, and clickbait are just becoming a bit too . . . much. And our souls need a break.

Taking seasonal breaks has become the norm for many. Giving up social media for Lent has become a common form of digital "fasting." Some choose to take a weekly or monthly tech cleanse, which can mean going an entire day without screens in order to give one's eyes and mind a Sabbath day of rest. Add to this trend the rise of meditation apps and podcasts promoting "calm." Overall, as more and more people seek ways to practice intentional silence and meditation, the message is becoming apparent: The noise surrounding us has gotten out of hand.

Silence, it seems, has become a rare commodity. I would even go as far as to say that experiencing silence has become a form of privilege, since it usually requires time, effort, and money to find it, especially if you live in an urban center. Silence may be more accessible for some of us, but for many, the daily rhythms of life and its surrounding environments make it extremely difficult to find a quiet moment.

But it can be done. It just takes intentionality and practice.

From a personal standpoint, practicing silence has been incredibly transformative to my way of living. In fact, I sought it so hard that I sold all I had, left the city, and found a way to live in a cabin in the woods. (But I tend to take things to the extreme!) What was once uncomfortable to me has now become my way of being. Still, even now, I have to be intentional. I may live in a quieter place, but I still have my phone and our noisy world at my fingertips.

It's ironic how you can curate peace and quiet for yourself while your inner self is anything but. Choosing to surround yourself with silence is only the first step. Quieting the mind is where the real work begins.

TIME AND
SILENCE ARE
THE MOST
LUXURIOUS
THINGS TODAY.

~Tom Ford

COLUMBIA RIVER GORGE, WASHINGTON

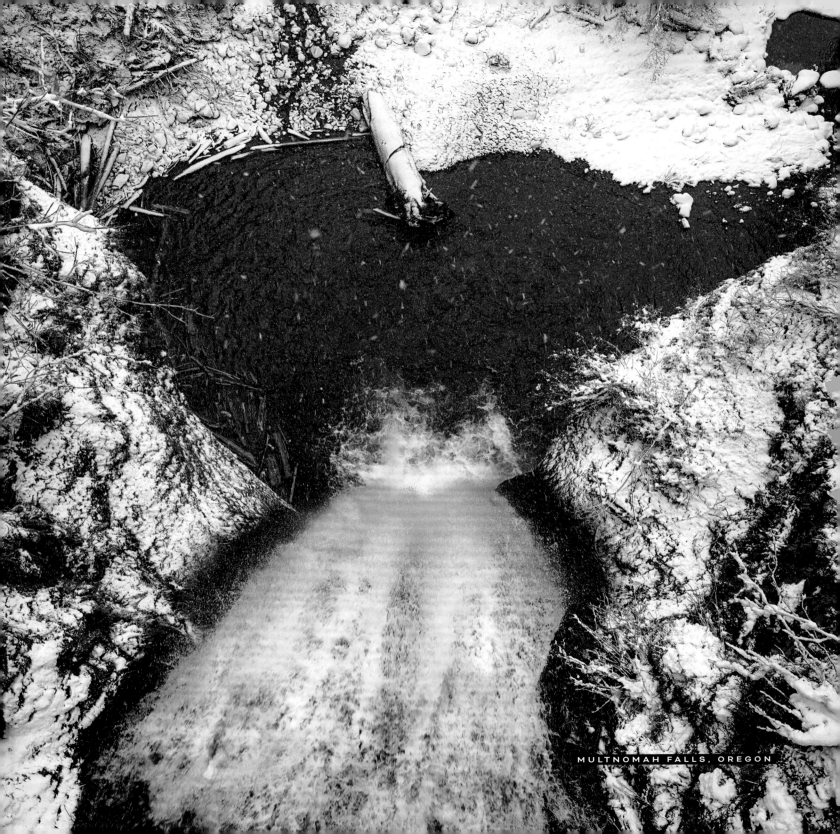

MULTNOMAH FALLS, OREGON

D O W N
B Y T H E
R I V E R

To sit in solitude, to think in solitude with only the music of the stream and the cedar to break the flow of silence, there lies the value of wilderness.

~ J O H N M U I R

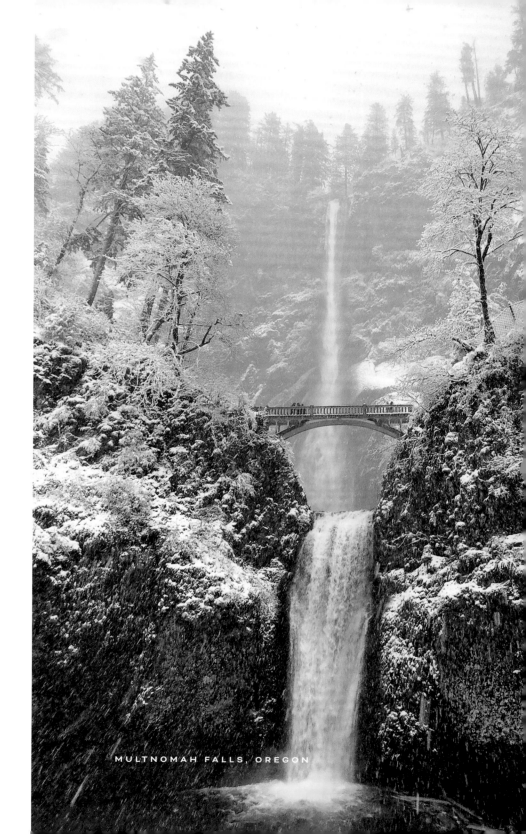

MULTNOMAH FALLS, OREGON

If you've ever practiced silence for an extended period of time, you may have experienced your brain going into full monkey mode, especially if you have ADHD like me. Your mind begins swinging from thought branch to thought branch, often leaving you with the feeling that you've failed. "I'm not any good at this!" is a response I've heard (and felt) many times.

For those of us who are perfectionists, practicing silence—alone or with others—can be downright frustrating. We're often tempted to break awkward silence with a conversation, even with ourselves. Thankfully, through the wisdom and leadership of a few patient mentors, I've learned about a mental exercise that's helped me focus on being present with myself in a quiet moment.

Thomas Keating was an American Trappist monk who played a leading role in the development of Centering Prayer, a modern contemplative practice. Especially for those who are new to practicing silence, Keating created a mental image to fall back on when our minds start to wander. And it goes something like this.[1]

Imagine you're sitting on the bank of a river enjoying a moment of stillness. And then, one by one, you see boxes floating past you on the water. These boxes represent your thoughts and feelings: conversations you had earlier that day, an argument with a partner or co-worker, an approaching deadline, an errand you forgot to run—you get the idea. All these mental and emotional moments keep floating by, begging for your attention.

One response would be to give in, swim out to a box, open it up, and rummage through its contents. Another might be to try and ignore them, acting like they aren't there. One might even be tempted to push the boxes away by hating, critiquing, or judging them. But instead, Keating invites us into a posture of healthy detachment by simply acknowledging them, speaking "peace" over them, and letting them float away. Even if the muse decides to speak in that very moment, imparting to you a symphony, poem, or the answer to world peace, just let it go. Because the reality is, the river of our mind is a looping stream of consciousness. And those boxes aren't going anywhere. They will always return again later. But for now, all they should get is a nod and a blessing.

Herein lies the essence of silence. It's simply being present with yourself and your thoughts. When I practice silence, I often return to "the river" and smile as I watch the boxes pass by. If I end up attaching to a few boxes, as I so often do, I cut myself some slack and embrace a little self-compassion. Because silence is an invitation for compassion, not critique.

Learning to quiet the mind is an act of loving-kindness toward yourself, and therefore, it often takes patience and practice. And when we show kindness to ourselves, we are better able to show kindness to others and to love the world around us more deeply.

1 "Watching the River," Center for Action and Contemplation, May 10, 2016, cac.org/daily-meditations/watching-the-river-2016-05-10.

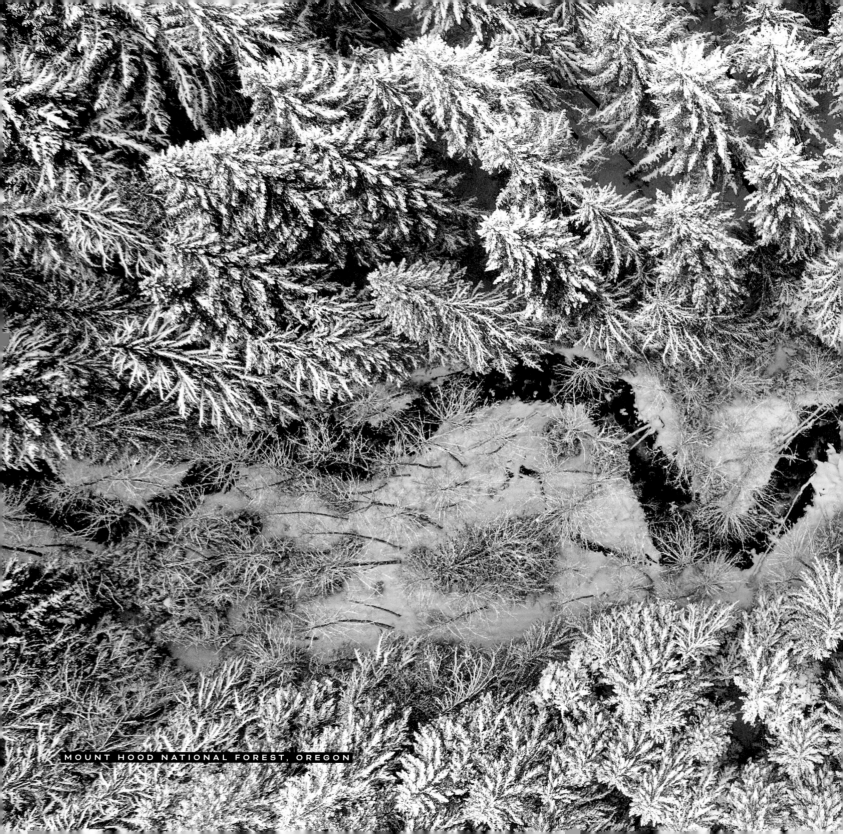

MOUNT HOOD NATIONAL FOREST, OREGON

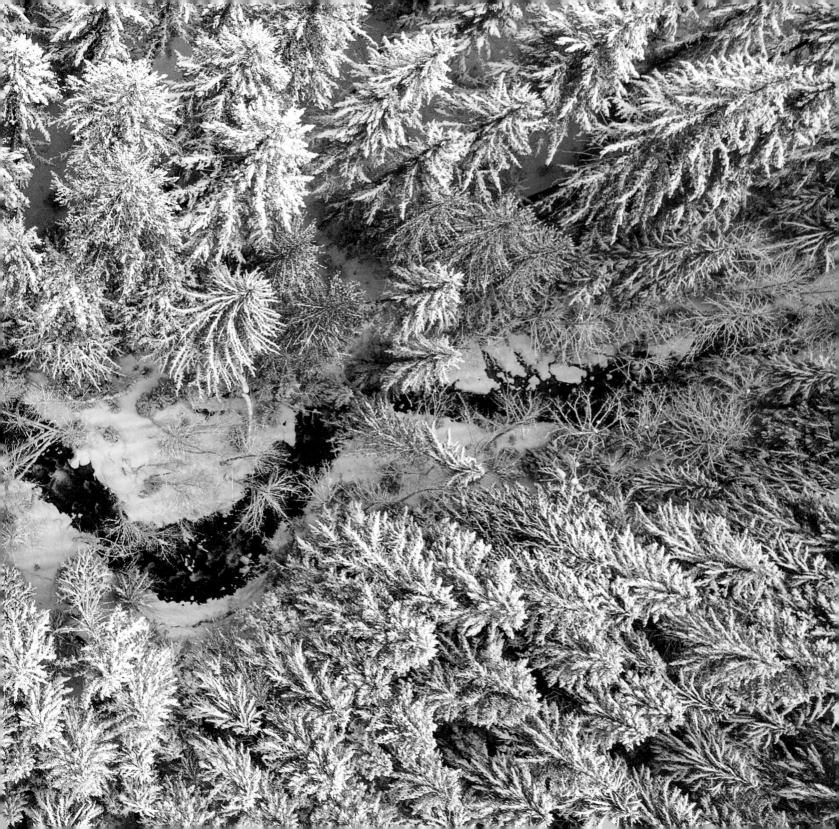

NORTHERN CASCADES, WASHINGTON

EVERYTHING HAS ITS
WONDERS, EVEN DARKNESS
AND SILENCE, AND I LEARN,
WHATEVER STATE I AM IN,
THEREIN TO BE CONTENT.

~Helen Keller

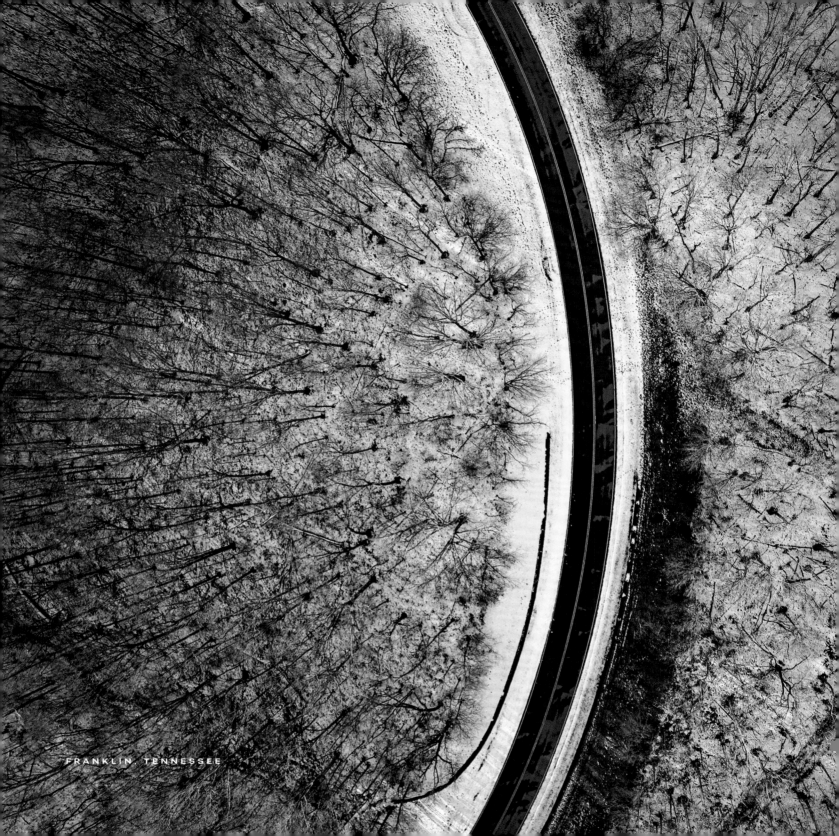

FRANKLIN TENNESSEE

SILENCE IS SPOKEN HERE

In a world of noise, confusion, and conflict, it is necessary that there be places of silence, inner discipline and peace. In such places, love can blossom.

~ THOMAS MERTON

On a warm September day in 2012, I packed up my gear and drove down from Nashville to Birmingham for a big gig. On my way down Interstate 65, I stopped in Franklin to say hello to my friend and mentor Ian Cron. I sat on his porch and confessed my reluctance and state of emotional confusion. It was a dream gig, yet on that day, I couldn't care less about going. I was simply too exhausted from a very busy and highly "successful" year.

In classic Ian fashion, he asked, "Have you ever been on a silent retreat?" He knew too well the burnout I was beginning to experience. I had heard him talk often about the power of spending a few days in silence, so the question didn't surprise me at all. In fact, I knew it was coming.

"No," I answered with a sigh. "It's been on my mind, but I just haven't made time for it yet."

"Well, you may want to consider doing that soon," Ian suggested.

That same month, I drove up to Kentucky to spend three days at the Abbey of Gethsemani, a Trappist monastery tucked away in the countryside. When I approached the grounds, I saw a sign that read SILENCE IS SPOKEN HERE. This gentle rule encouraged me to be mindful of my voice as I entered the peaceful domain, where practicing silence is a way of life. I checked in, found my room in the dormitory, and spent some time walking the grounds.

Whoever designed the abbey was so thoughtful in creating intentional spaces to simply be and contemplate. A courtyard. A library. A humble graveyard for monks who've passed away. Multiple prayer

gardens, some with winding paths marked by the Stations of the Cross. And of course, the sanctuary—a clean, white, minimalist chapel with a lofty ceiling, where prayers and psalms are chanted throughout the day.

But my favorite part of the abbey, of course, was the surrounding forest. Miles-long trails curve through the trees, past a lake, into a clearing, and up a hill. That forest became my haven. I spent many an hour in silence while I rummaged through the boxes of my mind and sought rest for my fatigued soul.

The first two days weren't easy. So many voices and anxious thoughts filled my head. It was almost too overwhelming. Trying to listen to the "still, small voice" within can be like searching for a needle in a haystack.

Which voices am I supposed to listen to? Is God even speaking to me? Or am I just wrestling with my own demons? My life is exciting, but am I truly happy? Do I like who I'm becoming? I can't stand going to church anymore, but this monastery is amazing! Maybe I should become a monk. Do monks have iPhones? Because if not, that would be too hard . . . no, wait, on second thought, that sounds amazing! I love these woods; I wish I could live out here. I'm getting hungry.

One of my favorite humans in the multiverse, Michael Gungor, did a wonderful job explaining this conundrum in his book *The Crowd, the Critic, and the Muse.*[1] When he went on his first silent retreat in Italy, he described it like a barrel of water rolling down a hill. When you first start practicing silence, it's like the barrel has hit the bottom and comes to a sudden stop. Except the water inside the container is still sloshing around like a wave pool. He said it usually takes about three days for the water to finally become still. And that's when the inner silence truly begins.

And so it is with us. We are like barrels of water rolling down a hill at all times. And then we try our hardest to slow down and stop. But even though our body's movement may come to a screeching halt, our inner self continues to slosh around. It can be quite uncomfortable. I think that's why so many of us avoid silence and stillness. As Ian says, "We don't like silence because we're afraid we might bump into ourselves."

But silence is where we can find our sanity again. Stillness is where we can find rest. The more we can do this, the less turbulent the water inside will become.

It just takes time. And practice. And compassion.

This is the way.

1 Michael Gungor, *The Crowd, the Critic, and the Muse* (Topeka, KS: Woodsley Press, 2012).

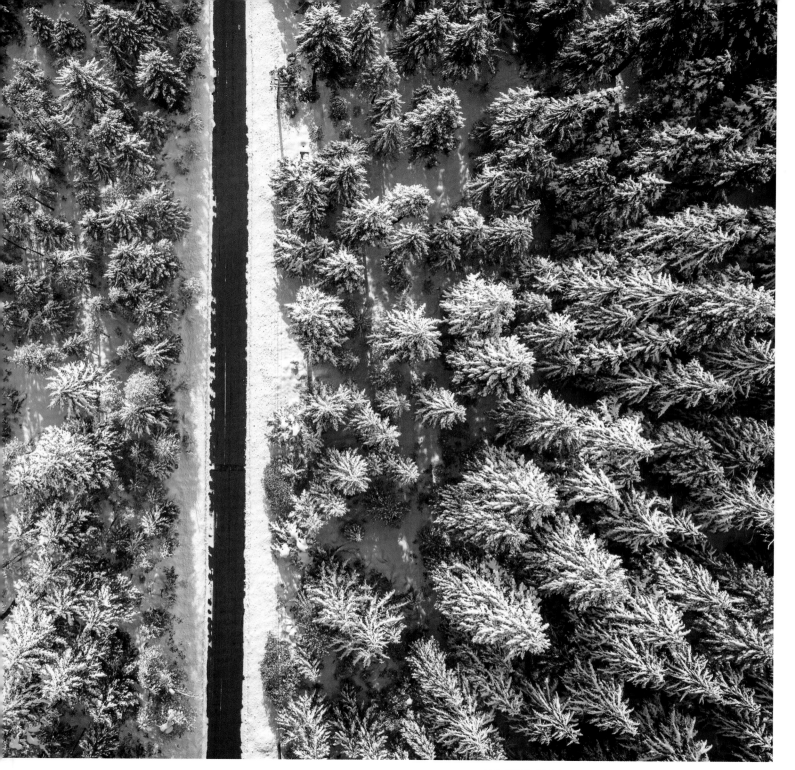

MOUNT HOOD NATIONAL FOREST, OREGON

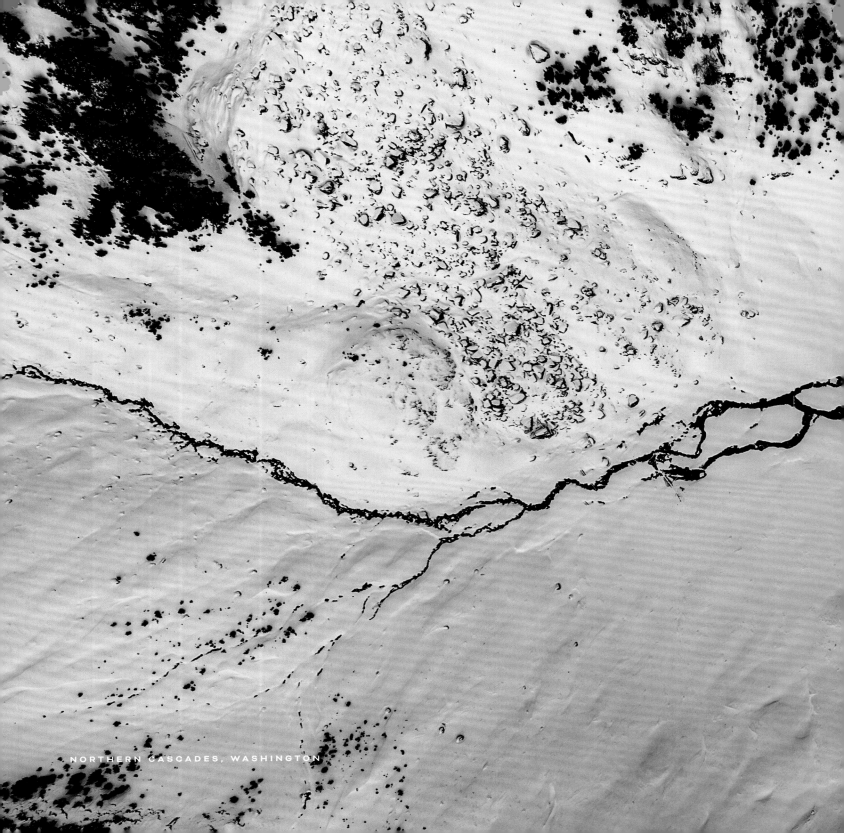

NORTHERN CASCADES, WASHINGTON

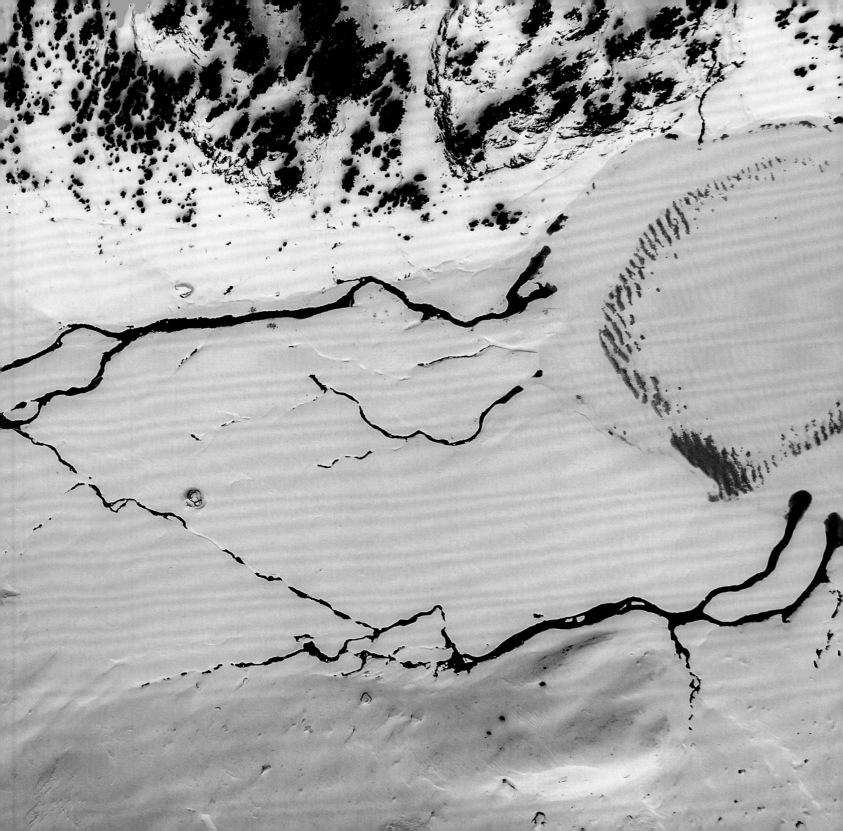

SCORING THE SCENE

The music is not in the notes but in the silence between.

~WOLFGANG AMADEUS MOZART

FJALLSÁRLÓN, ICELAND

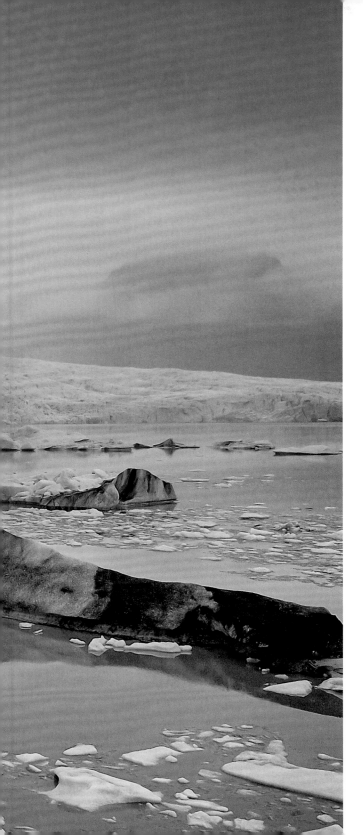

Winter wonderlands have been the source of inspiration for countless songs. With Christmas carols and nostalgic holiday classics sung by icons like Bing Crosby and Mariah Carey, winter is the only season with its very own musical genre! Unless, of course, you live in the Southern Hemisphere, where Christmas involves barbecuing on a hot summer day. But even still, our southern friends are used to hearing the rest of us sing about snow every December!

And then there are Christmas movies, with their nostalgic soundtracks. From *Home Alone* and *The Holiday* to *Elf* and *White Christmas*, our culture is constantly caroled for a solid month, and nowadays, sometimes longer.

Even after the holiday season has passed, winter still has a song or two left to sing. Whenever it snows, I'm inclined to crank up the volume on pieces like "Ice Dance" from the *Edward Scissorhands* soundtrack by Danny Elfman. And albums like Ólafur Arnalds's *For Now I Am Winter* create a vibey ambiance that underscores the icy chill and leaves me feeling calmed and inspired. (By the way, my condolences to you parents everywhere who are *blessed* with children who like to play—and sing!—*Frozen* on repeat whenever it snows!)

The correlation between the land, the seasons, and music continues to be of great interest to me. What makes a scene sound a certain way? Why do specific sonic textures work so well when paired with certain landscapes? So much of this has to do with the creative decisions made by the composers of our favorite movies, TV shows, and documentaries. With that in mind, I'd love to peek into their world for a moment.

James Everingham is a British film composer from Bristol. James and I met years ago when he was still in high school and working on a school project involving projection art. He emailed me to ask for some advice, which I happily gave. It was then that I discovered that James was scoring his earliest works on a synthesizer and computer in his bedroom. And I was quite impressed with what I was hearing. Fast-forward a few years, and James is now living in Los Angeles and working at a studio run by Hans Zimmer, one of today's greatest film composers!

In 2022, James was invited to collaborate with Hans and another composer, Adam Lukas, to create the score for BBC's *Frozen Planet II*. It is a magnificent, elegant soundtrack that truly captures the essence of ice, and I couldn't help but ask James to share a glimpse into his creative process.

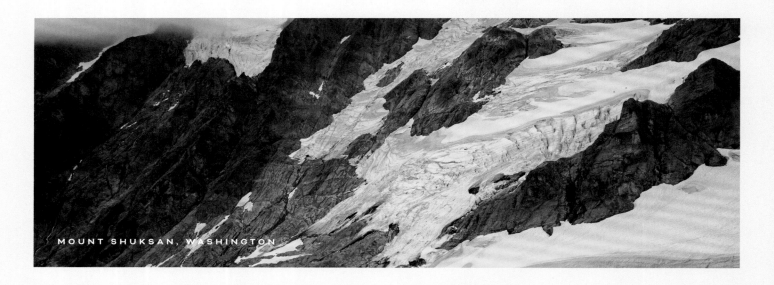

THE SONG OF A FROZEN PLANET

BY JAMES EVERINGHAM

When it comes to the sounds of nature, there's a wonderful instability and unpredictability that's really hard to achieve with synthesizers and conventional orchestral instruments. So even if I'm taking field recordings and processing them beyond recognition, having an organic sound source with an interesting timbre, and then working with it in a musical context, is something I've found really lends itself to scoring work. From macro photography of frozen lake beds to vast ice sheets collapsing with immense force, a documentary like BBC's *Frozen Planet II* presents a scale of both extremes, and natural sounds played a large part in the process of designing and writing the score alongside Hans Zimmer and Adam Lukas.

One example is through working with decades-old analog equipment, a process that inevitably introduces noise. But instead of trying to eliminate this noise, we tried to think of it as a musical incarnation of an icy wind—performing the controls of the tape machine to create swells and gusts across the music like an organic vinyl crackle. We also used reel-to-reel tape recordings to look at how we could resemble changing states of matter within a musical technique. Recordings

of acoustic instruments played backward at incredibly slow speeds became soundscapes that were familiar and grounded, yet textural and sporadic in a very uneasy, yet natural way.

We also explored ways to capture the phenomenal complexity of frozen forms with a string orchestra. With eight of London's best players at AIR Studios, we set about building a musical tool kit that represented the splintering of ice, the individuality of snowflakes, and the blooming patterns that occur beneath the surface of frozen lakes. With each articulation, we carefully sculpted the ensemble's performance like an organic synthesizer, emphasizing dynamics and allowing the individuality of each player to surge through. In a way, making these recordings was not so dissimilar to photography in its process—the magic of a fleeting moment, impossible to perfectly re-create, captured and stored to be enjoyed or used time and time again.

The sounds of the natural world are full-spectrum aural experiences, rich in dynamic range. And while perhaps not musical in a traditional melodic sense, I find a lot to learn sonically from the world around us—in the patterns and the noise, the rhythms and the stillness.

TIME TO FLY!

A MOMENT TO REFLECT

Take at least five minutes to spend in complete silence. For best results, seek out a location in nature or in a room that lends itself to quietness. Finish by listening to a beautiful piece of music that you aren't used to hearing. Some nice compositions can be found in the "Music for Ice" playlist provided at proktr.com/wildwonder.

Does practicing silence come naturally for you? Or is it typically an uncomfortable experience? Why do you think that is?

The next time you have a long commute by yourself, choose to spend that drive in total silence. Put your phone on Do Not Disturb and leave the radio or music off. Use this time to cleanse your mind and reset yourself for the next part of your day. And remember, when the boxes float down the river of your mind, simply acknowledge them and speak peace over them.

Establish a quiet hour (or day) in your home. Invite your family or roommates to share some silence with you. Turn off as much electronic light as possible, light as many candles as you can, and encourage everyone to stay off their devices. (Good luck if you have kids!) Let silence be spoken in your home; it has much to tell you.

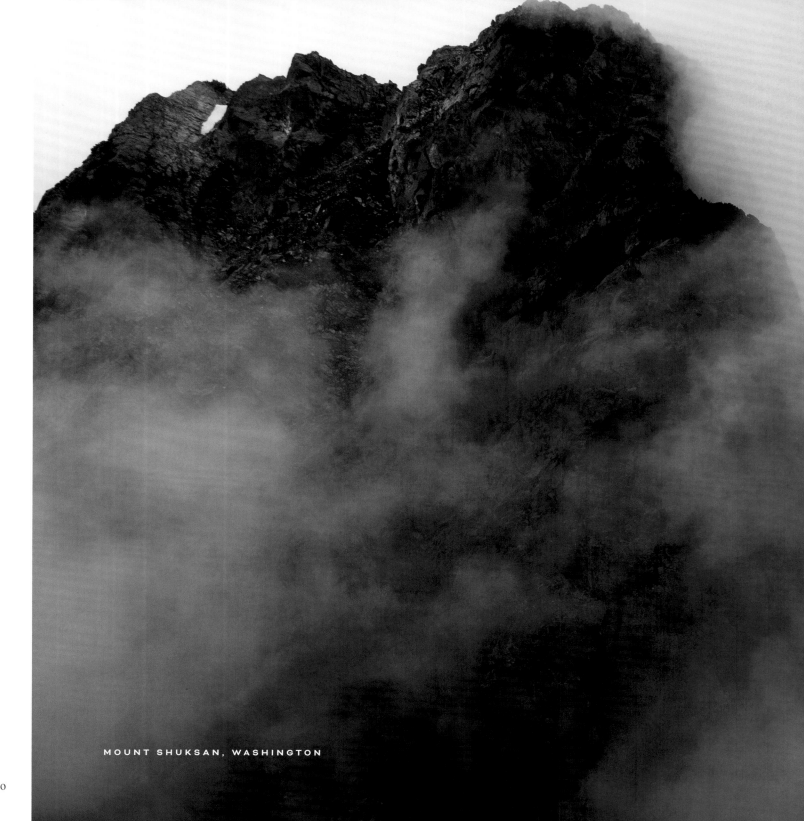

MOUNT SHUKSAN, WASHINGTON

IT ALL ADDS UP TO ONE THING: PEACE, SILENCE, SOLITUDE. THE WORLD AND ITS NOISE ARE OUT OF SIGHT AND FAR AWAY. FOREST AND FIELD, SUN AND WIND AND SKY, EARTH AND WATER, ALL SPEAK THE SAME LANGUAGE.

~Thomas Merton

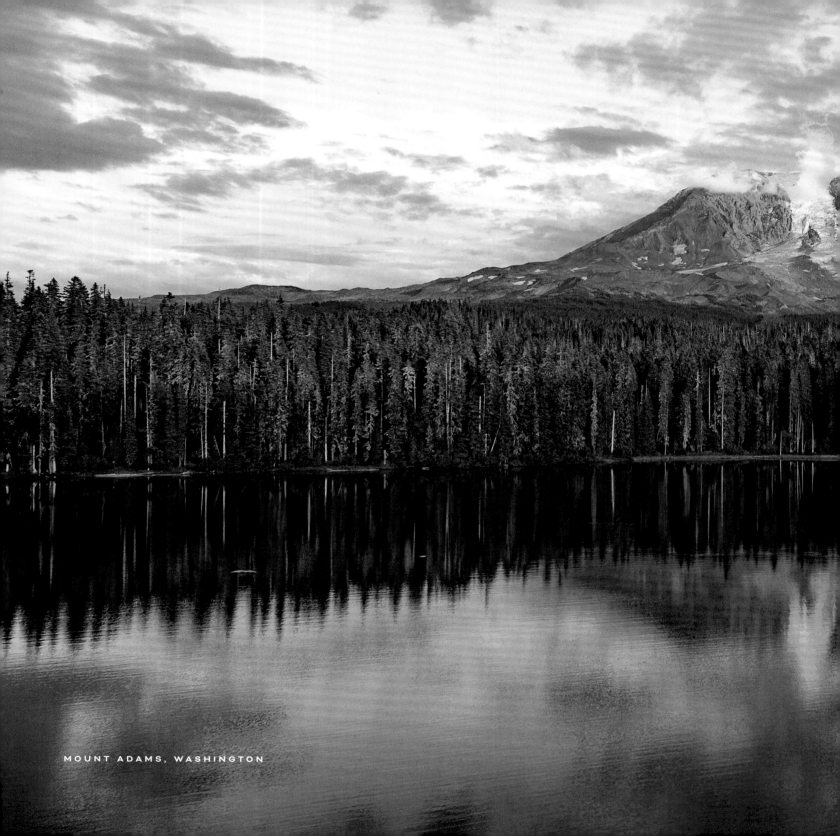
MOUNT ADAMS, WASHINGTON

SUITE NO. 5

MOUNTAINS

SANCTUARIES IN THE SKY

ASCENSION

I want to see mountains again, Gandalf, mountains,
and then find somewhere where I can rest.

~J.R.R. TOLKIEN, *THE FELLOWSHIP OF THE RING*

I'll never forget the first time I saw Mount Hood. I was sitting in the window seat on my first flight to Portland, and the size and nearness of the lonely mountain were overwhelming. It was so unexpected and shockingly majestic that my heart stopped for a second and a rush of wonder hit me. I had seen mountain ranges before, but not like this one. The Cascades of the Pacific Northwest are a different ball game.

Part of the Ring of Fire, the Cascades are dotted with massive stratovolcanoes that tower high above their evergreen kingdoms. On a clear day in Portland, you can see Mount Hood on the eastern horizon, sometimes glowing in the warm pink light of golden hour. You might also catch a glimpse of Mount St. Helens with her missing peak, a sobering reminder that these are not mere mountains but behemoths with fire in their bellies. Travel up north, and you'll be treated to the ginormous size of Mount Rainier, the king of the Cascades.

These mountains are one of the many reasons I moved to the PNW. Maybe it's because I grew up in the delta of Arkansas, where the only break in the flat farmland was Crowley's Ridge, elevation 550 feet above sea level. That's not to say that the South doesn't have its own inherent beauty, but for this southern boy, nothing can compare to seeing a giant jagged rock rising out of the ground, even from far away. And when I get up close, a mountain turns into a whole different world.

Switchbacking up a mountain road past the alpine tree line can feel like an ascension into Heaven. Climbing above the clouds often brings with it a sense of transcendence. The peak seems almost within reach, as if it's less of a mountain and more of a large hill to be climbed, but the perspective can be deceiving. Then you turn a corner and see it: the entire world beneath your feet. All you left behind seems so far away, dwarfed by the giant's shoulders you're standing on. These moments never fail to fill me with awe and wonder.

"Are you more of a beach person or a mountain person?" is a commonly asked question. Some want a rugged alpine adventure, and others just want a sunny nap and swim. Some people like it hot, some like it cold. While I won't say no to a lazy day at the beach, the mountains fill my tank much more quickly than time by the sea. I'd rather be hiking, skiing, or droning off the side of a cliff than getting sand all over me on a hot day. But that's just me. Different landscapes have different effects on people.

For us alpine folk, the mountains are our sanctuaries in the sky. We tend to thrive when we can get away from the world. We love going off by ourselves or with a close friend or two to take in all the wonder we can contain. We greatly welcome shifts in perspective and love gaining clarity on life. And summiting to the top can leave us feeling like we've conquered the world—or at least our own bodies, which is no small feat if you're out of shape like me!

Mountains fill us with awe and wonder while also taking our breath away, sometimes quite literally thanks to the altitude. This is the power and beauty of ascension. The higher our perspective rises, the more breathless and speechless we become.

But trying to describe the indescribable is another mountain to climb altogether.

NORTHERN CASCADES, WASHINGTON

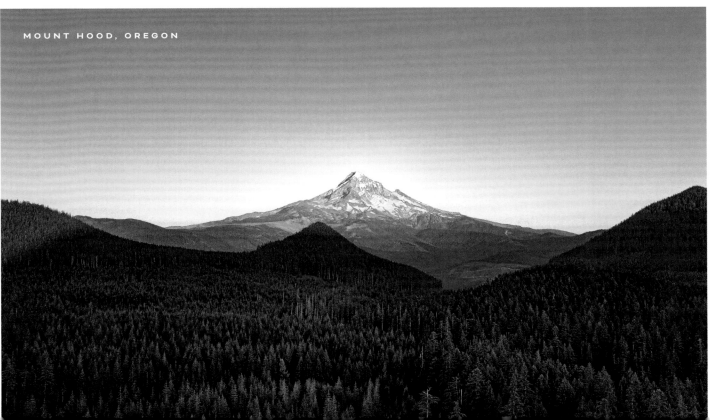

MOUNT HOOD, OREGON

155

OUTDOORS WE ARE CONFRONTED
EVERYWHERE WITH WONDERS;
WE SEE THAT THE MIRACULOUS
IS NOT EXTRAORDINARY, BUT THE
COMMON MODE OF EXISTENCE.
IT IS OUR DAILY BREAD.

~Wendell Berry

HALEAKALĀ, MAUI, HAWAI'I

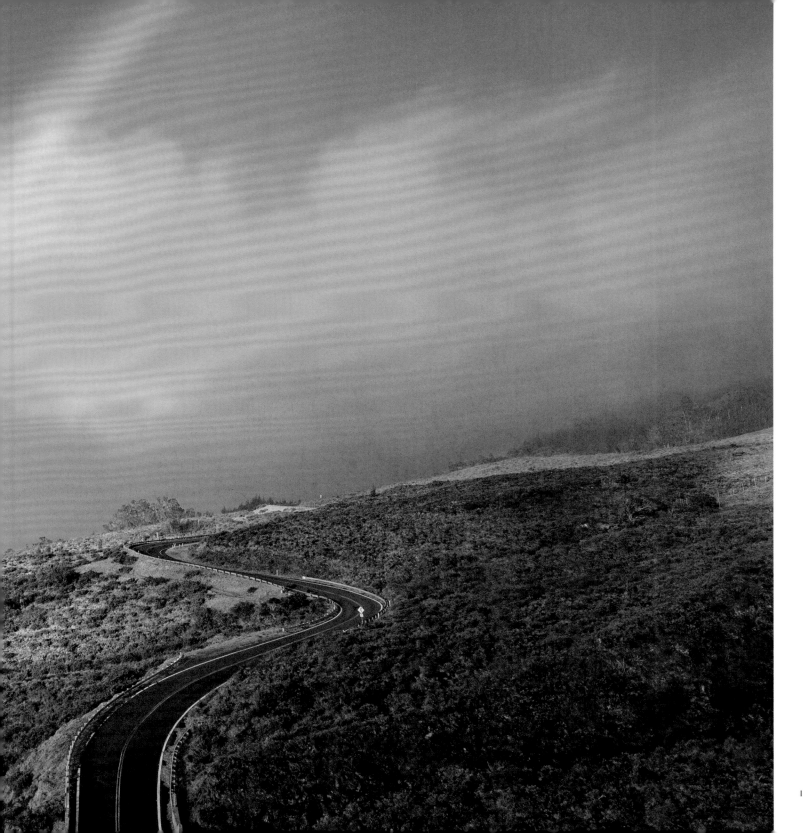

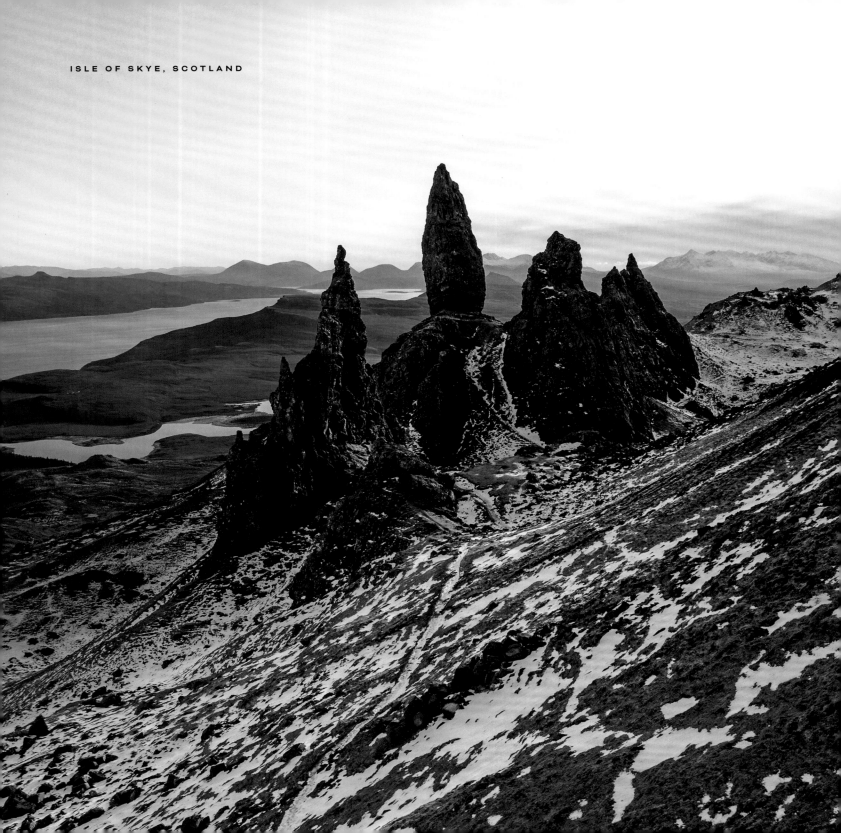

THEY SHOULD
HAVE SENT A POET

I . . . had an experience. . . . I can't prove it, I can't even explain it, but
everything that I know as a human being, everything that I am tells me that it
was real! I was given something wonderful, something that changed me forever . . .
A vision . . . of the universe, that tells us, undeniably, how tiny, and insignificant
and how . . . rare, and precious we all are! A vision that tells us that we belong
to something that is greater than ourselves . . .

~ CONTACT

How in the world do you begin to express the exhilaration of standing on the edge of something so vast and marvelous that your mind can barely comprehend it all? What words exist that fully contain the multitude of emotions that rush over you when you behold beauty that seems larger than life itself? When a scene so massive and majestic leaves you feeling fully alive yet small and insignificant at the same time, are words ever enough?

Simply put: How do you describe the indescribable? Is it even possible?

Let's take the Grand Canyon. For the sake of honesty, at the time of writing this, I've actually never seen it in person. Maybe you have, and you meet me, and you say, "Dude, it's crazy!" and proceed to tell me how awesome the sight and experience was for you. You could tell me all kinds of geological and historical facts. You could share with me an emotional moment you had while standing on the edge, which is such a priceless gift when getting to know someone. You might even show me a few of your photos, which would probably be followed by the phrase "Pictures just don't do it justice."

And you'd be right. Because words and pictures don't do beautiful experiences justice.

When I behold an epic scene, I'm often reminded of the movie *Contact*, in which Jodie Foster's character, Ellie, a space-obsessed scientist, is mysteriously transported to a neighboring star system and witnesses a celestial beauty that her scientific language utterly fails to describe.

"No . . . no words. No words to describe it. Poetry! They should have sent a poet!
So beautiful . . . so beautiful. I had no idea!"

Countless times, I have felt like Ellie when standing on the edge of a sea cliff, watching the waves crash against the rocks while being illuminated by a golden sunset. Or when I take in a mountain-sized glacier that carved out the vast valley in which I'm standing. Or even in the simplicity of a quiet moment, like when I'm hiking through a thick forest on a sunny day, where the only light around me is dappled through the leaves and branches, creating a silent shimmer that speaks volumes.

In those amazing, awesome, and otherworldly moments, I often feel like Ellie did on her cosmic journey: "They should have sent a poet!" But as I get older, I've felt less inclined to speak in the presence of beauty and more compelled to simply behold each moment with a tender slowness, stillness, and silence. At least that's my goal most days. Being slow to speak is a discipline that's taken some time to learn. Sometimes the most appropriate response to beauty is silence. Unless, of course, you're a poet, in which case a few words might do the scene a little justice!

As it turns out, the first civilian mission around the moon is being planned.[1] I speak in future terms here, since at the time of writing this book, the mission hasn't taken place yet. So by the time you're reading this, you may have already heard about this historic lunar mission. What makes it so unique is that almost every seat on SpaceX's *Starship* will be filled with artists. Photography, filmmaking, acting, music, and other creative practices will all be represented on this weeklong voyage around the moon!

I, for one, am extremely eager to hear the responses—both in words and in art—from these brave pioneers of culture who are reaching for the stars! My hope for this mission is that the whole world might be blessed with fresh and creative perspectives on what it means to be human and how truly precious and miraculous our place in this universe is.

1 "Dear Moon," dearmoon.earth.

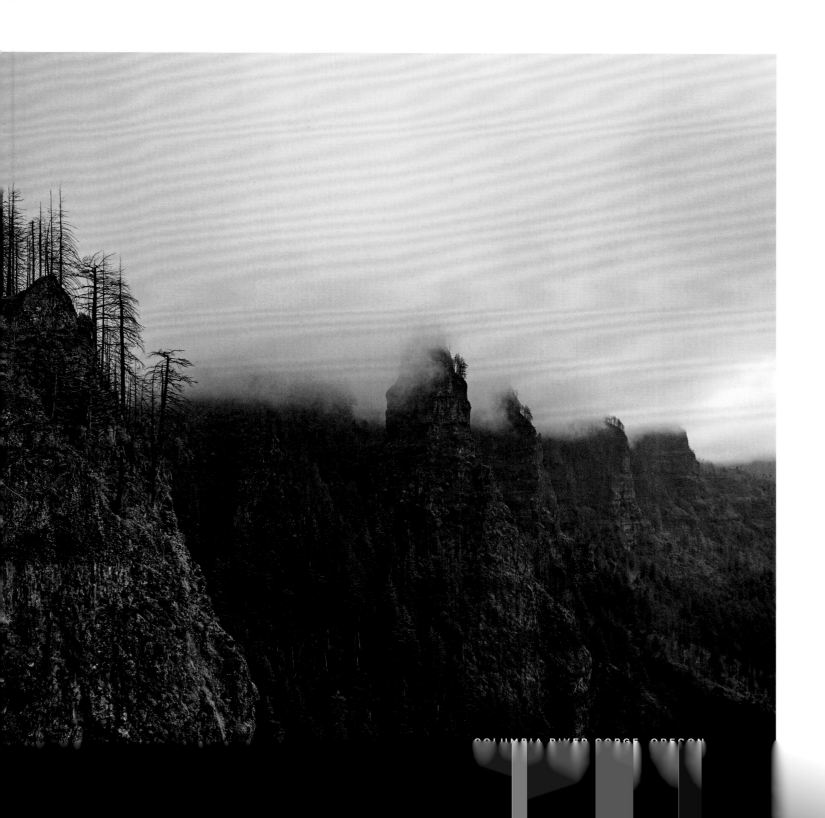

COLUMBIA RIVER GORGE, OREGON

THE OVERVIEW EFFECT

We came all this way to explore the moon,
and the most important thing is that we discovered the Earth.

~ WILLIAM ANDERS

The Overview Effect, coined by author Frank White in 1987, is a term used to describe the existential shift in perspective that astronauts can experience when they behold Earth from space.[1] White describes it this way: "There are no borders or boundaries on our planet except those that we create in our minds or through human behaviors. All the ideas and concepts that divide us when we are on the surface begin to fade from orbit and the moon. The result is a shift in worldview, and in identity."

Paired with this otherworldly painting, and similar to a mountaintop experience, comes a stark silence. All the noise from traffic? Gone. Every political debate and division? Disappeared. Pious posturing from self-righteous personalities? Silenced. The petty arguments you had with a family member? Hushed.

In the presence of that glorious, infinite silence, our awareness of reality begins to shift. This new perspective on all of life becomes a loving, patient teacher who, without saying a word, invites us to realign our priorities and purpose. For when we behold something big, we can often be left feeling small. I believe this can be a gift, especially as a counterbalance to the pride most of us undoubtedly struggle with. Because when we recognize how small we are in comparison to the vastness of the universe, what else can we do but be overwhelmed by humility and gratitude?

When we do that, we might begin to feel a level of connection we've never felt before—a connection that reveals deep within us what we might have suspected all along: that all of humanity is one. United in our planet, in our shared human experience, and, if you believe in a Divine Creator, united in being deeply loved by the One who created it all.

1 "The Overview Effect" (from Wikipedia): The term was coined in 1987 by Frank White, who explored the theme in his book *The Overview Effect: Space Exploration and Human Evolution* (New York: Houghton-Mifflin, 1987).

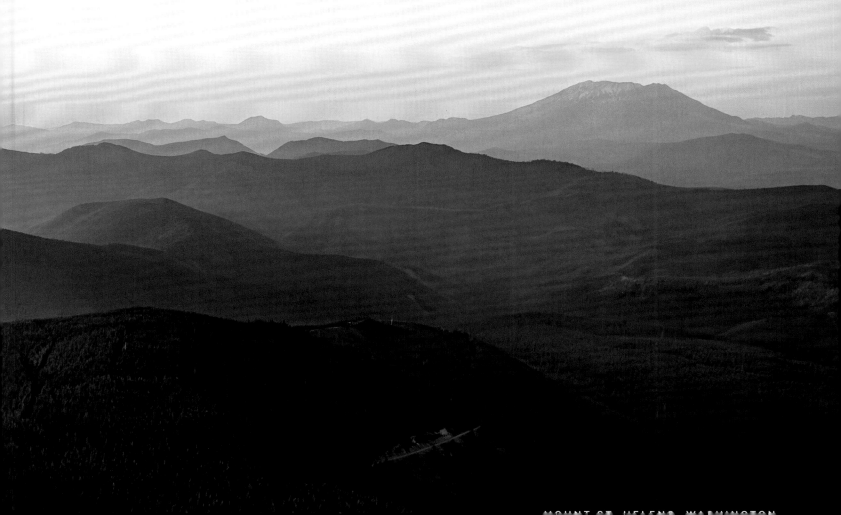

IT SUDDENLY STRUCK ME THAT THAT TINY PEA,
PRETTY AND BLUE, WAS THE EARTH. I PUT UP
MY THUMB AND SHUT ONE EYE, AND MY THUMB
BLOTTED OUT THE PLANET EARTH. I DIDN'T
FEEL LIKE A GIANT. I FELT VERY, VERY SMALL.

~*Neil Armstrong*

MOUNT ST. HELENS, WASHINGTON

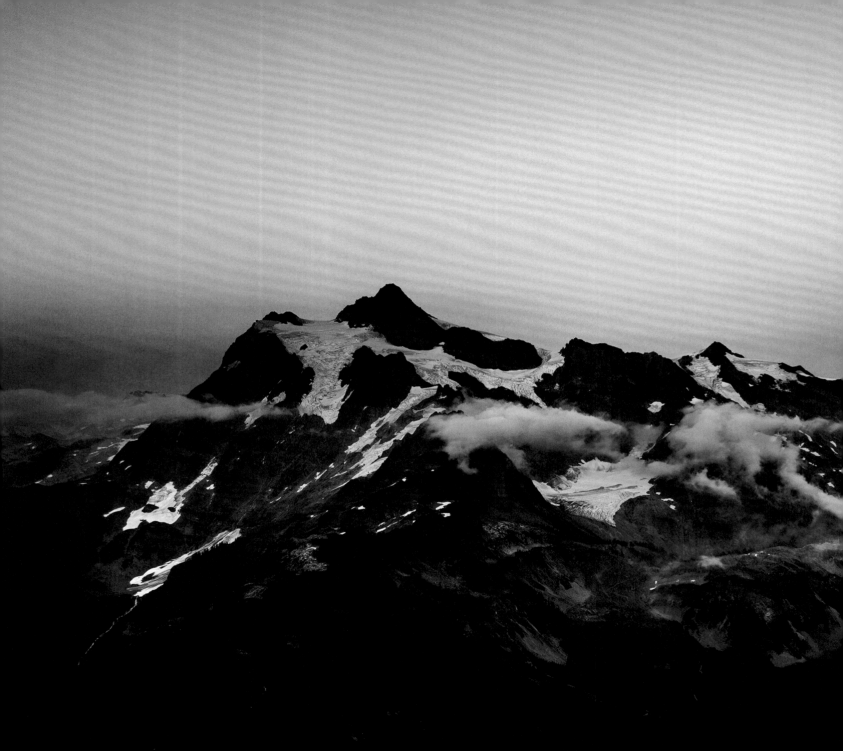

THE BELT OF VENUS BEHIND MOUNT SHUKSAN, WASHINGTON

THE PALE BLUE DOT

Look again at that dot. That's here. That's home.
That's us. On it everyone you love, everyone you
know, everyone you ever heard of, every human being
who ever was, lived out their lives. . . . Every saint
and sinner in the history of our species lived there—
on a mote of dust suspended in a sunbeam.

~ CARL SAGAN,
PALE BLUE DOT

The famous astronomer Carl Sagan once described his version of the Overview Effect when he saw "The Pale Blue Dot," one of the farthest photos of Earth ever taken, captured in 1990 by *Voyager I* from about six billion kilometers away. It's a wildly humbling image in which Earth is the size of a grain of sand.

In 2021, actor William Shatner, who is famously known for his role as *Star Trek*'s Captain Kirk, got a chance to go up into space for a few minutes. (I mean, how crazy is that! Captain Kirk actually went into space! My inner Trekkie just loves that.) After his landing back on Earth, everyone was in celebration, except for him. He had this sobered, awe-struck look on his face. Later, he described the unexpected experience and overwhelming emotion that overcame him. His response, far from being joyful, was more than a little surprising:

It was among the strongest feelings of grief I have ever encountered. The contrast between the vicious coldness of space and the warm nurturing of Earth below filled me with overwhelming sadness. Every day, we are confronted with the knowledge of further destruction of Earth at our hands: the extinction of animal species, of flora and fauna . . . things that took five billion years to evolve, and suddenly we will never see them again because of the interference of mankind. It filled me with dread. My trip to space was supposed to be a celebration; instead, it felt like a funeral.[1]

~ WILLIAM SHATNER

As with Shatner's space voyage, going on an adventure and beholding a mind-blowing scene isn't always fun and games. Of course, ascension can involve a thrilling rush of adrenaline. It's easy to blow through the experience, snap a few photos, and move on to the next point of interest. But that isn't what it means to truly *behold* something.

Beholding means being present with the fullness of reality. It requires stillness and space for us to ponder our existence in a new way. By doing so, we open ourselves up to a wide range of thoughts and emotions—including sadness and grief. If we learned anything from Pixar's *Inside Out,* it's that sadness is good and valid and needs space to be held.

I believe the Overview Effect might be one of the greatest and most precious gifts a person could ever receive. I hope that if I ever get to experience this rare shift in perspective, coupled with the mesmerizing beauty of viewing Earth from above, that it would lead me to be a more loving and kind person . . . to myself, to others (especially those whose views I'm opposed to), and to the entire planet. Such an experience could shift quite a lot. Because, despite all the luxurious and seemingly wasteful extravagance that can accompany such privilege, the Overview Effect might just be the healing medicine our sick and hurting world so desperately needs these days.

If humanity is to become an interstellar species, then my great hope is that we do so as caretakers, and not colonizers, of the cosmos. So here's to the ones who are responsibly pushing humanity forward and upward for the greater good and for beautiful reasons. And for the rest of us, let's do the same as we tend to our own Garden here on the ground.

May we all be open to new shifts in perspective with fresh eyes. And may the stunning, mesmerizing glory of our world invite us all to behold our planet and all who dwell on it with a renewed sense of awe, wonder, and loving-kindness.

1 William Shatner, "William Shatner: My Trip to Space Filled Me with 'Overwhelming Sadness,'" *Variety,* October 6, 2022, variety.com/2022/tv/news/william-shatner-space-boldly-go-excerpt-1235395113.

"THE PALE BLUE DOT"

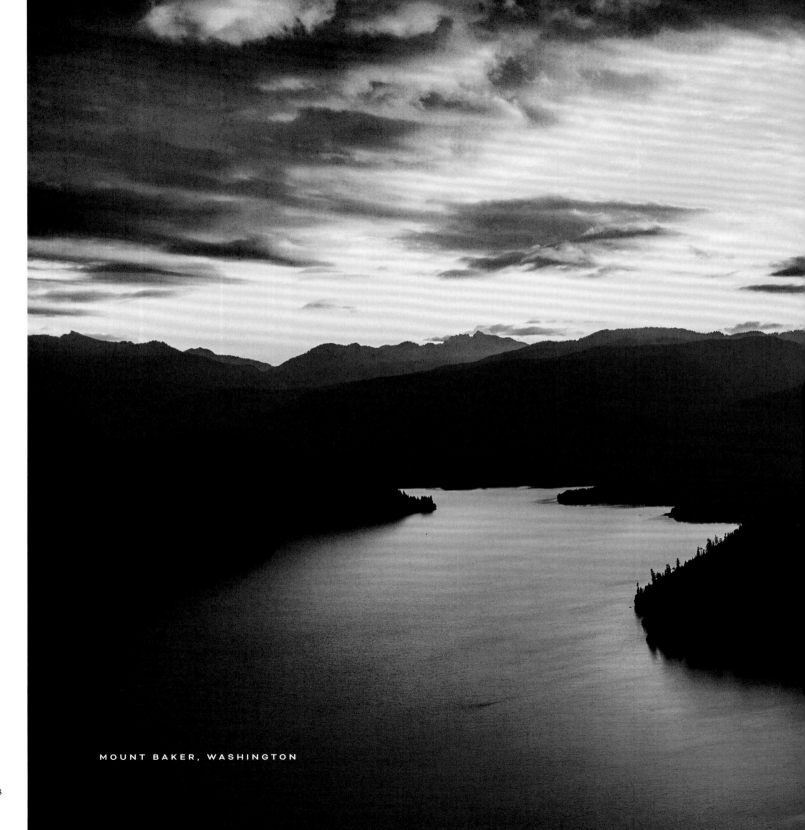

MOUNT BAKER, WASHINGTON

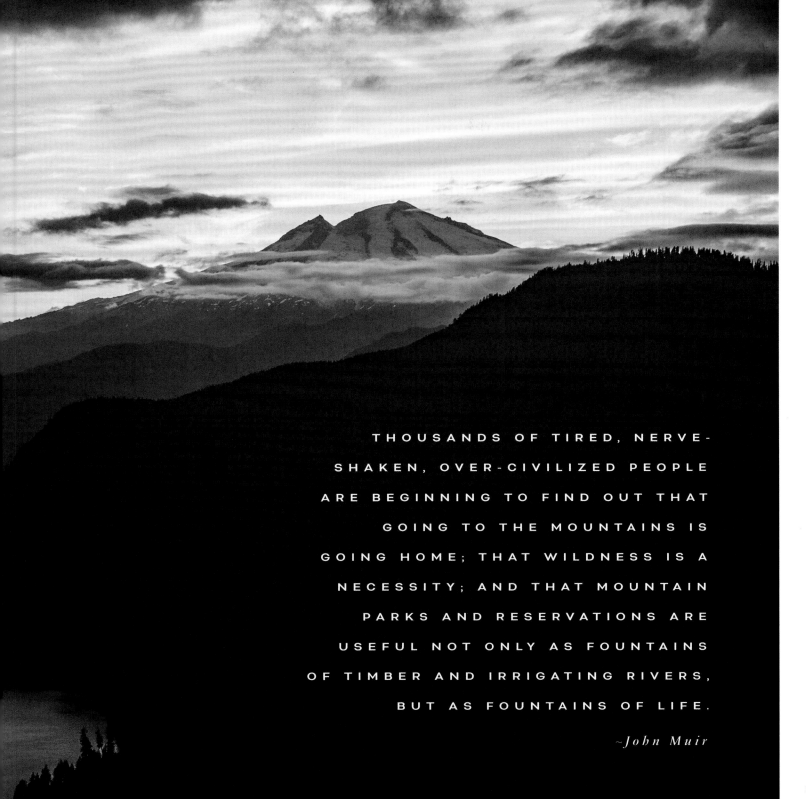

THOUSANDS OF TIRED, NERVE-SHAKEN, OVER-CIVILIZED PEOPLE ARE BEGINNING TO FIND OUT THAT GOING TO THE MOUNTAINS IS GOING HOME; THAT WILDNESS IS A NECESSITY; AND THAT MOUNTAIN PARKS AND RESERVATIONS ARE USEFUL NOT ONLY AS FOUNTAINS OF TIMBER AND IRRIGATING RIVERS, BUT AS FOUNTAINS OF LIFE.

~*John Muir*

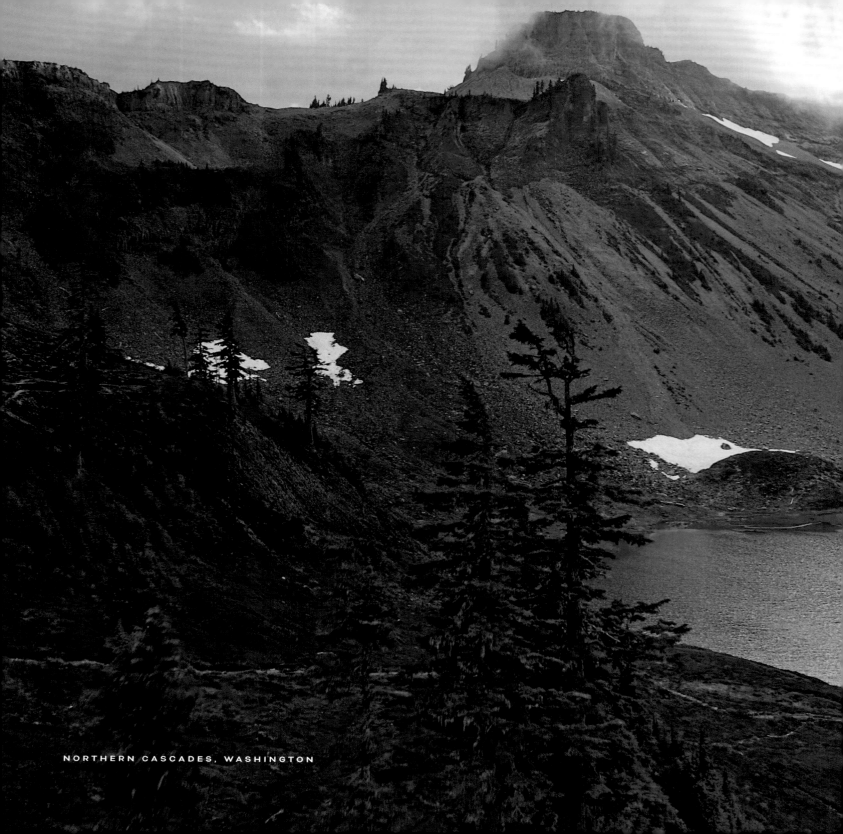

NORTHERN CASCADES, WASHINGTON

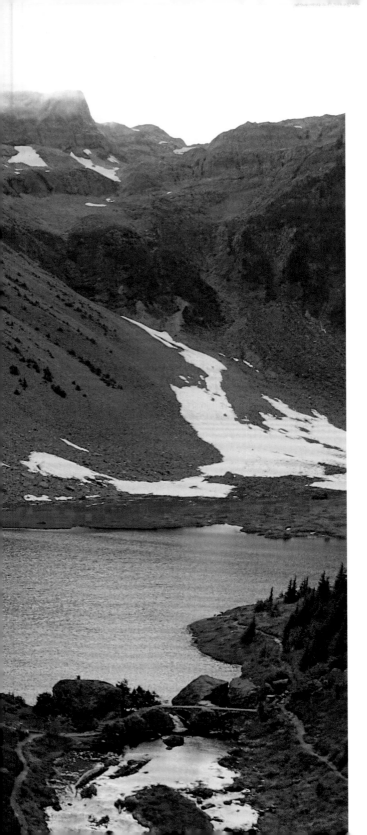

SCORING THE SCENE

Nature is the one song of
praise that never stops singing.

~ RICHARD ROHR

When I ponder the idea of ascension—that is, the act of ascending upward toward the heavens, whether literally or metaphorically—I often associate it with the sound of a choir. Choral music has historically been associated most heavily with spiritual contexts, since the sound of human voices coming together in unified harmony can often lead us to a state of worship and transcendence. So when it comes to upward-leaning landscapes, whether it be a cathedral-like forest or a sanctuary in the sky, the human voice seems like the most appropriate instrument of choice, at least in my humble opinion.

One of my favorite vocal ensembles is an a cappella octet from England called VOCES8. Not only are they masters at performing well-known classical pieces, but their contemporary approach to choral music has led them to collaborate with modern composers such as Ólafur Arnalds, Slow Meadow, Eric Whitacre, Jon Hopkins, and Paul Simon. Their fresh take on a timeless genre has filled my creative life with much inspiration.

So when the company's founder, Paul Smith, reached out to collaborate on a nature-based composition titled "Distant Earth Renewal," I enthusiastically said yes.

Not only is Paul's music stunning, but the lyrics he wrote for this project capture the essence of the changing seasons in such a beautiful and poetic way. I asked Paul if he would contribute a few thoughts about this creative piece as it relates to the connection he hears between the human voice and the Earth's cry for renewal.

SYMPHONY OF LIFE

BY PAUL SMITH,
VOCES8 FOUNDATION

The seasons change,
Earth slowly wakens,
The great dawn breaks,
Portrait of renewal.
Frigid rally of death,
Dance of transition.
Cold winds whisper,
Last sonnet of winter,
First song of spring,
Symphony of life.

~ "DISTANT EARTH
RENEWAL"

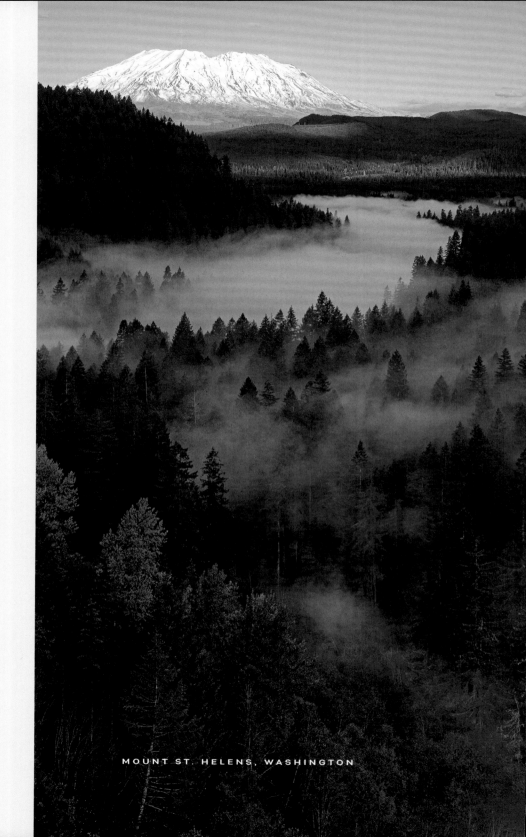

MOUNT ST. HELENS, WASHINGTON

Music is everywhere, in everything we do, be it the bustle of the city or the sounds of nature all around us.

I grew up with two distinct elements in my life that have played a huge part in the way I love to experience the world today. On one hand, growing up in the Lake District in northern England, I was constantly surrounded by mountains, lakes, and the sea, and I spent my childhood climbing mountains at every opportunity. On the other hand, I became a chorister at Westminster Abbey when I was ten, and so spent hours every day singing choral music in one of the most iconic buildings in the world. With nature, in cathedrals, and with choral music, I feel most at peace and most alive. The human voice is the most expressive instrument we have, and combining choral music with jaw-dropping scenes from nature can encourage us to take more interest and responsibility in the world around us, which I feel strongly about.

In "Distant Earth Renewal," the journey of the music and the text reminds us that we are part of a cycle of life. There is a sense of fragility that can be heard through vocal "droplets" in the harmonic language as mist and rain give way to the cold and the ice, before the emergence of new life with the arrival of spring, and the symphony of life. The film Stephen made captures this cycle so beautifully, with sweeping vistas that hold mystery, life, chill, and rebirth in the forests and mountains of the Pacific Northwest. This cycle of nature so strongly aligns with our own human journey, and the film, to me, acts as a reminder that we are all here, sharing the planet together.

We share our voices in the same way. Singing in a choir is an amazing way to connect with a community, to join in harmony, and to understand that by giving your voice to something bigger than any of us, we can create music that deepens our understanding of life and our connection with it. We all experience life differently, and yet in these moments where we combine the natural world around us with our voices shared as one, we can find a common moment for reflection, inspiration, and a vast, unexplainable sense of peace and joy that sweeps through us.[1]

1 The music video for "Distant Earth Renewal" can be viewed at proktr.com/wildwonder.

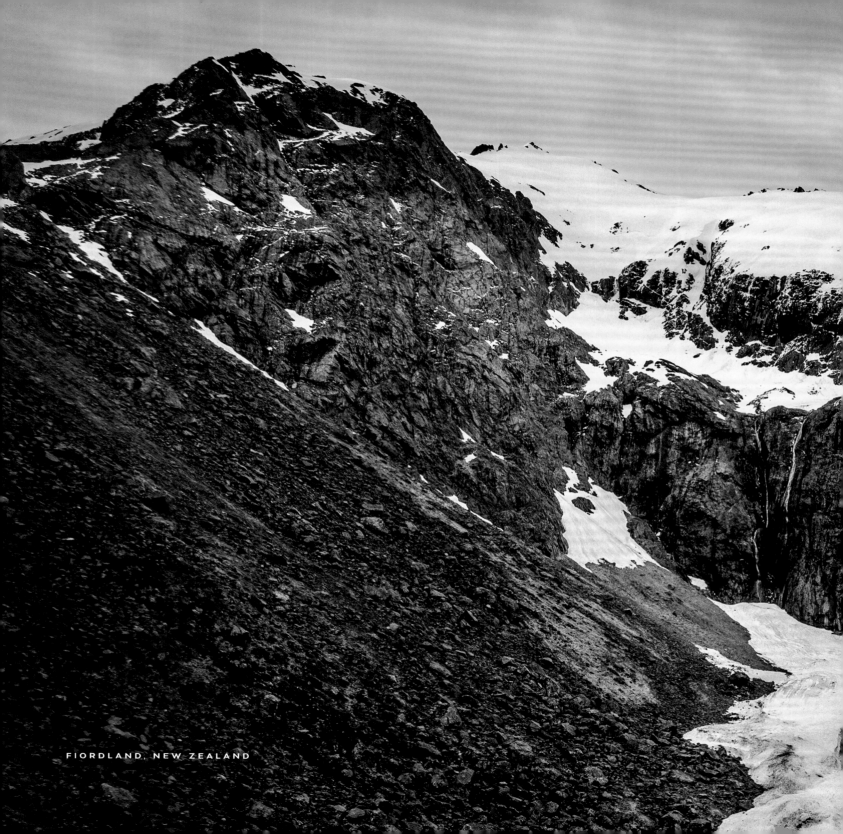

FIORDLAND, NEW ZEALAND

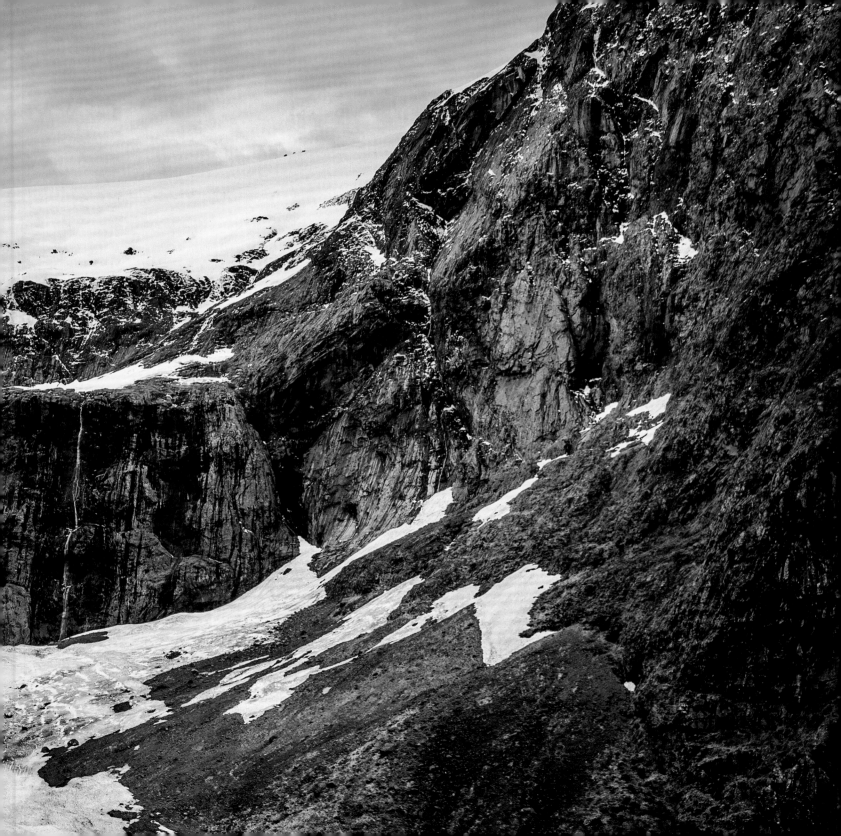

DANCING THE SCENE

We often forget that we are nature. Nature is not something separate from us. So when we say that we have lost our connection to nature, we've lost our connection to ourselves.

~ANDY GOLDSWORTHY

Throughout this book, we've explored the relationship between music and landscapes. With Paul's contribution regarding "Distant Earth Renewal," we've seen how the human voice enters the mix. And on that note, I want to take us one step further by inviting the movement of our bodies onto the stage.

Elisa Young-Schroth of Middleton, Connecticut, leads a contemporary ballet school and company, both under the name Ekklesia. I met Elisa in 2019 while participating in a theological cohort at Duke Divinity School in North Carolina. After we experimented with immersive projection and dance in front of a live audience, we started dreaming of more. Since we are both concerned by the climate crisis, we began using our art to explore how ecological justice relates to our faith.

Even though the pandemic slowed our creative efforts, our dream, titled *Body & Land*, finally took flight in 2022. The inaugural performance took place at Christ Church Cathedral in Hartford, Connecticut, where I was able to immerse the space and dancers in projections of my drone footage as well as a few other nature-based visuals. The second performance was at Duke Divinity School in a theatre equipped with a large movie screen. The fusion of music, dance, message, and visual was unlike any I've ever experienced in my career.

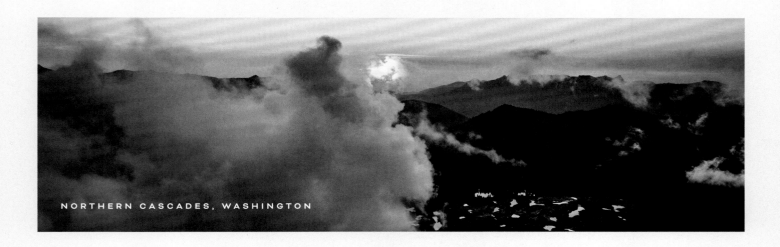

NORTHERN CASCADES, WASHINGTON

BODY & LAND

BY ELISA YOUNG-SCHROTH, EKKLESIA CONTEMPORARY BALLET

Body & Land is a four-part dance work that follows the path of the four seasons. I worked with Connecticut composer Scott Simonelli to blend his modern musical composition with excerpts from the well-known Vivaldi classic *The Four Seasons*. Together, we wanted to create a parallel of how the seasons have changed so drastically from Vivaldi's eighteenth-century world and the preindustrial era with our current postindustrial climate crisis. You can hear in the section of "Winter" the sound of cracking glaciers; "Spring" has a sense of flooding; "Summer," a crackling fire; and "Autumn," hurricane winds.

We often don't notice changes if they happen slowly or far from us, so we paired these timelines in order to feel them all at once. Each season is represented by one dancer. I placed all four seasons dancing together to show how the seasons have been melding together. Spring is coming sooner, summer is lasting longer, which is causing a disruption in the life cycle. This tension is felt especially between Spring and Summer. I choreographed Spring bearing the weight of Summer all on her own. The reality of what we have come to identify with our seasons is no longer what we have. We have warm winters, dry springs, and superstorm falls; the only season that is getting bigger is summer.

Stephen's projections vividly allowed the audience to be engulfed in the landscape of each season and also in the violent disturbances that we are experiencing. To further flex our creativity and imagination while engaging with our bodies and the land, we collaborated with our poet in residence, Kwamena Blankson, to write a poem for the work. Poetry plays with our language, and choreography plays with words and ideas in an effort to further understand the disconnect of our Body to Land and hopefully how to find our way back.

Theologian Ellen Davis stated in a lecture accompanying this work, "Land is not an 'it,' an inert thing on which we humans perform certain operations for our own economic benefit, or our own pleasure. We do both those things, of course, but if we are wise, we recognize the Earth for what it really is: namely, a living creature of God."

Ellen's words align with something we learned when we had a guest instructor, Iddrisu Saaka from Ghana, come to our studio to teach us West African dance. He told us, "When we dance, we do not stomp on the ground; we have a relationship with the ground because the ground is where we get our food, and the ground is where we bury our ancestors. It holds our life and gives us life. We must treat it as sacred. I imagine our world would look very different if we were all taught this lesson at a young age."

THIN PLACES

A thin place . . . is a place in which we sometimes see briefly through the veil that separates Heaven and Earth. At times that veil can seem as "thin as gossamer." But that is not to say that every other place is thick. Rather, it is to say that thin places . . . are like sacraments or living icons through which we glimpse the Light that is present everywhere . . . to cherish as a place in which our seeing is renewed, so that when we return to the demanding and conflicted places of our lives and our world, we do so with open eyes that have been refreshed.

**~JOHN PHILIP NEWELL,
*THE REBIRTHING OF GOD***

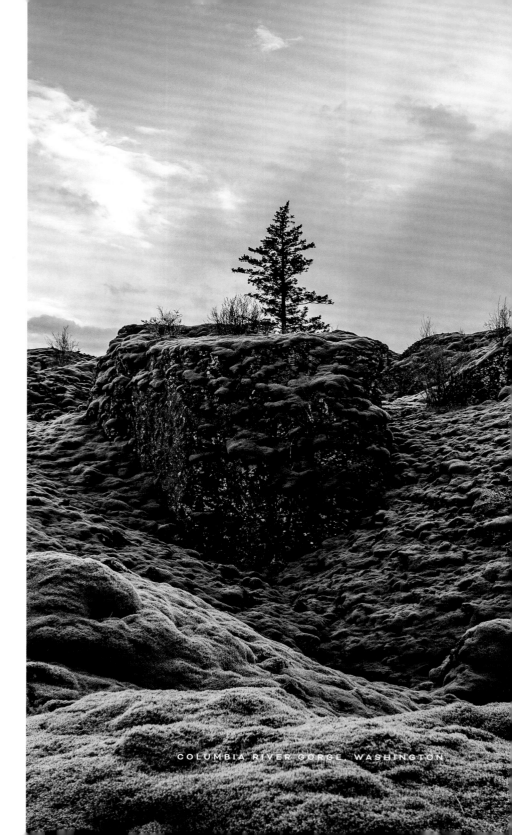

COLUMBIA RIVER GORGE, WASHINGTON

It was a chilly, overcast day on the west coast of Ireland when I climbed my first "holy mountain." I was on a solo adventure exploring the Emerald Isle, which ended up turning into a sort of spiritual pilgrimage. It was one of those times in my life when my faith was being stretched and expanded. And one of the main instigators of this stretching was a saint from the ancient Celtic world whom you might have heard of. His name was Patrick.

In A.D. 441, during a critical time in Patrick's mission among the Celts, he journeyed west to spend the season of Lent in solitude and prayer. There on the west coast stands a round mountain, where it is believed Patrick spent forty days and forty nights fasting and praying before God. Today, that mountain is named Croagh Patrick, or as the Irish call it, Cruach Phádraig, meaning "Patrick's stack." For over fifteen hundred years, it has been revered by the Irish as a holy place.

The ancient Celts saw all of Creation as sacred. They often referred to nature as the Great Cathedral of Earth, Sea, and Sky! They didn't believe that everything was created out of nothing by a distant and uninvolved deity, but rather that everything was made from the very substance of God and created out of a loving-kindness that is woven throughout the fabric of Creation.[1] With this posture, they treated the natural world as a being to be cared for and stewarded with respect, not as a neutral resource to be dominated, exploited, and abused.

Today, many refer to these sacred spaces in the wild as "thin places," for they are where the veil between Heaven and Earth are the thinnest. As Reverend Irvin J. Boudreaux of Louisiana describes it, "A thin place is any place of transition: a doorway, a gate, the sea shore, these are all places where very little movement will take you from one place to another."[2]

Seeing Creation through the Celtic lens has been one of my greatest teachers in the past few years. This perspective has taught me

> **MAYBE THIN PLACES OFFER GLIMPSES NOT OF HEAVEN BUT OF EARTH AS IT REALLY IS, UNENCUMBERED. UNMASKED.**
>
> ~Eric Weiner

to slow down and soak in the presence of a place. To embrace and be embraced by beauty. To not pull out my phone too quickly or snap photos too flippantly. In fact, in most thin places, I never even fly my drone. As Sean Penn's character says in the film *The Secret Life of Walter Mitty*, "If I like a moment, for me, personally, I don't like to have the distraction of the camera. I just want to stay in it." Some places are just too sacred, and some moments are just too personal. And I would rather be in a posture of receiving than taking, letting my eyes be renewed so that I can see a little better when I go back home.

Throughout my travels, beautiful traditions and spiritually rich cultures such as those of the Māori, Native Americans, and Hawaiians have taught me to see all of Creation as sacred, instead of only seeing the "thin places" marked by historic figures and events in that way. While holy mountains and sacred sites can be places of inspiration, mystery, and revelation, they are not meant to be treated as an escape from reality. Instead, these places help recalibrate our own spiritual compasses and send us back to our everyday lives to do the work of "thinning" the world around us.

All the reflections, photos, and practices I've shared in this book aim to aid us in this quest: to notice and nurture the thin places of our lives. From the ocean to the mountains, from music to meditation, from breathwork to tea ceremonies, from practicing silence to flying through the clouds—all these pathways can lead us to the thin places among us and within us. They can help us discover anew the places of wild wonder that surround us as gifts to be enjoyed and nurtured. They invite us to behold beauty through nature's lens and to see the unseen with a renewed vision. And as Jesus prayed, they can guide us in seeing our Creator's kingdom come and will be done on Earth, as it is in Heaven.

1 "The Substance of God," Center for Action and Contemplation, March 13, 2018, cac.org/daily-meditations/the-substance-of-god-2018-03-13.

2 Reverend Irvin J. Boudreaux, "Thin Places," *A Pastor's Thoughts* (blog), March 19, 2015, ijboudreaux.com/2015/03/19/thin-places.

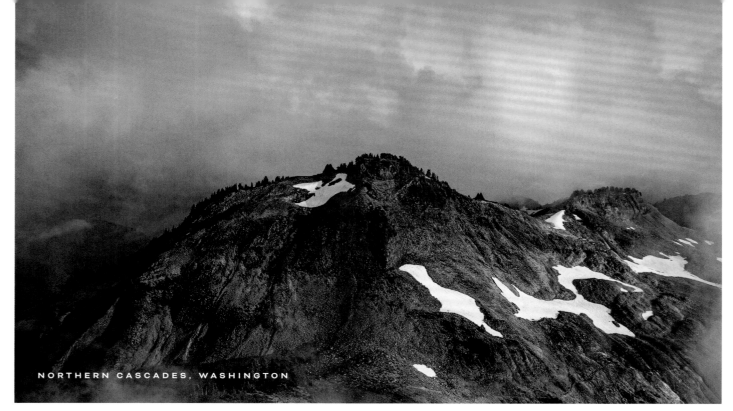

NORTHERN CASCADES, WASHINGTON

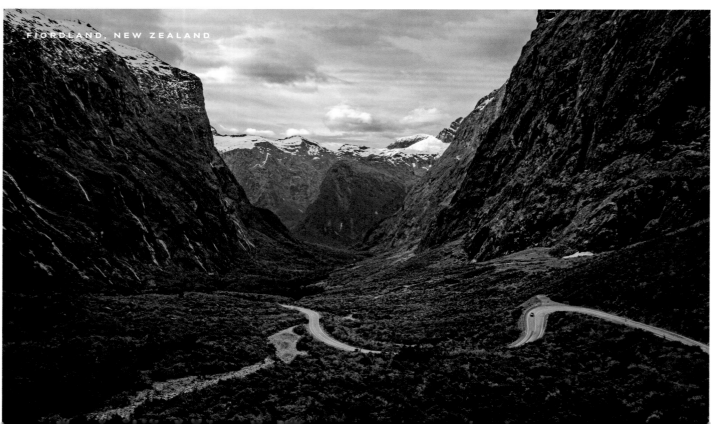

FIORDLAND, NEW ZEALAND

TIME TO FLY!

A MOMENT TO REFLECT

When have you experienced a moment in nature that left you completely speechless?

In the face of beauty, do words often come to you easily? Or do they disappear like a child playing hide-and-seek? Why do you think that is? Do you like that about yourself?

Think of a friend or family member you have shared a "mountaintop" experience with. Hold some space for them in this moment. Maybe reach out to them with a kind message of gratitude for their friendship and reminisce about your shared ascension.

Think of your favorite awe-inspiring scene in nature. Maybe it's a mountain, or perhaps it's a sky full of stars. If you're able, go somewhere that holds sacred meaning for you and seek perspective. Ponder the Overview Effect. Feel the thinness of the place.

Find a nature-based documentary you've never seen before (something like *Planet Earth III* or *Cosmos*). Invite friends or family to join you for an episode and behold some beauty and wild wonder together.

MOUNT BAKER, WASHINGTON

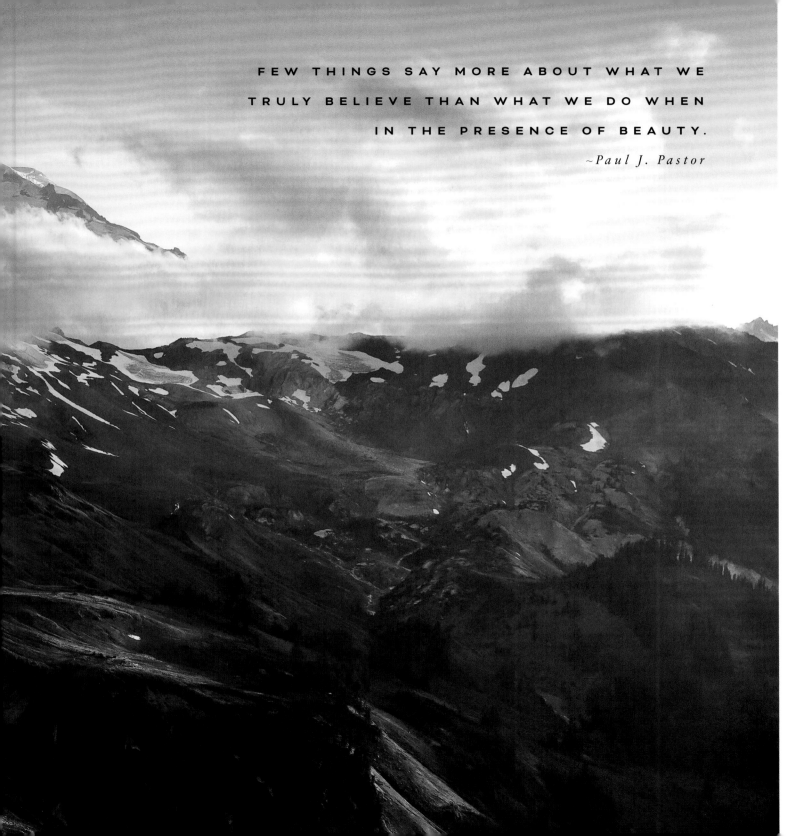

FEW THINGS SAY MORE ABOUT WHAT WE TRULY BELIEVE THAN WHAT WE DO WHEN IN THE PRESENCE OF BEAUTY.

~*Paul J. Pastor*

PARTING WORDS

Well, here at last, dear friends, on the shores of the Sea comes the end of our fellowship in Middle-earth. Go in peace! I will not say: do not weep; for not all tears are an evil.

~ J.R.R. TOLKIEN, *THE RETURN OF THE KING*

TONGARIRO, NEW ZEALAND

ADVENTURE RESPONSIBLY

With every flight of my drone comes the inevitable low-battery notification alerting me that it's time to bring it back in for a landing. And so the time has come for our flight to end as well. (Though I hope in this case our time in the sky is ending with a fully charged battery!) As I bring this book in for a landing, I want to leave you with a few parting words when it comes to exploring and sharing the beauty of nature in a respectful and responsible manner.

When posting on social media, please be mindful of geotagging. While it's fun to share where we've been, tagging specific locations can often lead to what the fishing community refers to as "spot-burning." Overly shared places can become beacons of light that attract the masses, and much of the natural world was not designed for heavy traffic. Many beautiful places and fragile ecosystems have been ruined by overcrowding. So when posting online, please use a general location such as the state or region where the scene was captured, unless it's a state or national park with adequate infrastructure. In the words of Gandalf the Grey from *The Lord of the Rings*, "Keep it secret, keep it safe!"

In the same breath, I want to encourage us all to leave places just like we found them. Whatever you bring into nature, take it with you as you leave. "Leave no trace!" Too often have I seen trash left behind in pristine places. I'll never forget when my friend Addi, a tour guide in Iceland, told me how many cigarette butts and plastic bottles he's found in the remote highlands of his country.

As we show respect for the land and people around us, let's also respect the local cultures that dwell in these beautiful places. I spoke a lot at the end about sacred sites. I should add that not all "thin places" are open to the public, nor should they be. Please, do your due diligence and research the places (and cultures) you are going to before you arrive. When in doubt, stick to designated areas, such as state and national parks, as well as any open trails marked for public use.

Speaking of trails, stay on them! I know more than most the urge to go off the beaten path. But in addition to harming the fragile ecosystem, this is the fastest way to put yourself in danger, not to mention the emergency personnel who put their lives at risk to rescue those in distress. The quickest way to get lost is to wander off the path alone. So keep in mind what the Harfoots say in *The Lord of the Rings: The Rings of Power*: "Nobody goes off trail, and nobody walks alone!"

On the same note, stay away from dangerous edges! Too many times when I go to a beautiful waterfall or sea cliff, I see a memorial of someone who's fallen. This is an awful and sobering way to be reminded of our own mortality. Even in my own neighborhood in the PNW, every year we hear of someone who has perished by getting too close to the edge of a tall waterfall. And it almost always involves a camera. Your life is infinitely more beautiful and valuable than your Instagram feed ever could be. And that photo is just not worth the risk.

Even when we do stay on the trail and follow the rules, we are still exposing ourselves to some level of risk, especially when venturing into the wilder places on this planet. Creation has immense power, and when it groans, we have to take great care. As C. S. Lewis described Aslan in The Chronicles of Narnia, nature isn't safe, but it's good.

TIKKUN OLAM

מ ל ו ו ע ק י ת

My final charge to you is a bit more hopeful. And it comes from none other than Mister Rogers.

No matter what our particular job, especially in our world today, we all are called to be tikkun olam—"repairers of Creation." Thank you for whatever you do, wherever you are, to bring joy, and light, and hope, and faith, and pardon, and love to your neighborhood and to yourself.

~FRED ROGERS

If you can't tell by now, the practice of Creation Care is near and dear to my heart. While much of the climate crisis narrative has been hijacked by politics and pundits, it is still our responsibility on both an individual and collective level to be stewards and caretakers of Creation. Every person, corporation, and nation on the planet has a responsible role to play.

The triggering topic of climate change can often be one of doom and gloom as well as skepticism and doubt. While I am highly concerned about this crisis, I don't believe that being an alarmist is always the most helpful or hopeful way to encourage others to get involved, though I do believe there is reason to be alarmed. With that said, I do hope more of humanity takes positive action in fighting this ecological and environmental injustice, especially since the ones who are affected by climate change the most are usually the ones who are the least responsible for it.

To get involved, whether through planting trees, participating in relief work, or donating to organizations focused on mitigating climate change, please check out the list of resources on my website. And no matter your political preference, let's hold our politicians and representatives accountable and encourage them all to create legislation that protects our planet (and in ways that don't fill their own pockets!).

But let's not just hold our leaders accountable. Each of us has a responsibility to be less wasteful and more resourceful in the days ahead. Even small things can make a difference in the end, and if nothing else, they can be symbolic acts that remind you of the invitation to care for the Earth. And yeah, some of the little things may seem silly and annoying at times, especially those paper straws that disintegrate too quickly. (I hate those things, too!) But still, let's not allow small frustrations to distract us from the bigger picture. Let us walk together into this uncertain future both humbly and creatively.

In short, let us all be a people of tikkun olam. As we allow nature to repair us, let us also be joyful repairers of Creation! After all, Earth is just one giant neighborhood.

As you go forward, may your eyes be opened wider to the world of wild wonder around us. And may you find the Light—and be the Light—in both the brightest and darkest places of our world.

Farewell. And fly well, my fellow adventurers.

MOUNT ST. HELENS, WASHINGTON

MANAAKI WHENUA, MANAAKI TANGATA, HAERE WHAKAMUA.
CARE FOR THE LAND, CARE FOR THE PEOPLE, GO FORWARD.

~Māori proverb

ROTORUA, NEW ZEALAND

ACKNOWLEDGMENTS

I am beyond grateful to the countless friends, family members, clients, mentors, and fellow artists who have loved me and believed in me throughout my life and career. I would not be who I am today without them. It would take another book to write down all the names and reasons why I am thankful. But there are a few people who I would like to specifically mention and thank.

First, to Paul J. Pastor! Thank you for your friendship, for your artistry, and for unearthing this book in me. None of this would have happened without you! May your supply of mugwort always be in abundance!

To the Ink & Willow and WaterBrook teams, especially my editor, Leslie Calhoun, art director, Lynne Yeamans, and designer, Kelsie Monsen. Thank you all for taking a chance on a drone pilot! And thank you for helping me craft and polish this book and for allowing me to share the beauty of the Earth with the world.

To Whitney Gossett and Content Capital. You are a dream agent and even better friend! I am so honored to be represented by you, both for this book and beyond. Thanks for believing in me and taking my career on this incredible *journey*!

To Makoto Fujimura. Mako, I am so thankful and humbled for the beautiful painting of words that opened up this book. Words will never be enough to express my gratitude for how you've inspired me and illuminated my imagination. Thank you for teaching me to see the unseen.

To the artists and composers who've invited me to collaborate on projects, especially Tony Anderson, Jordan Critz, Slow Meadow, Gungor, The Brilliance, United Pursuit, Leslie Jordan, Ekklesia Contemporary Ballet, Peter Gregson, VOCES8, Amit Inderdeo, Austin Fray, Julie Cooper, and Hanan Townshend. Your music is the wind beneath my drone.

To the creative geniuses who contributed to this book: Joel Pike, David Swick, James Everingham, Paul Smith, and Elisa Young-Schroth. Thank you for showing us a unique perspective of our world through your artistry.

A special thanks to these amazing people who have had a profound impact on my life: Beth Moore; Travis Cottrell; and my Living Proof Live family, including LPM, Lifeway, and the production crew. Melissa, my Galadriel, thanks for letting me be your Elrond. Chad & Jen Jarnagin + Luminous Parish in Franklin. All Souls Anglican in Portland. My spiritual director, Rick Ganz. All my friends in Arkansas, Nashville, and the PNW. My whānau in New Zealand, especially Mark Pierson, Goff and Sarah, Graham Burt and the FestivalOne fam, and Tash McGill. Dirk Dallas, for inspiring me as a fellow drone pilot and friend. (Go buy Dirk's photobook *Eyes Over the World*!) And thanks to all my friends who've traveled with me to the ends of the Earth, especially Jeremy Stanley.

To my family: Leslie, Mary Claire, John, Mark, Jonathan, Caitlyn, Calla, Jared, Leah, Hannah, Seth, and Morgan. I love you all so much! Special thanks to my incredible father, Rick Proctor, who has shown so much love, support, and grace not only my entire life, but especially during this season of grief. I am so proud to be your son. And to Mama, to whose memory this book is dedicated: thank you for being the best mother in the entire world and for praying this book into being. I am so thankful for the creative passion and love of Creation that you passed on to me. I miss you more than I can bear.

Finally, I want to thank my Creator and Savior . . . for creating this precious planet and the glorious cosmos that we're floating in. Thank You for loving me into being and for being *with* me every step of my weird and wonderful life, and especially for giving me the words to speak while writing this book. I love You!

Glory to God, Source of all being, Eternal Word and Holy Spirit:
as it was in the beginning, is now, and ever shall be . . . world without end. Amen.

ABOUT THE AUTHOR

STEPHEN PROCTOR is a visual artist who specializes in landscape cinematography and aerial photography to curate calming, imaginative experiences. Many of his current collaborations are with film composers, ambient artists, and modern classical musicians. For the past twenty years, he has toured with various bands and authors, producing visually immersive experiences for live concerts and conferences all around the world. Stephen lives in a small cabin in the Columbia River Gorge just outside Portland, Oregon.

NAMÁRIë.

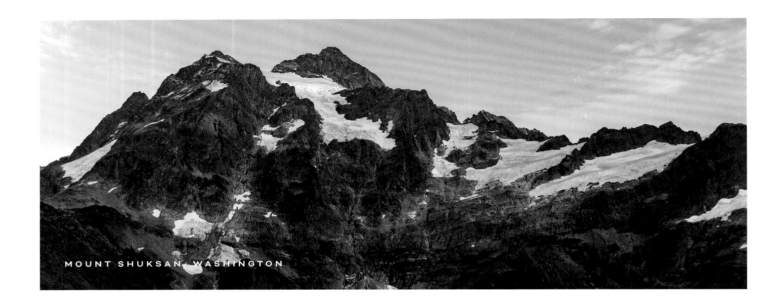

MOUNT SHUKSAN, WASHINGTON

WILD WONDER

All Scripture quotations, unless otherwise indicated, are taken from the Holy Bible, New International Version®, NIV®. Copyright © 1973, 1978, 1984, 2011 by Biblica Inc.™ Used by permission of Zondervan. All rights reserved worldwide. (www.zondervan.com). The "NIV" and "New International Version" are trademarks registered in the United States Patent and Trademark Office by Biblica Inc.™

Scripture quotations marked (NKJV) are taken from the New King James Version®. Copyright © 1982 by Thomas Nelson. Used by permission. All rights reserved.

Published in the United States by Ink & Willow, an imprint of Random House, a division of Penguin Random House LLC.

INK & WILLOW® and its colophon are registered trademarks of Penguin Random House LLC.

Additional photographs courtesy of: © Ryan Mclemore, page 10 (The Adventure Begins); © Ben Smallbone, pages 12 & 13 (Touching Grass); © Brandon Hendricks, page 14 (A Bird's-Eye View); "The Pale Blue Dot" page 167, courtesy of NASA/Voyager 1; © Jono Hale, page 184 (Parting Words); © Jeremy Stanley, page 191 (Acknowledgments).

Hardcover ISBN 978-0-593-58179-7

Printed in China

waterbrookmultnomah.com

10 9 8 7 6 5 4 3 2 1

First Edition

Book design by Kelsie Monsen

SPECIAL SALES: Most WaterBrook books are available at special quantity discounts when purchased in bulk by corporations, organizations, and special-interest groups. Custom imprinting or excerpting can also be done to fit special needs. For information, please email specialmarketscms@penguinrandomhouse.com.